Noel Sheridan

**On Reflection**

# Noel Sheridan
# On Reflection

Four Courts Press

ISBN 1 85182 609 2

Design: Bill Bolger
Printed by βetaprint, Dublin

# Contents

# Acknowledgements

I would like to acknowledge the assistance given to this publication by An Bord of the National College of Art and Design (NCAD) and An Comhairle Ealoinn (The Arts Council of Ireland) and I thank Linda and Tony Pilaro and the Cap Foundation for their support.

I thank Ciaran MacGonigal who, as Director of the RHA Gallagher Gallery, first suggested the idea of a retrospective, and Patrick Murphy, the present Director, who brought an end to my vacillation by setting a date, allocating the spaces, and proceeding to do it. I thank the staff of the RHA Gallagher Gallery: Ruth Carroll, Exhibition Co-ordinator and Stephen Brandes, Jason Murphy, Brendan Early, Liam O'Callaghan – and Japonica Sheridan.

My special thanks go to Billy Bolger, Head of Visual Communication at NCAD, who got close to the material and gave it a design coherence that was better than I thought possible. Anthony Hobbes digitised all that I thought had faded from forty-year-old slides that my friend Niall Hyde had taken when he and Dorothy visited us from Philadelphia in those barmy '60s daze. Francis Keavney while photographing our kids for his book on kids also took ambient shots of me in the studio and still had the negs. I thank Bill Farley not just for his negs but for his optimism for art and life. My thanks to Fergus Bourke for the *Playboy* photo- graph and to Gary Proctor for the Warbarton images. Barbara Dawson and Christina Kennedy of the Hugh Lane Municipal Gallery for their help. Mary Clarke of the Civic Museum tracked the images for 'The Head' and Ray Flynn of NCAD's Department of Visual Communication photographed the recent work. I thank Brian King, Head of Sculpture, and Brendan Begley, John Kavanagh and Gerry Nolan for technical advice, and Leigh Hobba for making Sony half-inch video tape from the 1970s viewable again.

Andrew Folan of Fine Print and Michael Kay and Cliona Harmey of the NCAD Media Department: thank you for burning the CDs (no, this is a good thing) and Joe Egan for the video transfers and edits and Brian Maguire for the lightbox.

Edward Murphy and his staff in the NCAD Library tracked references from the NCAD National Irish Visual Art Library (NIVAL). I thank Anne Hodge for her initial research.

My secretary Marion Lynch and Helen Fegan of the Accounts Department brought order to what always seemed to want to get out of hand: Ken Langan, Registrar, and his staff were also very helpful.

Thank you Mick O'Kelly (Core Studies), Enda Walsh (Fine Art), David Bramley (Accounts Department) and my daughter Anne for being Poussin field workers, and Professor Angela Woods (Head of Design) for getting everyone dressed to look the real virtual thing in John Banville's fictional painting (thank you, John, for permission to use the text). Thanks also to Ian 'Demeter' Breakwell (external examiner in Fine Art) for his trust and generosity and Anthony Hobbs for recording and helping me to rearrange things.

The following owners lent paintings to be photographed and although space has not made it possible to reproduce every painting I thank them:

Ian Baird, Michael Carroll, Kitty Conroy, Randal Faulkner, Niall Hyde, Katherine Fitzgerald, Christine Hetherington, Breda Kelly, Cora Kelly, Paula Loughlin, Desmond MacAvock, Fiachra MacFhionnlaoith, Seamus Monahan, Edward Murphy, Mary Murphy, Pat Murphy, Office of Public Works, Sheila O'Hagan, Thomas Ryan, Tony Ryan, Tony Sadar, Ann Sheridan, Liz Sheridan, Japonica Sheridan, Fedelma Simms, Jackie Stanley & Campbell Bruce, Kevin Roche, Dorothy Walker, Oliver Whelan.

I was privileged to know the artists and writers who contributed to this publication – George Alexander, Robert Ashley, Donald Brook, Brian Hand, Ken Jacobs, Bernice Murphy, Des McAvock, Brian O'Doherty, Mike Parr and Stuart Sherman.

# Noel Sheridan Dublin 1950s

WHATEVER the categorisers may say, or more usually, write, the Fifties to those who lived through them could be revelatory, innovative, and even exciting. After the stasis of the Ireland of the 'emergency', suddenly the world opened up: travel was possible, publishing seemed to explode and provide almost instant access to what was happening in the arts everywhere, well, in the West anyhow. All this meant that, even in Ireland, awareness of the latest movements in art, almost as they were happening, was available to anyone interested in partaking of them. Colour-reproductions were much improved and widely available; one could subscribe for instance to the Amsterdam Stedelijk under Sandberg and receive their wide-ranging catalogues as they appeared; likewise those from the New York MoMA were authoritative and easily procurable. Above all, there were more art magazines dealing with the latest manifestations of the zeitgeist (itself one of the newly fashionable words!).

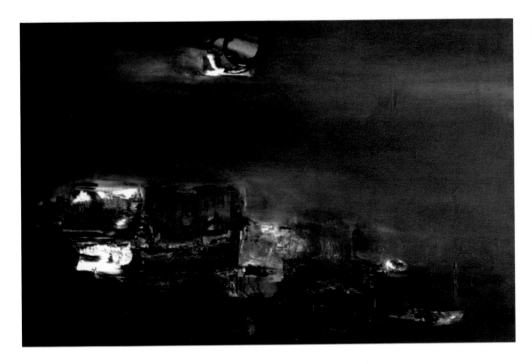

Double Sun
39 cms X 60 cms

1

Orange Shore
35 cms X 45 cms

And Dublin itself was also exciting for a young painter. Living Art was in its heyday with its welcome for whatever experiment was indicative of the prevailing atmosphere of the time while Leo Smith and David Hendriks at their respective galleries were eager to exploit these developments, so that collectors, themselves more aware, had venues to cater for them also.

Noel Sheridan in particular lapped all this up with a youthful voraciousness; he bubbled with the excitement of discovery and endeavoured to incorporate this into his painting. (Lend him an art-book and it came back obviously well used.) Noel's family background provided an entrée to the vibrant theatrical life of the time. Noel, while a student and already thinking of himself as a painter, wrote for and performed, mostly in revue, but also, I remember, in *The Scatterin*. This play,

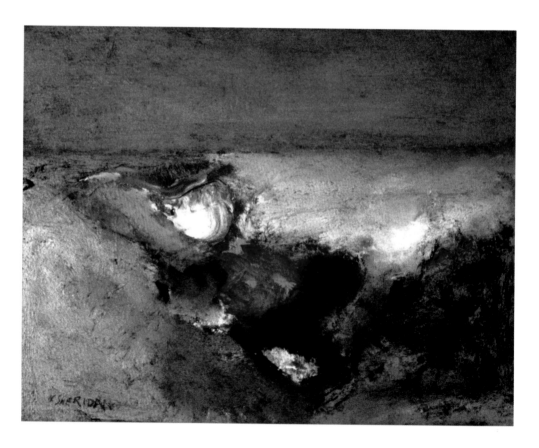

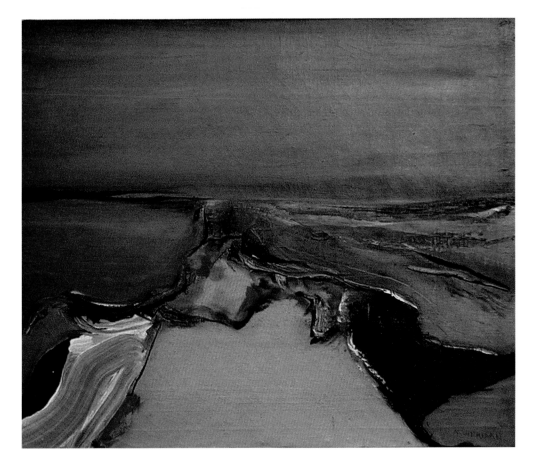

White Bight

by the sculptor, James McKenna, perhaps epitomised the times dealing as it did with the scourge of emigration, but in a very free, spontaneous form (rock & roll) which reflected almost as much as the content, the prevailing flavour of the times. In this moving between different areas of expression Noel was exploiting the values of his inheritance, but also allowing himself to develop a range of expression not open to others and this was to show its value later as his expression broadened into fresh spheres, particularly the intermingling of the visual and the verbal, which even then was beginning to manifest itself.

The centre at this time of fairly intense youthful activity was a small bedroom in the family home in Harold's Cross which at times could be more hazardous than I think the rest of the family were aware of, as when, in endeavouring to replicate the textures of a Burri, a canvas took fire with more vigour than was expected. All his paintings at this time were immediate and very expressive of their making in gesture and brushstroke, so that on seeing them one felt that one partook of the excitement and even surprise of the painter himself at their emergence from the crucible of imagination and paint.

New York, when he arrived there, changed all this. Now married to Liz and with the start of his family, he first got a job at the Museum of Modern Art as a guard. From our conversations then and indeed the examples of his work at the time, it seemed as if he never left the rooms containing the Matisses. He was particularly focussed on the large *Piano Lesson*, the planes and colour structure of which had an influence on his own work, now domestic scenes. Chairs dominated in his next exhibition in the Dawson Gallery in 1967. But more importantly and notably, while New York marked his development as a painter, it also saw the emergence of the Noel Sheridan we now know with his wide-ranging and deepened interests in which painting, however marginalised it may have been from time to time, has always played a very important part in his imaginative life.

*Des McAvock*

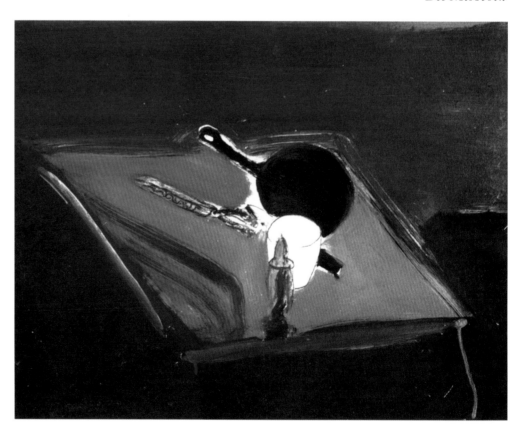

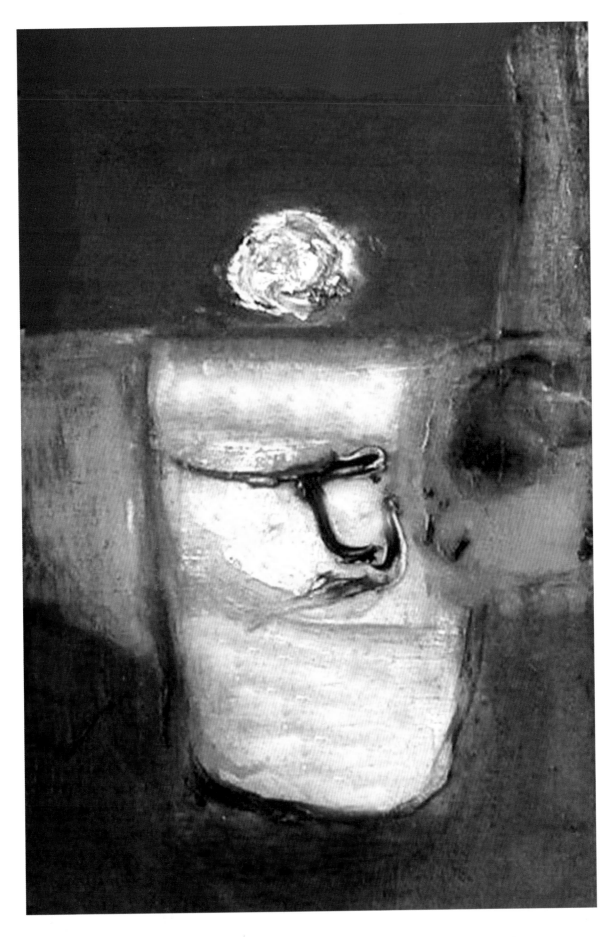

Cerulean Landscape
86 cms X 97 cms

Three Shapes
91 cms X 61 cms

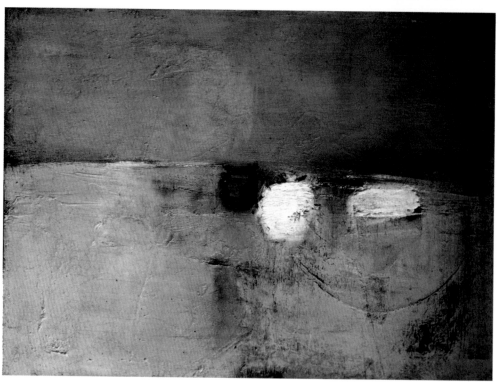

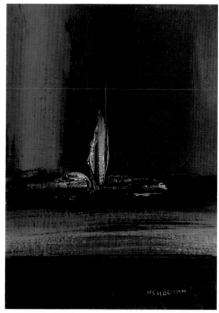 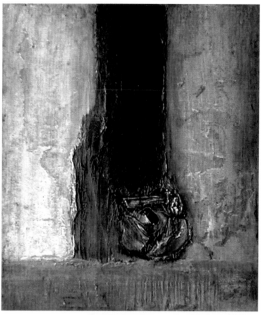

Lamp
15cms X 10 cms

Still Life
15cms X 15 cms

Dark Shapes
122 cms X 122 cms

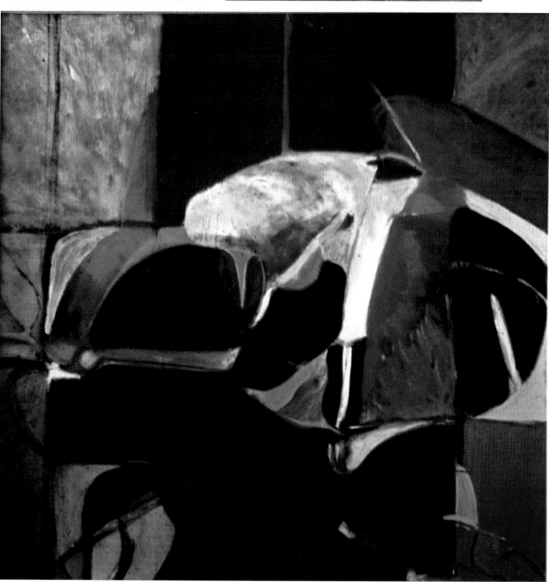

Drawing
10 cms X 20 cms

*Personal reflections on the 1950s (N.S.)*

When I left Synge Street CBS I got a job working as a clerk in the Circulation Department of Independent Newspapers. After a trial period I was moved from that position to that of Office Boy. But it was good as I got to write the stop press posters with the felt pens that were new at that time and which I used to make my first drawings. What I also got to do was spend a great deal of my time next door in the wholesale area of Easons (collecting papers, checking orders etc.) but mainly collecting all the colours of Penguins on philosophy, art, new writing, poetry, politics and whatever else the publisher elected as essential reading for universal education at reasonable prices at the time. ('Plastics in the Service of Man' was one I seem unable to forget.)

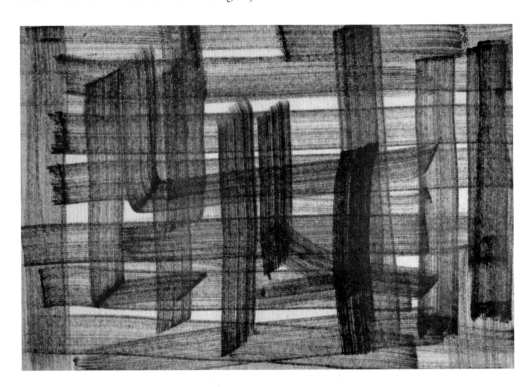

My reading was all over the place, but I knew there was a great deal more to the world than we got to glimpse at Synge Street. The only night course available at that time was at Trinity College and I went there for four years in the evenings

8

Clockwise

Still Life
22.5 X 19 cms

Still Life
91cms X 61 cms

Vincent
51.5 cms X 61.5 cms

Off Shore
27.5 cms X 39 cms

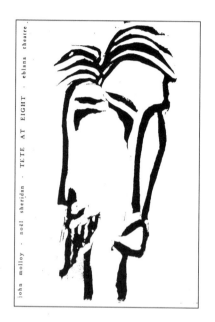

doing a DPA (Diploma in Public Administration) and a BA, BComm. When I left I was sure I would never use any of this again, but later it proved useful to know how to read a set of accounts, and understand double-entry bookkeeping etc. I wrote some sketches for the Trinity Players revues and got to know John Molloy who played in them. I wrote for him too and eventually appeared with him in revues one of which *Tete at Eight* was taken to New York in 1963. When I got there I stayed – to paint. This was an amazing time in New York. But before that:

I met Cecil King in 1958 when he came to our house to collect my father who had agreed to appear in a fund-raising event for An Oige at the Olympic Ballroom. Cecil King was the Secretary of An Oige at that time. I'd read quite a bit about painting but this was the first painter I'd ever met. Through him I met Patrick Collins, Patrick Scott, Maureen (Mo) West and Barbara Warren. Cecil had attended classes with Neville Johnson and he also held some classes himself where Neville Johnson's methods were adopted ('scumbling' was a feature). Cecil had a collection of paintings; I remember a small Henry Moore drawing ( figures in the underground), a Roger Hilton, a Neville Johnson and others. The real eye-opener for me was getting a copy from Desmond McAvock of a retrospective at the Whitechapel of Nicholas de Stael, a Russian painter who had committed suicide in Paris in 1955. I felt I 'got' these works right away.

The reproductions were in black and white so I had only the tones to go by and had to make up the colours myself. I was amazed when I got to Paris to see de Staels to find he often used clashing primary colours. I used local colour – greys. sap greens, earth colours etc.

I showed at Living Art each year from about 1957. I left some paintings in to be framed with Leo Smith. When I went to collect them he told me he had sold them to, I think, a Lord Beaver, and one to Brian Robertson of the Whitechapel Gallery, and did I have more and would I like a show. I said I had (I didn't) and in my bedroom at 10 Casimir Road I painted the show in the small space around my bed. The show was successful and Leo became my dealer.

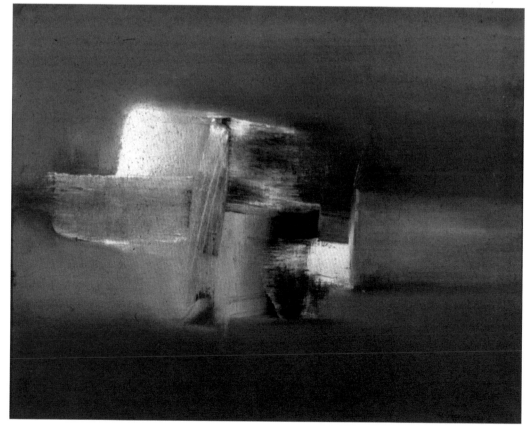

Marine Scene
50 cms X 60 cms

Icarus 2
45 cms X 61 cms

White and Purple
40 cms X 50 cms

I met Gerard Dillon through Living Art and he became a friend and was most helpful and through him I met Nano Reid. The main point here is that the art scene at that time was quite small, maybe a dozen people; you could meet all of them and they were most generous in their advice and support.

I won £50 in a poster competition for books ('Books are bound to interest you' was my effort) which allowed me to leave the Independent and paint. I also wrote for a morning radio sponsored programme which paid 30/- p.w.

I met Charlie Brady around 1958. We became friends and with Owen Walsh, Elizabeth Rivers and others we formed Independent Artists. I was the first Secretary (BA, BComm!) and Noel Browne opened the show. I think it was the first time Barrie Cooke and Camille Souter got to show ten paintings each.

In 1960 I won the Macauley Scholarship (£1000) and in 1961 I went with Liz to live in London for two years. ( £1000 was a lot of money at the time but mostly it was Liz's salary that kept things going.) I made a show for Leo Smith in 1963. That year I appeared in a revue with John Molloy (a lot of it was about JFK euphoria) which took us to New York that fateful November.

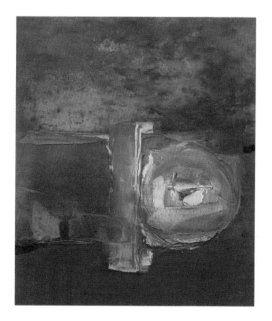
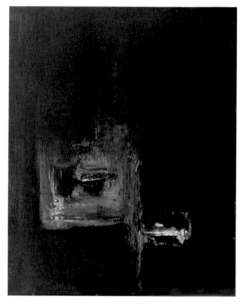

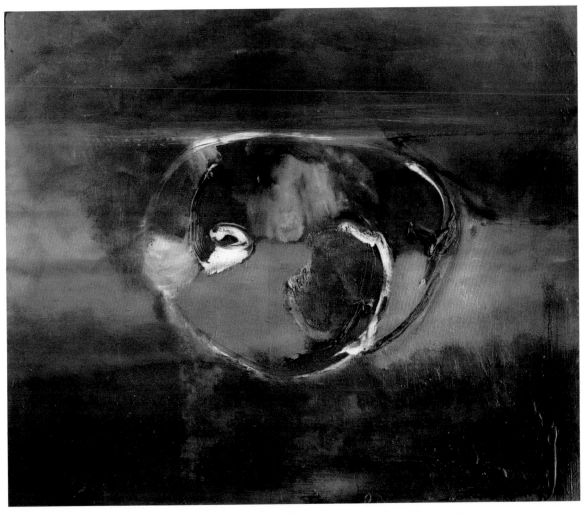

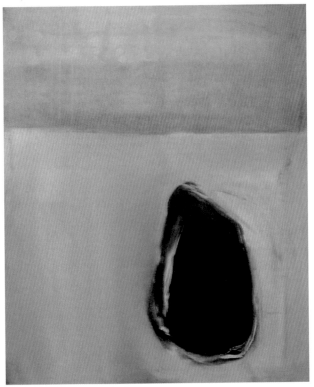

# 1963 **New York**

I GOT to New York in 1963 where, as a guard at the Museum of Modern Art, I got paid to look at masterpieces of modernism all day. This was bracing but also disconcerting. I had not gone to art school so I decided to construct a foundation course for myself as a bracer – like going to a bar and trying all the drinks off the top shelf. The idea was to get steady! A painter I knew sublet my loft, sold it while I was away, and dumped all this work. This was in 1969, before Baldessari did something similar intentionally.

Figure Study
152 cms X 152 cms

*Opposite*

Figure Study
122 cms X 152 cms

Figure Study
153cms X 152 cms

Figure Study
152 cms X 182 cms

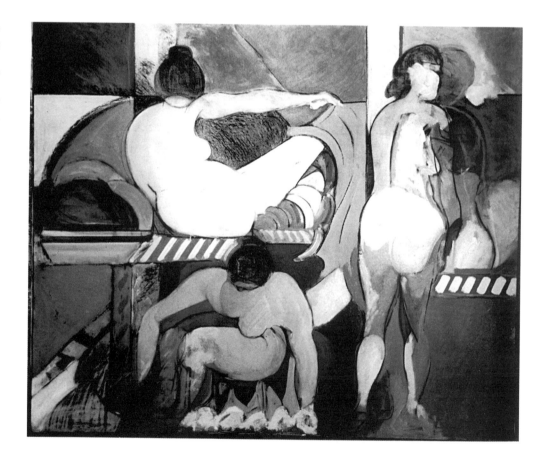

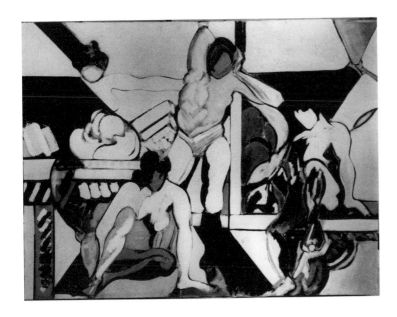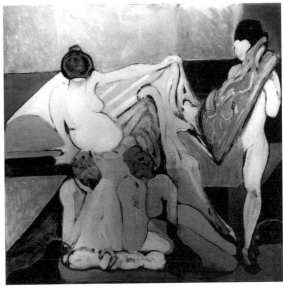

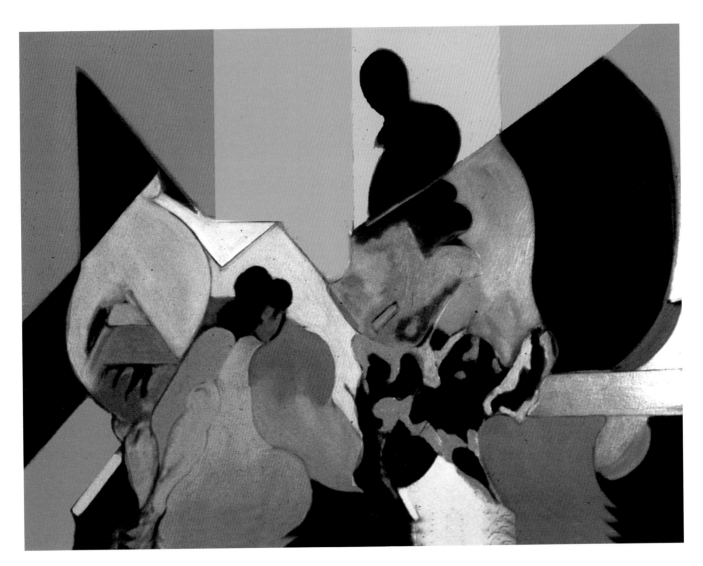

15

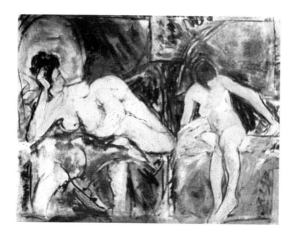

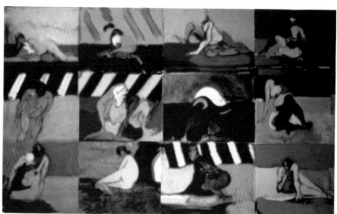

Two figures
214 cms X 120 cms

12 figures
107 cms X 81 cms

Figures
182 cms X 182 cms

Figures in landscape
92 cms X 61 cms

Nude

Animals
182 cms X 170 cms

Circus
92 cms X 120 cms

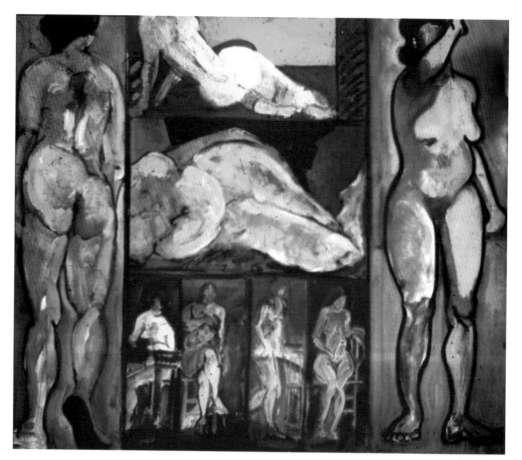

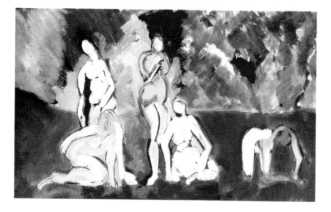

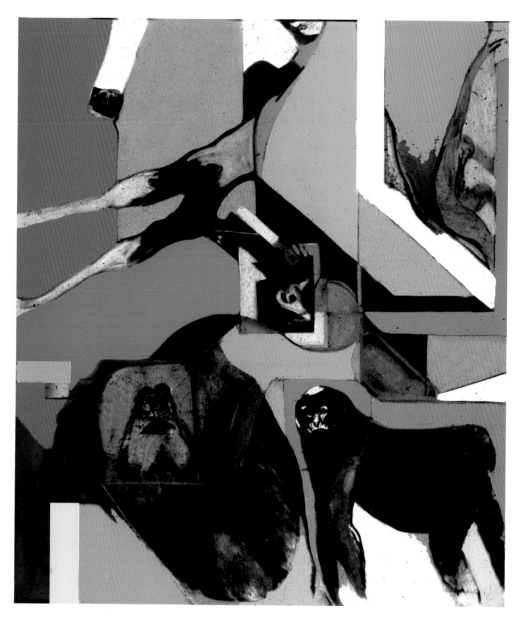

From Larry Rivers and John O'Hara's NY manifesto:

6. Do you hear them say painting is action? We say painting is the timid appraisal of yourself by lions.

9. If you are interested in schools, choose a school of painting that is interested in you.

13. Youth wants to burn the museums. We are in them – now what? Better destroy the odours of the zoo. How can we paint the elephants and the hippopotamuses? How are we to fill the large empty painting at the end of the large empty loft? You do have a loft, don't you, man?

18. Hate animals and birds. Painting is through with them.

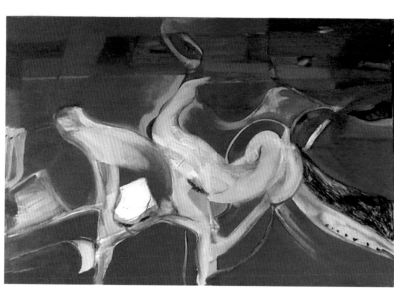

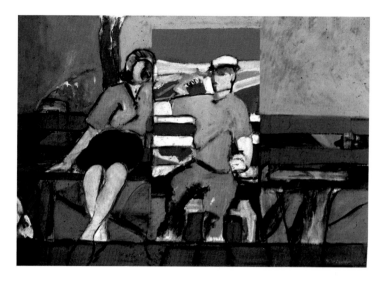

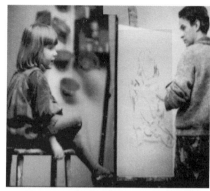

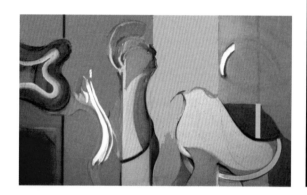

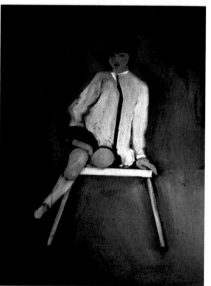

Woman with a Diebenkorn. Guri Zeckendorf had a wonderful collection of Diebenkorns and I imagined her sitting beside one.

Francis Keavney took some photos of my daughter Anne from which I painted her with her cool haircut.

I can't remember this blue painting but clearly I was looking at Stephen Green, Gorky, Miro and Matisse all at the one time!

I painted the triptych HCE in lieu of a paper on the Wake for W Y Tindall at Columbia. Wrong call at this time when what was interesting about the Book of Kells was not the movement but the geometry, as Frank Stella clearly appreciated.

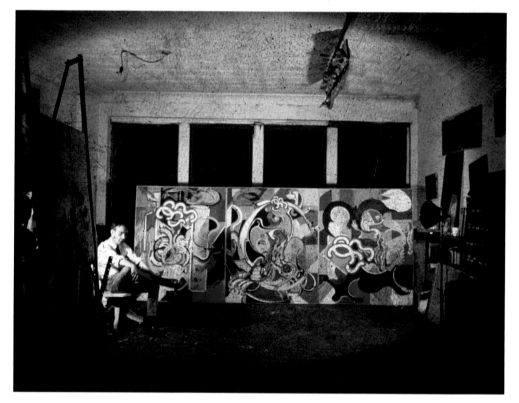

Woman with Diebenkorn
90 cms X 120 cms

Untitled
61 cms X 92 cms

Anne
92 cms X 76 cms

HCE
146 cms X 276 cms

Maternity 2
152 cms X 120 cms

Landscape
120 cms X 120 cms

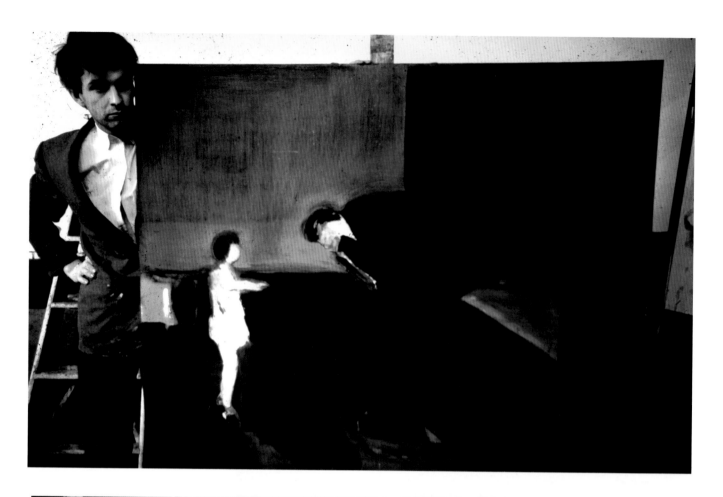

The painting of the man and the little girl came from a photo of JFK greeting his child when he came off a plane. It became this.

I was present at the birth of my daughter. I painted my memory of her arriving many times.

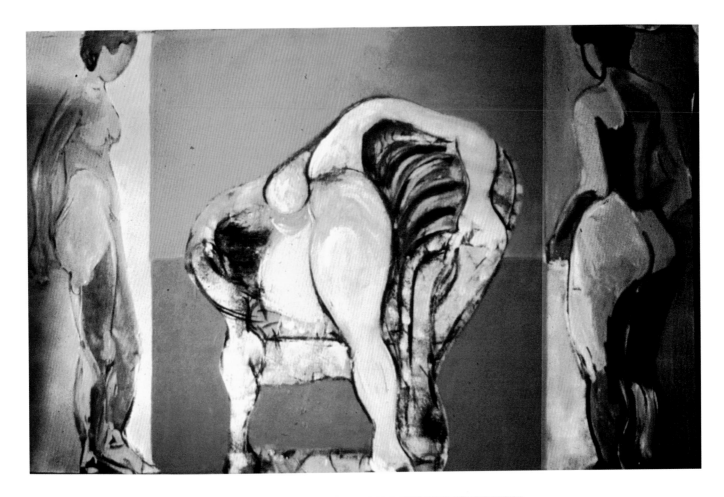

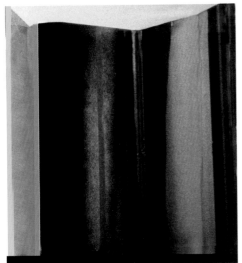

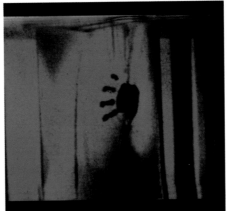

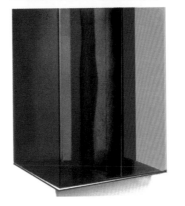

JFK
120 cms X 152 cms

Maternity 1
120 cms X 120 cms

Landscape
120 cms X 152 cms

Group Therapy
184 cms X 120 cms

Blue Veil (Lucite box)
61 cms (h) x 58cms (w)
x 10cms (deep)

Red Hand (Lucite box)
61 cms (h) x 65 cms (w)
x 10cms (deep)

Purple Veils (Lucite box)
34 cms (h) x 34 cms (w)
x 34 cms (deep)

# Downey's Bar

**J**IM DOWNEY (Downey's Bar on 48th Street) decided to open an uptown 'Irish Pavillion' on 57th Street. Sean Kenny designed the space and asked me to make work for it. Brian King helped me with this.

*I have the failing of my tribe. I believe in the sacred rites of conversation even when it is a monologue.* Gertrude Stein.

Full-size figure at the end of the bar. *Evening Press* in the overcoat pocket, hand on pint, gaze fixed on pint. Inside the man an audio loop-tape is playing fragments and mixes of songs and anecdotes. I had been four years in New York. What did I miss about Dublin? I missed this.

*Yeah. I saw it in the papers. They took a picture of the back of the moon. What's so great about that? What's so mysterious about that? Of course I know how they did it. You want to unravel that mystery, right? Know how to do it. You want to take a picture of the back of the moon? That's the problem, right? How do you do it? It's simplicity itself when you think about it. First of all – send up your rocket. Then attach to the side of your rocket, a camera. Now, you know the little clicker thing on the side of the camera; for taking snaps that you click. Right. You attach that to a clock. You know when your rocket is going to be at the back of the moon, so you set your timer. Back of the moon; your alarm goes off, as planned, the clicker pulls, photo taken, bring your rocket back to earth and there's your picture. Well it'll be a negative actually, but that's easily developed. Where's the mystery?*

*Sings:*
Fly me to the Moon and let me play among the stars
Let's find out what things are like on Jupiter and Mars.
* * *
Gigi, am I a fool without a mind
Or have I simply been too blind
To realise. Oh Gigi

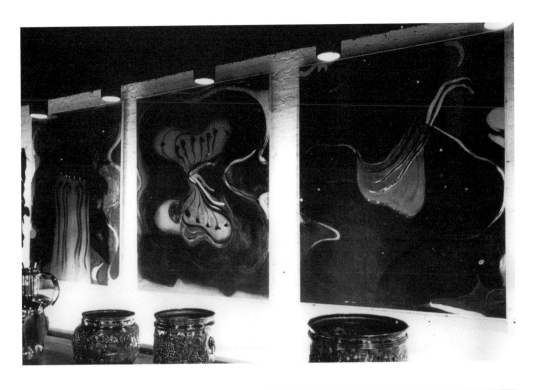

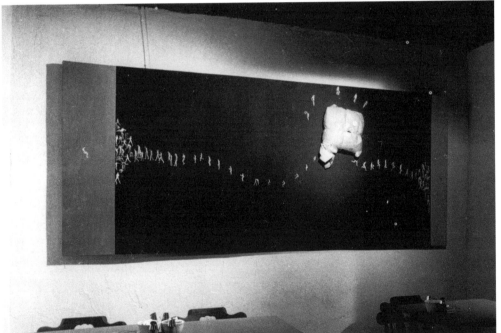

Give me the moonlight; give me the girl,
And leave the rest to me.

\* \* \*

I wonder who's buying the wine
I wonder who's buying the wine
Who's buying the wine?
WHO IS BUYING THE WINE
*I wonder who's buying the wine.*

# Chairs New York 1963

FOUND the chairs discarded on 21st street. They seemed cut from a cube, perfect for the shallow picture plane, except for the drawing extension arm which would not fit. This was the problem; where to accomodate it?. I was also interested in maintaining the content as 'chair' but changing the form of representation. I should have made this clearer at the time as the exhibition looked like a group show. Leo gently pointed this out and suggested I should not exhibit again until I had everything worked out

Orange Chair
92 cms x 92 cms

25

Green Chair
120 x 90 cms

Blue chair
98 x 107 cms

Blue and Pink Chair
120cms x 1200 cms

Chair and plant
92 cms x 76 cms

Bird Chair
120cms x 40 cms

Red Chair
120 cms x 60 cms

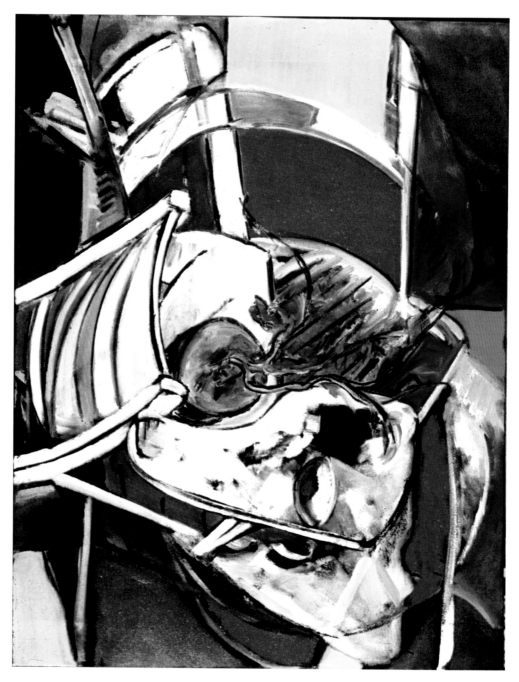

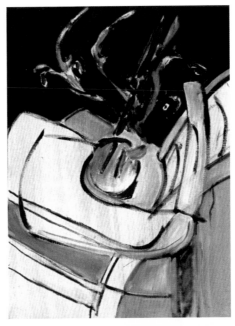

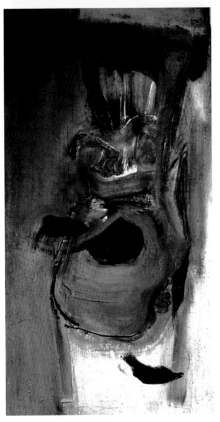

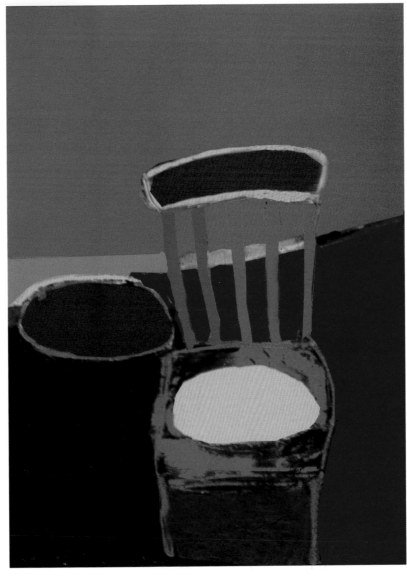

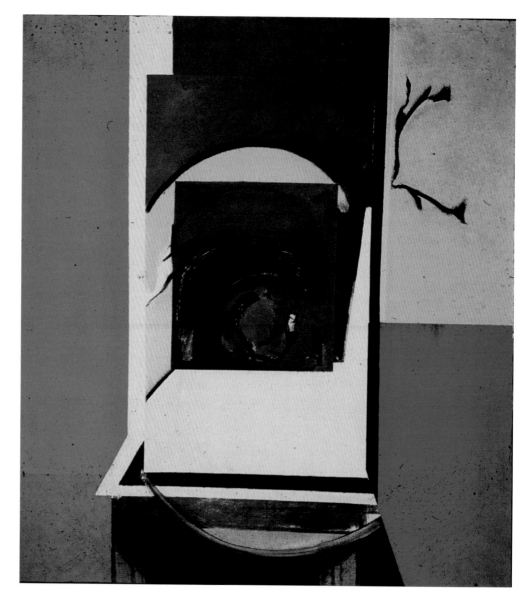

Hard Edge Chair
92 cms x 76 cms

Dark Chair
120 cms x 60 cms

Chair Drawing
61 cms x 51 cms

Linen Chair
142 cms x 92 cms

Breaking Chair
124 cms x 124 cms

Chair and Painting
92 cms x 63 cms

Chair
120 cms x 120 cms

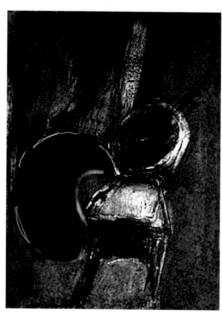

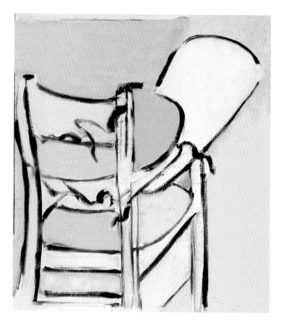

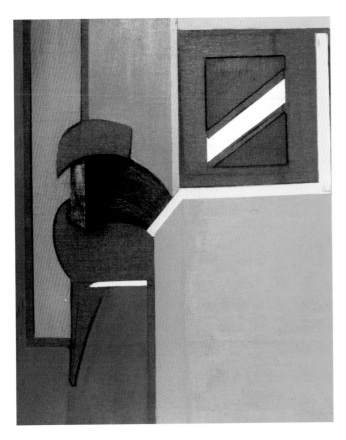

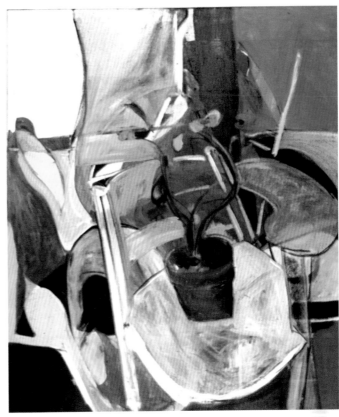

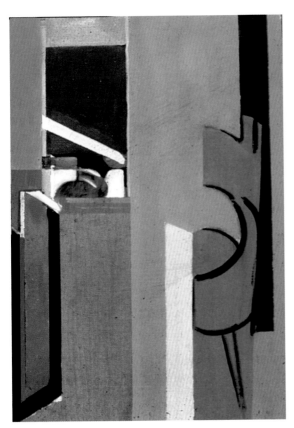

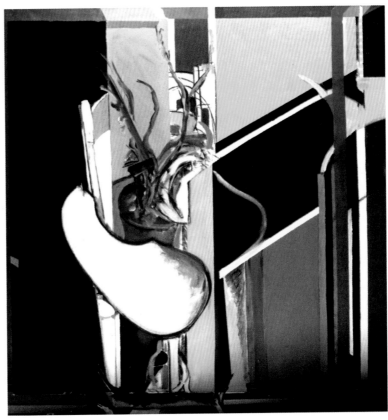

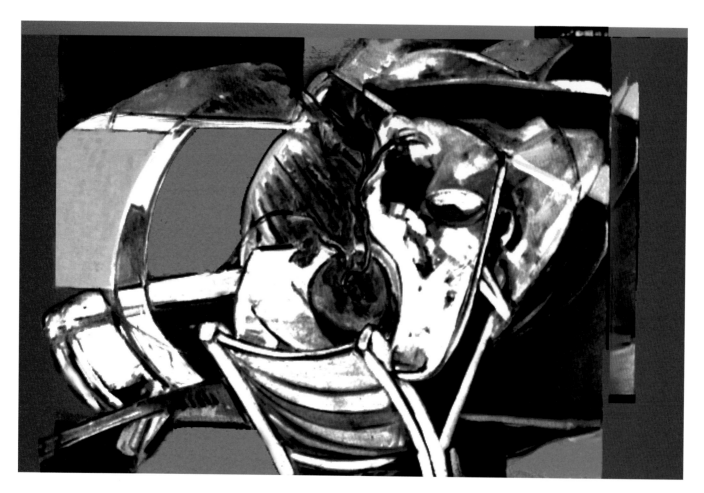

Chairs
60 cms x 107 cms

Man in Chair
180 cms x 120 cms

Man in Chair
92 x 56 cms

Window
56 cms x 63 cms

Window Composition
56cms x 56 cms

Pink Office
92 cms x 124 cms

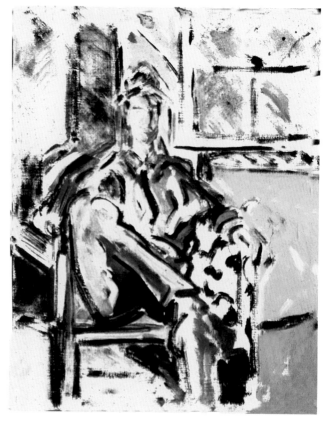

From 1965 to 1967 I painted at night. In contrast to the uproar of 21st Street by day, the Hopper stillness and silence of New York by night was uncanny. The building opposite was in total darkness except for one floor that left its lights on all the time. How *not* to paint a Hopper was the problem (Matisse save us.)

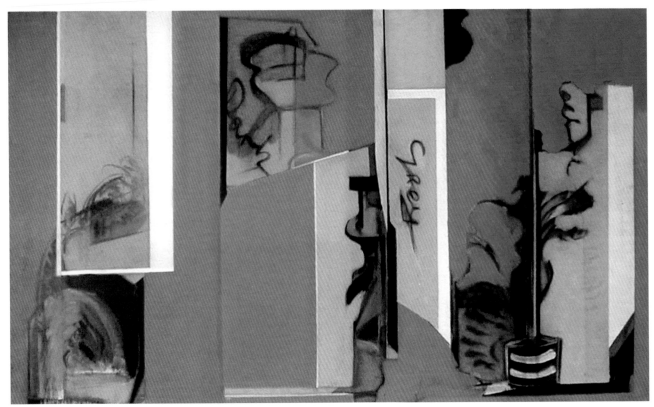

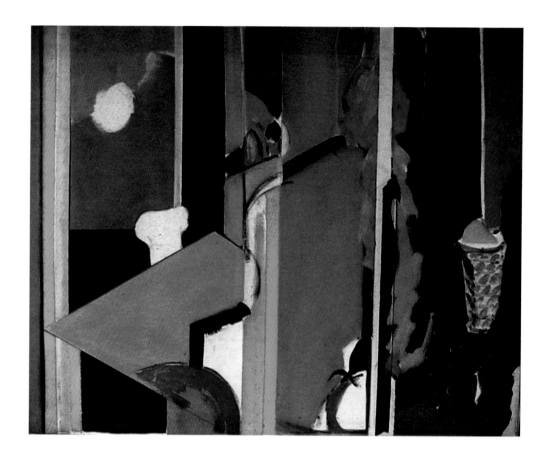

Blue Office
92 cms x 92 cms

Blue Office
92 cms x 92 cms

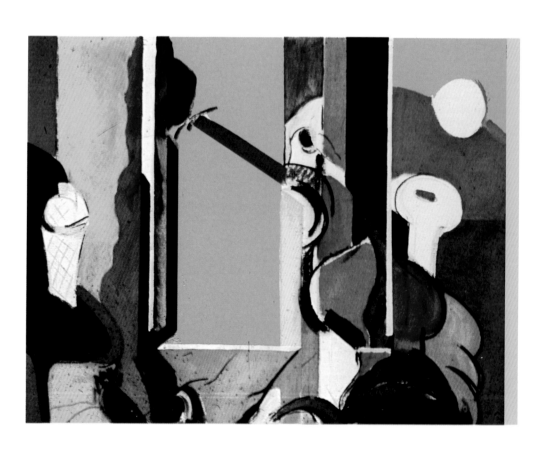

# Assembling Sheridan

**N**OEL SHERIDAN is a man of many parts and the parts are scattered over three continents. How to conduct this act of retrieval? The task is facilitated by the fact that wherever he went, he left his mark, depositing versions of himself which can be compared with the original. First of all there is uneradicable Dublin persona, the slanting delivery of vatic vernacular which takes gracehoper jumps (make up your own continuity). There is the capacious bag of gifts he brings with him everywhere. Then there is the pedigree, the unforgettable Cecil in whose shade is still deposited an hilarious share of Dublin's mythos.

You might begin by picking up a *New York Times* on a morning in 1963 and read about a satirical review starring two young Dubliners, mounted by an American producer, Josephine Forrestal (relic of the noble James, Secretary of the Navy) and reviewed, if memory serves, by Brooks Atkinson, who had the next desk to mine (or mine to his) at the *New York Times*. The Gate in Dublin gave Noel and his partner a warmer reception than did New York. Noel Pearson tells the (apocryphal?) story that when father Cecil came down to breakfast a day or two later, there was Noel sipping his tea, and Cecil thought he hadn't been away at all.

In this you can find, if not a moral, at least a fatal habit: The Return, which has scribbled its signature across Noel's career, as it did on that of many of our generation. Before the return there is the Departure, and bitter it still was in those days. But the return, or serial returns, were tests to see if the Dublin atmosphere was still too toxic to sustain imaginative life. Noel, with a corporal agility that matches his antic conversation, was back in New York almost before he had left for Dublin.

New York on first acquaintance frequently injects a kind of Burroughs-virus that presages a life-long addiction, and Noel was not immune. (Michael Farrell arrived a few years later and his laconic hard-drinking charm was made for New York. I introduced him to several luminaries, including Rauschenberg and

Rothko. Rothko loved him.) New York can be an arctic place if you don't like it, but New York loved Noel – and Liz, to whom I remember miming through the solid sound, strobes and pulsating walls of the Electric Circus where she worked. Noel was in his studio painting, but his doppelganger was a busy man, waitering at the Village Gate (all that jazz), guarding at MoMA (how many artists started as guards at MoMA?). He did an MFA at Columbia with Stephen Greene, an artist of paintings so neurotically beautiful that you felt you were getting a dose of French symbolism through a hypodermic (Greene also trained Frank Stella – that is, if Stella ever needed training). And of course where Noel was, the 'Wake', beloved of Pollock and Tony Smith, wasn't far away, since it coils around every Irishman and woman's DNA. Noel took William Tindall's (legendary) course on the 'Wake'; Tindall, Noel reports, 'was cool and accepted a large painting in lieu of a written paper.' The painting? A tri-partite H.C.E. smuggled into clusters of lacertines.

H panel of HCE triptych
146 cms x 92

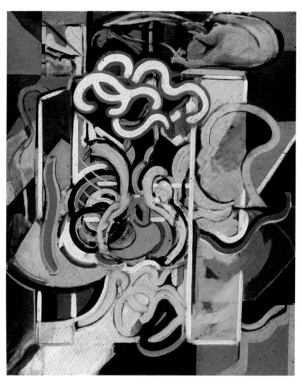

Noel and Liz were very dashing, I remember, beautiful dolphins ducking in and out of the avant-garde mainstream – an attractive couple who attracted. Noel met Edwin Denby, the (legendary) dance critic (who wrote a poem about 'The Shoulder' in one of his friend De Kooning's paintings); and through him Red Grooms, Alex Katz, the poets, Ted Berrigan and Mark Strand. He played a bum in 'The Richest Man in the World', a film by Rudy Burkhardt (a descendant of 'The Civilization of the Renaissance in Italy' Burkhardt) and appeared in Ken Jacobs' Shadow Play, 'Thirties Man' at the Filmmakers Co-Op and at MoMA. Alanna Heiss and Gene Highstein lived in the loft below, and Alanna, ever the artists'

34

truest friend, and Liz, who made vintage clothes fashionable before Madonna, kept the pot at least simmering. Paddy Bedford arrived with 'Philadelphia, Here I Come' and expansively stimulated a show in the loft which resulted in a great party but no sales. But the loft began to have visitors – Eloise Spaeth, a model patron, brought others, including a Zekendorf, whose family then bestrode real estate as Trump does now (indeed, at that time Barbara Novak and I were slotted into the 18th floor of a Zeckendorf building; Noel and Liz visited bearing gifts); and the director of the New School Gallery, Paul Mocsanyi, a smooth grey otter whose nose always pointed to good work which he acquired with a conspiratorial Hungarian whisper. So our man Noel was on his way. Or was he? Not if Noel could help it.

Noel had conducted a long and passionate affair with painting and painting, in return, loved Noel for he was a natural painter and the stuff gratefully flowed from his fingertips. I think it was in 1970 that I was asked to do an exhibition of Irish painting for Rosc (which till then stood for Representation Out Side the Country), and I remembered Noel's fine hand, but where were the paintings? From the evidence that survives (Noel is always surviving the evidence), the gifts exhibited were/are simply enormous and not at all at home in the frequently placid pond of Dublin painting in the Sixties. I suppose a painting immediately tells you how much it is taking in or how much it is keeping out. Noel's work flexed itself in the broadest competitive arena, and was doing just fine. You'd have put money on him.

In 1967 there was another Return, this time to an exhibition at Leo Smith's of paintings of chairs. Noel had rescued two chairs from the street and, ever docile, they posed for him uncomplainingly. Each chair (I didn't see the show, but I am in possession of some colour xeroxes) was represented speaking in tongues, announcing its chairness with a luxe and volupté that Kosuth (around the same time) stripped to bare definition in his chair-work. These profusely inventive variations on a theme show Noel loping along in his double-breasted, the Zeitgeist strolling at his shoulder. For Leo Smith (and Dublin) Noel may have transgressed the Stylistic Imperative (each painting should break out from the same egg, that is, have an identifiable style – a badge of selfhood, originality and so on). Noel was/is a brain as well as a hand, a thinker-meddler, ever engaged in a variety of cross-cultural and cross-disciplinary conversations. He took a second look at that ever-biddable hand of his and, after much soul-searching, decided to get a divorce from painting. Forsaking (or being forsaken by) your first love is a wrenching business. But Noel – the noun 'Noel' is really a transitive verb – had to move on.

Before moving on he moved about, visiting his other talents – literary, multimedia, theatrical, musical: a six-projector extravaganza for the designer Jack Lenor Larsen, using the Beatles and Janis Joplin, that incomparable virago ('When I'm there [singing] I'm not here') to echo Irish themes (immigration; North/South), syncing the Book of Kells with Pollock etc. helping out Jean Erdman for her 'The Coach with the Six Insides'; consuming avant-garde film ( Brackage, Ernie Gear, Kubelka, Anger) at Jonas Mekas' Filmmakers' Coop (later Anthology Film Archives), saw Lenny Bruce's act, Yvonne Rainer dance, John Cage being Cage at the Electric Circus, met the enigmatic Master of Mail Art, Ray Johnson, worked with the Fluxus people on a piece for the Avant Garde Festival and lived in De Kooning's old studio on 21st Street ($175 a month including the studio below). What's remarkable about all this? The faultless instinct – our man Noel was nosing out what was most genuine at the cutting edge. One of his endearing assets is a generous wonder when he bumps into good work anywhere. Spread across several fields as his multiple talents invited (dictated?), he was, I believe, undergoing a kind of dispersal and reconstitution of some sort of self in the avant garde matrix of sixties' New York, a time when conventions were tossed around like skittles and a cocktail of sex, drugs, art, rock and roll and Vietnam sometimes induced a dangerous high – lots of transcendence, lots of casualties. During his New York stay (1963-1970), Noel's ways of thinking were profoundly imprinted. But since he lives in advance of himself, he was thinking of his next moves. There is a visual text for Noel thinking. The filmmaker Harry Smith, a denizen of that grungy Parnassus, the Chelsea Hotel, recorded some 400 feet of film of Noel at a table doing nothing much but thinking furiously.

Box
27 cms (h) x 27 cms (w)
x 27 cms (deep)

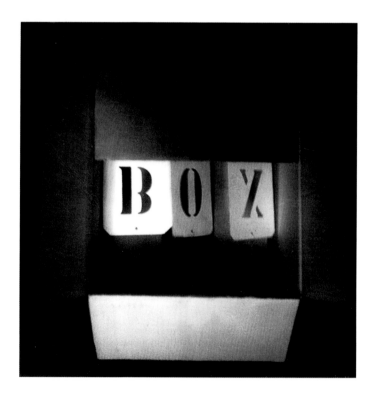

Thinking was a way of arriving at art in the late sixties. The often despised child, conceptual art, was following up the good works of minimalism by radically altering the modernist (mainly painterly) paradigm. Noel took a box (vox-box?) and coaxed it to articulate the word B.O.X. in the hollow of its cardboard larynx (cf. Robert Morris' Box with the Sound of its Own Making), neatly telescoping object, sign, and the reciprocally signified. Noel's conceptual footwork quickly became as dazzling as his dancing. A deadpan text 'describes' a '… painting (that) seems to soar away from terrestrial perspective, with its simple arrangement of foreground, middle ground, and background …' Above the text, an all-black painting in which you can't see a stim. Watch this man; he is in the right city at the right time (1969), writing and thinking well.

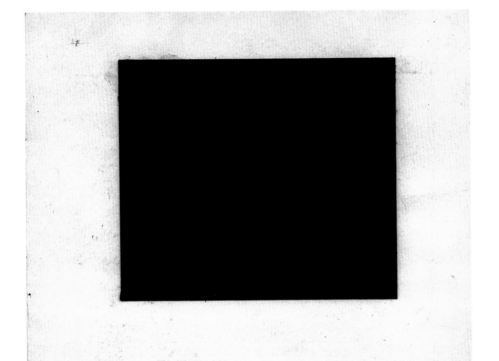

Black Painting (draft)
25 cms x 18 cms

Just as the music of Wagner is saturated
with sensous and symbolic allusions, so this
incunabula of abstract art conjures up a whole
inventory of associations. No naturalistic or
sentimental residues muddy the overall formal
organisation. The scheme that determines the
form is woven into the background. And now,
too, the attempt to produce illusions of space
disappear. The picture seems to soar away from
terrestial perspective, with it's simple arrange-
ment of foreground, middle ground and background,
into a cosmic perspective in which the clear
recession is replaced by and merges into a more
complicated space.

A handful of these early conceptual works survives (Noel's career frequently pushes you into posthumous mode). 'Looking through the School Gates' is accompanied by a beautifully written text which measures and quantifies like Robbe-Grillet and incorporates a sudden meltdown; 'Gathering Together' is an elaborate group word-piece in which the I Ching and Bishop Berkeley make appearances and in which we discover that Piero is Noel's favorite artist. Then something beyond unexpected. In the ideological crucible of dawning New York conceptualism, Raftery's 'Anois Teacht an Earraigh' (with 'Mise Raftery an Fíle' probably most students' surviving Gaelic mantra) becomes the subject, object, fulcrum and wand of a work correcting the exile's yearning with a realist's sharp awareness of his country's post-colonial attempts at self-definition. Several English versions of the poem are recorded, and played underneath serial images of a boat the sail of which (árdó mé mo sheól) contradicts the poem by progressively declining into the horizontal. People, if they're lucky, find what they bring with them to New York. Can Raftery's literalized metaphor, standing on a sound pedestal of tongues wagging in English be interpreted thus? The Gaelic poem

Anois Teacht an Earraigh
(document) 2 pages
29.7cms x 21cms.

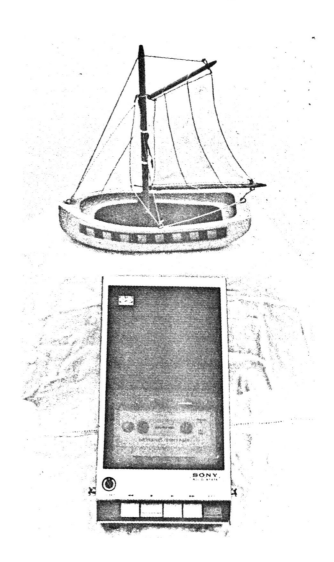

is memory; the declining sail its loss, the many differing versions efforts at recovery, the marriage of image and spoken text a filtration of one culture through another, as the artist/voyager (Noel himself) filters his past through a new N.Y. artform. The poem opens with an attack of home-sickness. But where is home? In an almost cosmic joke of Baudelairean correspondences, Noel will relocate himself, on the strength of an accident of naming, to a phantom home. Not to Ireland, or the new Ireland, but to New Ireland, near New Guinea, north of Australia. What folly is this? Is this bringing conceptualism too far?

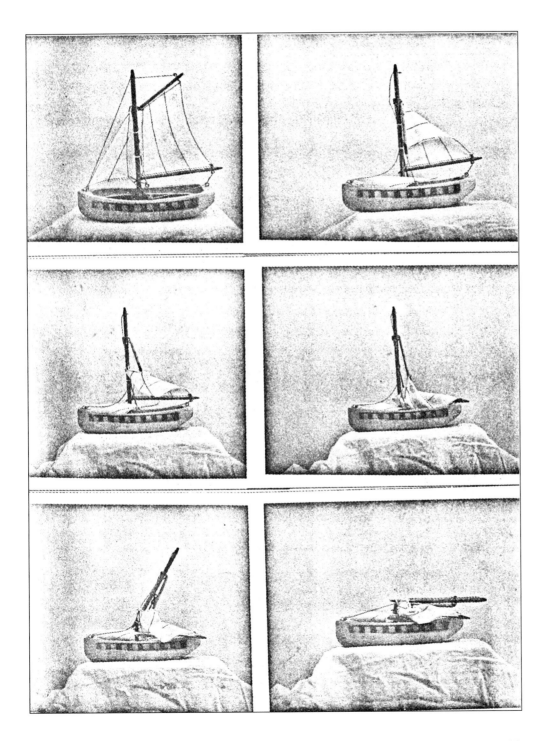

This is what convinced me that Noel is, however temporarily rooted, on a picaresque journey. Here he is, in New York, alert and open, in the best of company, at the start of the conceptual adventure, and he disappears. (One of my regrets is that Michael Farrell and Noel didn't stick around; I'd have had the right kind of company from 'home'.) Before picking up his spoor again, let me put on my dun-colored critic's overcoat and summarize what I know of Noel's idea work in New York. He had heard the music and he gave it words. It is a small body of work, but it will be a smart museum person who corners it. For it shows an Irish artist contributing to the mix at a moment when definitions of art were changing, who had the pictorial sophistication, linguistic nimbleness and performative wit to intersect with that moment. The history of Irish art will get to this, of course, but better sooner than later.

After that, Noel became for me a rumor, several rumors. There were sightings in London where he may have been introduced to that most gallant of curators, Bryan Robertson, by Australia's own Brett Whitley, a friend he met when they both showed at the Paris Biennale in 1960. Another Noel may have landed in Dublin, inhaled speculatively, said 'Not yet!' and left. At the same time, was another Noel really in New Ireland – a thin island shaped like a careless appendix scar? By invoking the madness in Noel's method, I have solved the enigma of the New Ireland adventure. The Michael Rockefeller wing at the Metropolitan Museum in New York wraps itself around stunning examples of house-broken primitive art. On a visit, Noel was taken with the notion that the whorls and intricacies of some New Ireland artefacts (in which little figures are trapped) rhymed with the spirals of Celtic art (#1978.412.706 is a perfect example). The colloquies of the Wake, never far from Noel's mind, began to chime with some native ceremonies, e.g. New Ireland burial practices during which the dead are elevated to hill-tops to be smoked and burned and symbolically replaced by the young. Intercultural assonances began to signal back and forth in Noel's mind, conceivably between the inhabitants of Kavieng and the natives of Ballsbridge. Always on the conceptual alert, Noel was ready to link correspondences, which the naming of that geographical region encouraged. The skinny island of New Ireland segues across St George's Channel, into a fatter New Britain, an island curved like a scorpion's tail. Everyone had a go at New Ireland – the Dutch, the Germans (who renamed it New Mecklenburg), the Australians, the Japanese and back to Australia again. I have manufactured and deposited in New Ireland an unforgettable image of Noel in whites and pith helmet *á la* Somerset Maugham, teaching English to the tribes. Somehow or other – I am not sure of the details – he was deflected to a continental island (or island continent) to the south where I consign him to the inspired and solicitous care of Donald Brook.

40

With one reservation. A work Noel thought about in New York was realized in Australia. Since its conception coincided with our New York friendship, I may be permitted to comment on it. Professor Brook in his essay touches wittily on this tour-de-force. When writing *Inside the White Cube* in the mid-seventies, I asked Noel if he had anything I could use in a chapter called 'The Gallery as a Gesture'. I received a photograph of a gallery floor completely covered with rounded stones; on the walls, small framed texts. Was this one of Noel's enigmatic messages – Noel as a convocation of rolling stones? Puzzlement, occasionally revisited, persisted over several years. The mail eventually offered a brown book of some 72 pages outlining in four parts a stone-mad scheme. The matter of the stoney floor was now illumined. In Part 1, the visitor is invited to tramp over the carpet of stones to select a stone according to its property, resemblance, and function; three

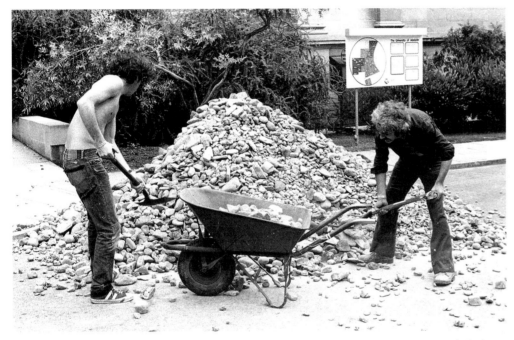

Tim Burns asssists with installation

lists helpfully provide guidelines. The results are permuted to present alphabetized conundrums which can be deciphered, e.g. DDD+BB+R translates to 'the softest stone like a rose that can be used as an amulet'. CC+U+X yields a stone that is like 'the most porous and chalkiest egg'. But Part 1 – an analogous stroll on a beach or river-bed – is just to get you warmed up.

Part 2 grows odder. Pick a stone that is (out of 26 choices) 'ludicrous' and that may be used (out of 26 choices) 'for killing two birds with'. Part 3 presents two columns one of adverbs and one of nouns, which may yield a stone that is 'tentatively lambent', then on to stones selected by the learned gallery-goer on a 'like a' basis, e.g. like a Zadkine, or Boccioni or (the easy one) like a Moore. Across the final list of Part 3 falls the shadow and the shadow is Berkeleyan. The text invites you to 'Select a stone whose shadow best suggests the meaning of shadow as …'

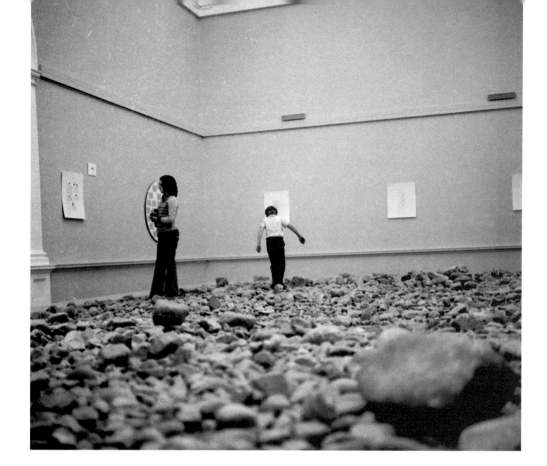

(26 choices) 'echo' or 'wake' or 'decolorization'. You are then passed through 26 (26 counties? 26 letters of the alphabet?) quotations from Levi-Strauss describing a 'bricoleur' to Lord Russell 'bringing into human life the vastness and passionless force of non human things'. The ubiquitous Wittgenstein is present, as is the obligatory Beckett, and conjoined across the gutter (of the book) Lady Gregory and Donald Barthelme lie in state. After surviving this exhilarating journey you may well be stoned in several senses. You are now ready for Part 4, which is a page of six exercises for the body – 'Lie on back. Raise both legs slowly to an angle of 45 degrees and lower slowly. Attempt to keep the back flat on the floor'. Have we just enacted a parable of the mind-body problem? Thus ends the work entitled 'Everybody Should Get Stones'.

What a dazzling bit of prestidigitation in 1970! The work has its conceptual rubrics in place – the registers of lists; the instructions from the simply accomplished to the arcane; the mathematical exhaustion of possibility; the post-modernist solicitation of the viewer; though with a touch of modernist harassment (stepping on stones); the documentary photographs; the invocation of relevant texts.

Much conceptual art relished its own seriousness, and that was fine – but often to the point of grimness. What is bracing about Sheridan's conceptual opera in four acts is its easy tone, its good-natured bifocal glance at children's book simplicities and its unflinching stare through metaphorical densities at the desired terminus.

The uncompromising will is there, however charmingly dissembled. One of its rosary-like lists reads like poetry: 'Select a stone for leaving unturned – Select a stone for gathering moss – Select a stone for skipping on water – Select a stone for impatiently kicking to refute the strange and fragile theory of George Berkeley, Bishop of Cloyne'. Has Charles Olson been listening in?

How does this work stand in the international canon of conceptual endeavours? Very highly, I suggest. It is there and it is unavoidable. It is certainly ripe for reclamation by the country that produced its author, though such a claim would probably be viewed suspiciously by a man who always seems to fly under the radar. Something Donald Brook said in reference to the 'emergence of the new art industry' closed in my mind with an audible snap: 'His (Noel's) conviction that to the extent that there is such an industry it has little to do with art...' That's our man all right, suspicious of scene-making, and we should try and get a clear look at him.

Lurking in the interstices of 'Get Stones' – the ghost in its elaborate machine – is a figure that dissolves back into the work even as it comes into focus: organized, inventive, highly intelligent, tenacious, a discriminating reader, agile, moving, as the work does in its first three parts, from empirical through metaphorical to functional to – in the final list – the impalpable and impossible. Around the materia prima, the irreducible stone, Dr Johnson's stone, is a forest of transparent signs signifying Idea. The practical dialogue of the work is between Johnson and Berkeley; its philosophical conflict is between nominalism and essentialism; its language counterposes simile and metaphor. Its elaborate system operates between logic and a poetic madness, openness and self-reflection, and its actual execution continually wavers between choice and chance.

But this high-fallutin' reading neglects the work's most beguiling quality – the wit, irony and vernacular humor that compose the joker in this pack of words which, added to the figure described above, seeks out its reflection in the audience. There is something else about that figure – and here I speculate – that is more than commonly elusive. Is there a desire not to be noticed, to offer itself with a reluctance that amounts to an apology for breaking its silence? Indeed – to go further – do I perceive in the work a need not just to escape its own systems, but to abandon the very category in which it resides, that of the artistic enterprise itself? Beneath its conceptual dazzle does there lurk a certain pessimism, to quote the work itself, 'the meaning of shadow as … mirage'? Perhaps.

Some of the stigmata inflicted by the Ireland of my youth persists into exile, even when they are out of date. For the exile carried with him (or her) a culture that

gradually slips out of register with the reality back home. The code that enables you to make subtle readings on your return is easily lost, and it takes frequent visits to restore and maintain it. During one return, I discovered to my puzzlement that everything from the trivial to the exalted was 'brilliant', a word probably borrowed from an island farther east. When applied to any act of reasonable competence, the word, for purposes unknown to me, was revalued, and no substitute was available to denote what 'brilliant' formerly signified. I had not been in the grandstand when this important linguistic event took place. Such are the minor hazards of the Return. The Return by proxy – sending back an artwork – is doubly hazardous. When that work is shown as an example of Irish art in London, the codes are further scrambled. The exhibition, in 1978, was called, with perhaps appropriate ambiguity, 'A Sense of Ireland', and to it Noel sent (from Adelaide) a work of personal and political nostalgia, suitable for multiple misinterpretations. Through a memorial anti-chamber with posters of Irish patriots – Larkin, Pearse, Connolly, Casement et al. – the visitor approached a monitor displaying the legs of a small boy step-dancing, accompanied by the instructions of an exemplary teacher ('Back straight! Don't jump – leap. Batter Batter. Eyes straight ahead'). Dancing on graves? Celebrating release from oppression? A disguised act of military training? In terms of intention, none of these. The impulse for this piece seems to have been two-fold: the reflux of a nostalgic wave; and the discovery – shocking to Noel – that his daughter couldn't find Ireland on the map. In that year of our conflict (1978), ready responses were in place in Ireland and England. I'm confident some British viewers saw the work as revolutionary agrit-pop. Or alternatively, as a redundancy of Irish clichés. One Irish audience perceived a retro nativism, a republican call for endurance and perhaps action in the site of revolutionary activity in the North. Another response was a dismissal of the iconic fetters of an outgrown nationalism in favor of an internationalism conducted under various ideologies. What Sheridan, away in Australia may not have understood was that post-colonial thinking in Ireland was mutating into new forms too complex to annotate here. For the purposes of ideology, it is necessary to perceive contrary opinion as extreme to legitimize your own (often extreme) position. Shadings got lost, as they usually do. The possibility of a national pride exemplified by the emblems of sacrifice sited in an international and sophisticated view of the world is forestalled. I prefer to think that this latter was a significant content of Sheridan's provocation.

This work was a kind of passport sent ahead by Noel to be followed by himself. Was this to be the final Return? When I arrived in Dublin, I discovered that someone was masquerading in his name as the Director of the National College of Art and Design. This imposter looked and spoke like the Noel I knew, but watching him in action (over several years as External Examiner in Sculpture) I

was enormously impressed by his eloquence, management style, political tact and wit. Ah yes, wit. Perhaps it was the same man. He handled committees beautifully. So I am pleased that he has allowed us to resurrect several members of his most intimate committee – Noel the painter, Noel the performer, Noel the pioneering conceptual artist, the vernacular Noel, the Australian Noel and lastly the Dublin Noel, to whom I owe a great deal. For it was this elusive and important artist who, along with the incomparable Dorothy Walker, preserved my tie with a country I, over many decades, only wished to exorcize. But then, this penultimate – I hesitate to say final – Noel is among other things devoted to the arts of reconciliation. I am rewarded if I can encourage the Noels I have known (over close to forty years) to present themselves in a way that allows the public some purchase on their manifold good works.

*Brian O'Doherty*

TRANSITION
Open/Closed shop sign

45

# The Muses   New York 1964

I T WAS time to check out the lead to the landlord who paid cash to have apartments on the Lower East Side painted out. If you could get in and out in two days you got $200 plus materials. I met the man in a railroad apartment.

'No, not $200 – this is not as big as my other apartments – $150.'

He showed me the rooms, brushing past the diminutive couple who lived there, avoiding conversation with them. Yes, he did know their rights, repainting every seven years, that's what he was doing. Of course it would be done perfectly. 'This is the painter.' They surveyed me with narrow eyes that had known many bitter disappointments.

'He's the painter?'

'Yes.'

'We're entitled to a real painter.'

The landlord didn't deign to answer them as he showed me into the front room with the bay window. It was a dentist's surgery; downmarket art deco, custom-built glass cases set into the walls, shelves, more glass, curtains, and in the centre of the room a huge 1930s dentist's chair – Bakelite? – that left almost no room to move.

'I'll have to paint around all of this', I said, indicating the panels and the cases trying to get the price to $200.

'That means less for you to paint. Right?'

I felt a growing solidarity with the little couple, but this was business and I'd be back the next day. Floor cloths, rollers, turps, brushes, no ladder, but I could stand on an old chair.

'You want to stand on one of our chairs? *He wants to stand on one of our chairs'* (to his wife in the kitchen.)

OK, I'll bring my own chair. This place will look really good all white. Would you like that?

You got to do it the exact same colour. That's the agreement.

He explains to me the history of this rent controlled apartment, the present bastard of a landlord who just wants to get them out – *we've had lawyers* – and that they get to choose the colour. That was the law.

* * *

If you mix the dregs of tins of many colours together you get either brown or green. They had the green. It was an elusive green; part yellows that were not any longer manufactured with could it be a cerulean blue that gave that strange, almost neon glow and pinks, definitely, but in what proportions and, had I but thought of it at the time, how do you prepare enough of the base to go with the suffcient of the white to do the whole job. I laid the cloths, prepared the walls and then spent the rest of the day in the strange alchemy of trying for the green.

I thought I had it a few times but the man and his wife wouldn't agree. Sometimes they agreed when I showed them a small sample but when it was enlarged to cover a wall it was clear, even to me, that that wasn't it. What is it about scale and colour? I painted half a wall and then, in a different hue, the other half. What was interesting was the zip, the Newman/Rothkco threshold between the colours. It partook of both, but it found a third space. Newman was a great fan of Edmund Burke's writings but the German Butcher cut through the shambles, the horror, the stench, the darkness, to get to – what? I was looking to try and see this when, in passing on his way to the surgery, the little dentist noticed.

'You missed a bit there.' He passed on, resigned.

I painted out the zip. Now it was just the green. Green is supposed to be the nothing colour; the leaden mix that holds to feature the main action. The Poussin special. It was auxilary, the filler – until Matisse. That green moiling cluster – praying muslims? – holding the left hand corner of 'The Morrocans' – not fighting their corner exactly, it was more that they made the moves, threw the shapes, that kept them in it. And that green in 'The Piano Lesson'. *And here for the first time ever, ladies and gentlemen, "Green".'* Painted in 1917, during the First World War. What was Matisse thinking? *'Stop, you mad fucks, look at this. Sit down. Armchairs please. Now do you see?'*

Windsor and Newton made a sap green that was so good, you had to give it up. It painted Irish Landscapes by itself. If it fancied you, it took your stuff and, even on a bad day, it made you believe it wasn't your fault. *This happens. Next time.* We don't deserve colour like this. It's no test. It saps you. It makes you a sap. It says so on the label, like 'Smoking kills'. Yes, I knew. Still.

The couple bring me soup. It is the sixth day and I feel I am settling in here. The soup is a favourite of her son's, now living on Long Island, also a dentist. He's very good, but the wife ... They have different views about the wife. I listen and I understand that while there is nothing vague about 'reality', everything is provisional concerning its true nature. If only art was like this, cut and thrust, contradictions, not the same old imperative editorial line.

I agree to do the shelves – not in the contract – and they agree a green. Not the one we wanted, of course, not the real green.

It's done. I show them around. What did they think? We process through the rooms. I await. Finally they say:

'Maybe you learned something, sonny. So next time, you'll do better.'

*He had heard these voices before. He felt his soul swooning. So this was where his muses lived. Avenue B and 5th New York City*

.

# The Limelight Restaurant: New York 1964

THE KEN JACOBS ANGLE on N.S.

Synopsis: *Irish priests and Irish cops pursue us. I hide out at The Limelight and meet recent arrival (from Ireland) Noel Sheridan. Thirties Man, offstage, chiseled profile bent in shadow, takes a deep draw on a coffin nail.*

It is 1963. The Sixties are still in the grip of the Fifties. My films starring Jack Smith, BLONDE COBRA and LITTLE STABS AT HAPPINESS, and Jack's own FLAMING CREATURES – three illegals defying then American censorship still in control of the Catholic Church – make some – Lower East Side (not yet East Village) noise. American Underground Film – comparable to Beat literature – shoulders aside Euro-elegant Art Film. But writing's cheap, and I've nowhere to turn for money to complete my 4-hour STAR SPANGLED TO DEATH, also starring Jack. Warhol has money and picking up on what Jack and I and a few others have done commences to turn out a feature a day.

Other film-artists emerge. Jonas Mekas books theaters from owners either too innocent or too desperate to object; I manage them, Flo paints posters and sells tickets. Together we earn $10 an hour (rent on our loft alongside Brooklyn Bridge is $65 a month including utilities and freight-elevator access) until this idyll is interrupted and we're arrested for screening suddenly notorious FLAMING CREATURES. I'm intimidated but Jonas, post-war émigré, experienced with both fascist and Stalinist bullying, while out on bail singly defies the cops (who, recognizing intellectuals when they see them, address us in the jailhouse as commie fags) and defies the Fathers with yet another illegal screening. Flo is let off but Jonas and I get six months in the workhouse probation (should we err again we serve the time). The case goes

on appeal to the Supreme Court, is deemed 'moot', and thus we play a part in gaining free-speech rights for an adult American cinema, including freedom for the Mafia to turn out real porn.

Flo and I do not choose to risk a jail-stay with another arrest and so lose our sub-sistence-level income. As far as the titillat-ed public knows, New York Underground Film in its moment of peak inflammation is Jack Smith compounded by Andy Warhol championed by Jonas Mekas. I become a waiter. It's now 1964. The smoldering cities have burst into flame and even some Catholic priests and nuns are rebelling and there's no question the numbing grip of the Fifties is broken.

The Limelight, in Greenwich Village, caters to a species of intellectual some-how integrated into the economy, able to afford restaurants, an awesome lot. It exhibits photography when hardly any-one does. Sunday mornings the future mayor of New York, Edward Koch, then on his opportunistic rise in local Progressive politics, enters with entourage to sit in state for servings of bagels and lox. I hadn't expected so quick a return to servility and do not serve gladly.

But while I'm a grump another waiter is a stranger-in-paradise. Hustling in black and white waiter's costume in and out of the kitchen where the crazies, the lifers, lord it over the temporary help, nothing can throw him. He's determinedly amused, unmistakably Jewish sense of humor. 'Flo, you have to hear this guy talk. He comes over with a theater group from Dublin, satirical revue of the Kennedys. As they're flying over Kennedy is assassinated. The show bombed. He stayed.' 'How awful.' 'He's delighted. The revue was his way to get to New York. He comes from a theater family, his interest is painting. We mostly talk painting. He talks with everyone,

with all the customers. People succumb to the accent, open up. American speech fas-cinates him, he amuses himself doing imi-tations, all of which sound Irish. I think he's absorbing us as material for a skit he'll do in Dublin. He must do a great me.

The owners are very good about allowing me to feed Flo on the cuff and I cherish the memory of serving my lovely girl, back then when we ate everything, cheeseburgers with chips at an outdoor table (cholesterol with a topping of automotive exhaust, for-give me, darling). We then meet Noel's Liz, quintessential Irish beauty and wit, carrying their third child. The family casually dazzles with their beauty and becomes a welcome presence in the new self-romanticizing protest-and-pleasure-driven scene. Pleasure as Protest.

Odd coincidence: as I write Flo is listening to an interview on WNYC radio with the creator of The New York Dolls, a trans-vestite singing group of the early Seventies. He says his inspiration was: avant-garde film-artist and jazz and folk musicologist and proselytizer of drugs, homosexuality and mystic nihilism, Harry Smith. It was by this time that the Sixties, become fever-ish, were souring into the Seventies and lives were going down the toilet (see CIAO! MANHATTAN, 1973). It became a fashion for druggy middle-class kids to be begging in the crowded and hellish downtown streets. Noel was now a New York Painter, dapper in bell-bottoms when we met but edgy, not entirely his amiable wise-ass-observer self. It got so that he seemed to be pointedly ignoring an encir-cling ring of Goya monsters. It would be meeting with gnomic Harry Smith that finally signaled Noel, together with family but perhaps just barely so, that it was time to go. With thwarted Harry left jumping up and down like Rumplestilskin on the shore, figuratively speaking, the Sheridans escaped to Australia.

# Goodbye Old Paint

**C**LEMENT Greenberg had simplified the painting agenda to 'art that showed the means of its own production' and the terminal problem of how to float colour. This was not good news to me in the late 1960s

During this period I whiled away trauma by dropping paint onto a small toy horse, which gradually came to remind me of a title 'Goodbye Old Paint' that Gerard Dillon used for a pivotal work marking his transition from painting to collage in the late 1950s. He got the title from a cowboy movie - or maybe it was the title of a popular song from the 1930s – but, whereas his work took flight in the wonderful 'glove bird' series, I just felt stranded. When I saw the result of my doodling in a mirror I got the idea for this object which I have redone from my memory of it from 1967.

Goodbye Old Paint
(remake)
30 cms (h) x 30 cms (w)
x 20 cms (deep)

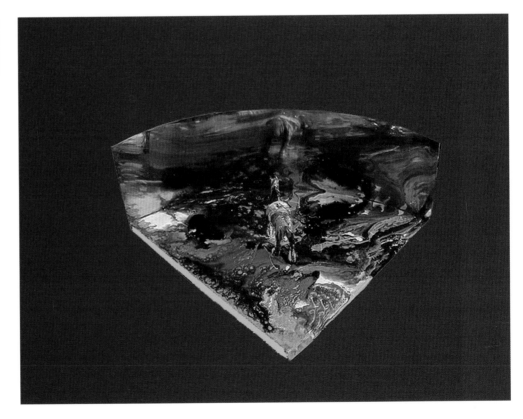

New York 1969 # The essentialist theory of art fallacy theory

Essentialist Theories
(remake)
28 cms (h) x 21.5 cms (w)
x 10cms (deep)

Miss, charm, expression, pretty lady, chance, freedom

true love, vanilla fields, steel mod, sensation, hot, cold

# Gathering Together

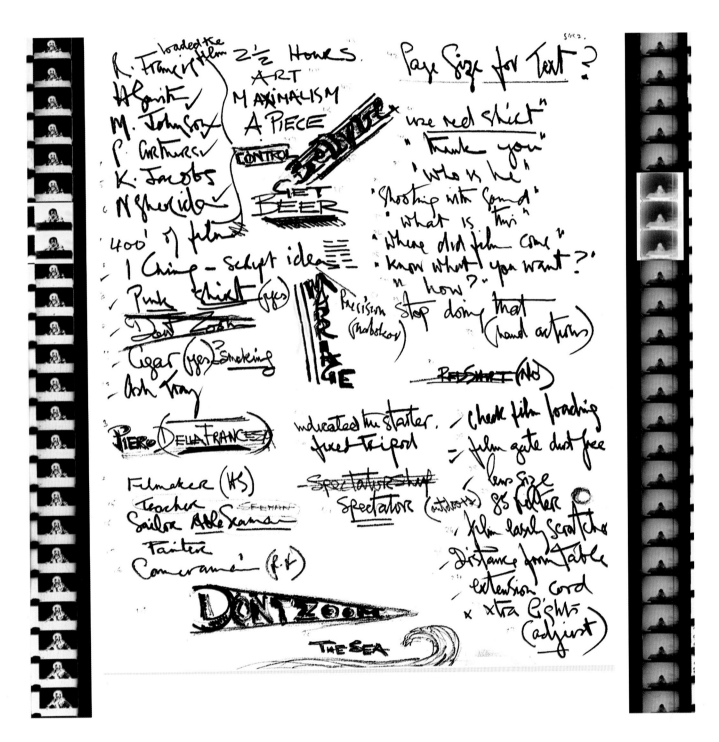

| PROFESSION | SECESSION |
|---|---|
| Film maker | Art |
| Able Seaman | Marriage |
| Teacher | Maximalism |
| Painter | The Sea |
| Cameraman | Control |
| Spectator | Sound |

| SCHEMATIC | RANDOM |
|---|---|
| 400 feet of film | smoking action |
| page size for text | Ken Jacobs |
| pink shirt | some hand movements |
| script idea from I Ching | breaking ash tray |
| distance of table from camera | I Ching hexagram |
| choice of lens sizes | red shirt |

| ADVISE | CONSENT |
|---|---|
| "use the red shirt" | made hand movements slower |
| "the film is easily scratched" | avoid zooming |
| "don't do that they'll put you in Bellvue" | agreed that the extension cord was in the wrong socket |
| "use 85 filter outdoors" | double checked the lens readings |
| "stop doing that" | got beer |
| "don't zoom" | agreed to pink shirt |

| APPRECIATION | DEPRECIATION |
|---|---|
| Harry Smith | film was scratched |
| a piece | Peter Arthurs |
| got beer | tripod head |
| control | ash tray |
| 85 filter | lights |
| Richard Francis | start button |

54

| CONTRIBUTION | APPROPRIATION |
|---|---|
| loaded the film | 400 feet of film |
| indicated the start button | beer money |
| fixed the tripod | blue silk dress |
| plugged in the extention cord | "thank you" |
| checked that the film gate was dust free | a piece |
| adjusted the lights | $2\frac{1}{2}$ hours |

| IMPERATIVE | VOLITIONAL |
|---|---|
| art | Bellvue |
| pink shirt | "the film gates are dust free" |
| cigar smoking | Michael Johnson |
| blue silk dress | page size for text |
| hand actions | didn't do it |
| maximalism | light adjustment |

| UTILISED | ABEYANCE |
|---|---|
| ash tray | the sea |
| marriage | 85 filter |
| "thank you" | red shirt |
| beer money | extra lights |
| 400 feet of film | precise script idea |
| $2\frac{1}{2}$ hours | |

| INQUIRY | REPLICATION |
|---|---|
| where did you get the film? | a film maker and cameraman |
| who is he? | Harry Smith |
| are you shooting with sound? | Piero. He is my favourite painter |
| what is this? | Richard Francis |
| do you know what you want? | a sea man teacher |
| how? | the film is loaded |

55

R. Francis
H. Smith
M. Johnson
P. Arthurs
K. Jacobs
N. Sheridan
film maker
able seaman
teacher
painter
cameraman
spectator
400 feet of film
page size for text
pink shirt
script idea; I Ching
table distance
len's size
use the red shirt
film easily scratched
Bellvue
85 filter outdoors
stop doing that
don't zoom
H. Smith
a piece
got beer
control
85 filter
R. Francis
loaded the film
indicated the starter
fixed the tripod
extension cord plug
film gate dust free
adjusted the lights
art
pink shirt
cigar smoking
blue silk dress
hand actions
maximalism
ash tray
marriage
"thank you"
beer money
400 feet of film
2½ hours
where did film come
who is he?
shooting with sound?
what is this?
know what you want?
how?

ash tray
shirt
table
400 feet of film
N. Sheridan
cigar
art
marriage
maximalism
the sea
control
sound
smoking action
Ken Jacobs
some hand movements
breaking ashtray
I Ching hexagram
red shirt
slowed hand movements
avoided zooming
extension cord socket
checked lens readings
got beer
agreed to pink shirt
film was scratched
P. Arthurs
tripod head
ash tray
lights
start button
400 feet of film
beer money
blue silk dress
"thank you"
a piece
2½ hours
Bellvue
film gates dust free
M. Johnson
page size for text
did not do that
light adjustment
the sea
85 filter
red shirt
extra lights
precise script idea
sound
film maker & cameraman
H. Smith
Piero, favourite painter
R. Francis
sea man teacher
the film is loaded

VESTIGAL

the sea

a spectator

ADJUNCT

a spectator

the sea

SOLIPSISM

A Spectator

the sea

ANIMISM

The Sea

a spectator

Dr Brook,

I have written some explanatory notes on this work;
                    Gathering Together.

This is a deliberately dense piece. The information
provided is scrappy, ambiguous, cryptic and in many
places, contradictory - like life or at least that part
of it which structures our beliefs about reality.
I set up a filming situation; camera, lights, props etc.
and I asked some other people to help me with a work.
I explained as little as possible about what I wanted
and what information I did give suggested that there was
an underlying plan. The events themselves were to be the
work and to have explained this beforehand would have
defeated the project.
We shot 400 feet of film.
This activity, which took 2½ hours,was very disturbing
for everyone.
At the end of the session I made some brief notes;listing
the people involved and those events which most impressed
me and stayed uppermost in my memory.
These headings appear on page 4 of the work and while
they act, for me, as mnemonics for what happened, they
will trigger different responses for others, as intended.
I subdivided the headings and placed them in categories.
Having named and used a category to classify a list,
I also used it's antonym to the same purpose.
I continued to do this until all the headings, with the
exception of - Spectator - and - The Sea - , were absorbed.
These form the residuum.
They appear on the last page as a "poem object".
It bears little relationship, even as far as I can fathom,
to the initial concept.

At the top of page I are two I Ching hexagrams. The one on the left
is "Gathering Together"and it gave direction to the work. The one to
it's right is it's opposite which influenced the final form of the
work.

The listings under "Formulation" are a fairly brisk and confident
statement of intent. And accurate.

The listings to the right under "Confutation" are more slack and
in some cases seem to modulate and refute the statements to their
left. They are also accurate.

I willexplain some category decisions which might be obscure.

Under Subject are the subjects named. Object includes objects in
the vicinity. I am included because of the passive 'object-like' role
I played in the proceedings.

Profession lists the professions of the subjects. Spectator is
included as I had seriously considered this a x possible profession
for myself at one time.Practiced it , in fact, in 70/7I.

Seccession lists things left. Art was ceded by one subject in pursuit
of a career in T.V. This on his own admission. Another was divorced.
A subject, a minimal painter,had abandoned the idea of maximalism.
The able seaman had received an injury which forced him to abandon
the sea. I ceded control in the work . The film was shot silent.
Sound was left out.

Schematic. Planned. I planned to use 400 feet of film, wear a pink
shirt, and use the I Ching to script the idea. The last two entries
are technical decisions. Page size refers to my decision as to what
size Xerox paper to use for the final document.

Random. Ken Jacobs arrived as we were filming. I had not planned this.
The red shirt was lying around and became an issue later. The other
entries seem obvious.

Advise. Bits of advise given during the filming.

Consent. Things I agreed upon.

Appreciation as addition or extra. A piece which is this work,and
a 85 filter which one of the subjects gave me in case we might be
shooting outdoors. The control to cede control on my part. Beer.

Appreciation as esteem highly. Harry Smith and Richard Francis for t
their generosity in helping.

Depreciation. as subtraction, loss of value, wear and tear.Lights
ash tray, film and tripod.

Depreciation as loss of esteem. The infallible Arriflex start

button got stuck. Peter Arthurs for personal reasons.

<u>Contribution</u> help given.

<u>Appropiation</u> ; something taken. I took a "thank you" from one of
the subjects who dident mean it. And I took a piece from the proceedi ngs.

<u>Imperative</u> . All the items listed here, with the exception of the
blue dress were imperatives of mine. Thxx Possesion of the blue dress
was another's imperative. I'm glad they got it.

<u>Volitional</u> where a choice was involved. "The film gates are dust
free" was an expression subjects choose to use a lot. Michael
Johnson choose to leave before the end.

<u>Utilised</u>; things used. Marriage is there as a mnemonic for me. Rxxxx
I       I used"thank you" to everyone and meant it.
<u>Abeyance</u> ; things not used. The sea by the former sailor.etc.

<u>Inquiry</u>. Questinns asked during the 2½ hours.

<u>Replication</u> . Answers given; not necessarily to the above questions.

I believe all the category decisions are justified.
Because the element of personal belief or prejudice plays an
important part in these decisions, I have been reluctant, until now,
to make the work public.
I am for the work being dense, difficult and ambiguous - but

I am against it's being xxbix imprecise or engineered around a false
logic.The logic should be viable - however arbitrary to the reality
question.
A paper by the Australian philosopher, Max Deutcher, entitled;
"A causal account of inferring" examines the part played by belief
in the' p supports q 'operation. This paper has become the"thin end
of the wedge" for me, on my way out of thatvparticular wood.
xxxxxxxxxxxxxxxxxx I am satisfied with the category decisions
and the markings on page five of the piece will have to serve as a
chart of my mental connections until a more sophisticated brand of
neuro surgery, than at present exists, emerges.
Thank you for persisting with these tedious notes. I didint ask for
these problems - seems the history of art has just -made me a present.

Orange Oak
200 cms x 200 cms

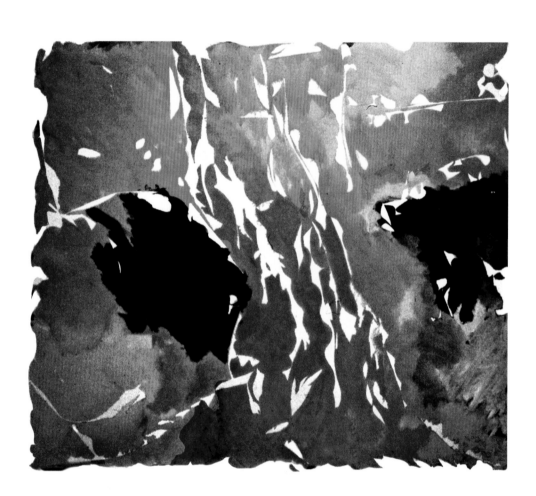

# **Orange Oak**  Wicklow 1970

I N 1970 we had returned from New York to live in Wicklow. This final picture was painted with my daughter Lutie. I started with the idea of trying for the way the sky came through the leaves of the oak tree in the near field. I cut leaflike shapes from masking tape and collaged them around the canvas. I went in on top with yellow ochre, orange and black. I began to let in the light by removing parts of the masking tape. I couldn't decide when to stop doing this. I began to stroke in a grey to the side and knew to stop.

I asked my daughter to look at the painting and say what she though of it. Did she think more bits of tape should be removed? I removed tape until she said to stop. Now she wanted to go but I asked her didn't she think the large black  shape made a hole in the picture. That was nice and the shape looked like an animal's head which she also liked. OK?

The work got a painting prize that year from Sir Roland Penrose. As I was unlikely to again get such a sympathetic judge or benign agency – she would be six next birthday – I decided to stop.

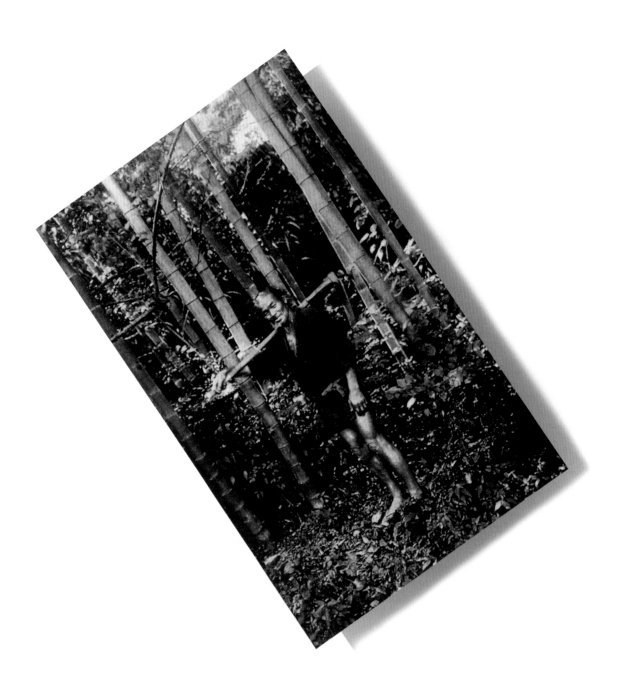

# **Australia** From 1971

CHARACTERISTICALLY, for him, it was in pursuit of a very small island that Noel Sheridan came upon Australia, in 1971. A project inspired by *Finnegans Wake* had brought him from New York in search of New Ireland which is a narrow Melanesian outcrop some 282 miles long, and was at that time quasi-colonially administered from Sydney. His purpose was so implausible to the bureaucratic mind that his progress was resisted, and he settled instead for an investigation of the curiosities of the larger Pacific settlement west of Oceania.

The Australian art world was then under radical reconstruction by ranting ideologues who listened, each to the other, for no longer than it took to find a ground of contradiction.

There was Sydney versus Melbourne, of course; a conflict extending back before the time of federation of the independent colonial states in 1901. There was also figuration versus abstraction; rooted in the modernism that had been smuggled past a censorious department of Customs in the baggage of European migrants, returning expatriates and the international art magazines. Most urgently of all there was the issue of an Australian cultural identity *versus* American-type painting. Very roughly, Melbourne inclined toward a native Antipodean mythography, Sydney toward New York painting under the tutelage of Clement Greenberg.

It was not yet local knowledge that it was already too late – almost by as much as twenty years – to go anywhere under the tutelage of Clement Greenberg; although Noel, fresh from New York, knew this. What he brought with him was not a high and serious ambition to ride the dialectic of History. It was something more like – although less sacrificial than – the scepticism of artists such as John Baldessari, who had burnt all of his life's work in the celebrated *Cremation Piece* of 1969. 'I consider all these paintings a body of work ...,' Baldessari wrote. 'Will I save my life by losing it? ... Will the paintings having become dust become art materials again? I don't know, but I feel better.'

Noel's first significant contribution to art in Sydney was called *Seconds*. It was a re-cycling piece of analytic rather than apocalyptic temper; not grandiose, and not sentimental. The question of how to move as an artist was, for him, the secular one of engagement with a rational and public world in the absence of any canonical and trustworthy aesthetic system. One might have said at the time that his position, between the imperatives of social intelligibility and subjective compulsion, was more evident in his life than in his art. The very good reason not to have said this is that he did not distinguish in the usual ways between life and art.

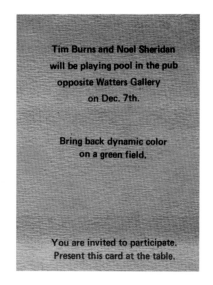

For example: the wearing of the green. This drastic monochromatic commitment was widely, and wrongly, regarded in Sydney as an amiable eccentricity, unrelated to serious art-production. He wore green socks. Green shirts. Green shoes. Green handkerchiefs, hats ties and jackets. He wrote with green ink on green paper, and sent people green postcards. I have one of them on my desk as I write. It is undated, but responds to a letter that I sent to him from Adelaide toward the end of 1974, in which I spoke of the hard row he would have to hoe if he accepted an invitation to become Director of the new Experimental Art Foundation (of which, more in a moment). The card, printed in Japan (with Russian and French assurances of its communicative function) bore a succinct message on the back: 'Have hoe,' Noel wrote 'Will travel.' And on the front, pictured standing deep in a green bamboo jungle, there is a green-shirted Japanese peasant smiling toward the camera and carrying across his shoulders a hoe so immense as to be capable of manipulation only by an artisan of heroic determination.

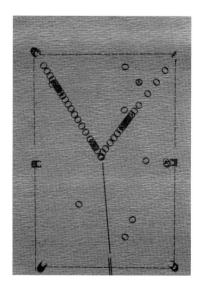

It is not known how this item came so conveniently into Noel's hand, and then into mine. It was, for him, such an ordinary detail that speculation about its peculiar felicity would be idle. Most of his transactions with the world were like that. To raise the question – as if his casual, densely referenced, transfigurations of the commonplace were not absolutely normal – would be as inappropriate, or perhaps even impertinent, as to interrogate a traffic policeman about the choreography of gesture. Occasionally, if one suspends the question for long enough, illumination flickers past: as, for example, concerning the sub-text to the simple republican narrative of green, I learn from an email at thirty years' remove that 'Although my wearing green was a way to remove aesthetic choice in deciding what to wear, it was also a last salute to Greenberg's terminal painting problem 'how to float colour' by choosing one colour and floating it in life on my person.'

To be a painter in Sydney at the beginning of the Seventies was to stand somewhere in the field of colour, affirming or denying. The Power Institute of Fine Arts, newly endowed and opened in 1968 at the University of Sydney, had assumed a duty under the terms of its bequest, to 'bring the latest ideas and

theories about the visual arts to the people of Australia.' Belatedly, Greenberg had given the first of the annual John Power Lectures, called *Avant-Garde Attitudes*. This had been followed a year later by a lecture of my own called *Flight from the Object*, pointing in another direction.

The new direction was yielding, internationally, varieties of art variously mis-characterised as conceptual, performance, environmental, video, multi-media, poverty, and so forth. The problem for the theorist was to put a finger on the uni-fying principle that would make coherent sense of their variety and save them from the charge of triviality, as stylistic variations on the end game theme of the avant-garde. We had settled, in Sydney, on the general name *post-object art*; although with deep misgivings that turned out to be well founded Despite our protestations that 'post-object' was not a stylistic prefix comparable to 'post-impressionist,' that is how it would be taken in the long run; and perhaps why it would be rejected.

But I move ahead of the action. In 1971 the buzz of experimental energy in Sydney was so congenial to Noel that he put his commitment to Joycean exegesis into sub-textual mode and joined us. We might be no more than level with the international pack in the pursuit of an art for our own time, but we were well ahead of the game of transforming the way art was going to look in Sydney Edit-ing the Contemporary Art Society's *Broadsheet*; contributing to the work of the University's new art space called (for locally obvious reasons) The Tin Sheds; performing and exhibiting from time to time; Noel rapidly became a force in a fractured art world that was still anxious about its provinciality, narrow, generally conservative, and thorny about the issue of cultural identity. A world that had until then shunned its Aborigines was above all determined to be *Australian*.

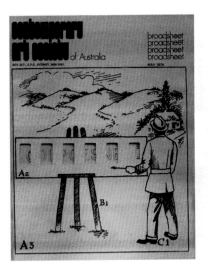

At least to be Irish on the Australian scene was not so offensive as to be English. The English had always dominated; the Irish (excepting, of course, the protes-tant gentry) had always been part of the colonial underclass. Among aliens, Irish-ness was a mitigating circumstance Besides, Noel is a charmer. He can make it seem a privilege to be wrong-footed.

Sydney was the big smoke then, as it is today to all but the Melbournians. It is where the artist with ambition (in the vulgar sense of the word) will settle and strive for recognition. It is characteristic of Noel that his ambition would take him instead in pursuit of nothing more tangible than a good idea to a small town standing about as far away from Sydney as Molly Bloom's Algeciras stood from Dublin. Adelaide was not then on the map of where anything is at, despite an attractively green cricket field with a view of the cathedral and the river. Thirty

years ago one could still park outside a shop in the city centre, in the shade of a balcony with lacework supported on cast iron pillars.

The good idea – that he would assiduously tend with the aid of that massive hoe – was called The Experimental Art Foundation. I had myself recklessly moved from Sydney to Adelaide in 1974, to a university that promised – but never delivered – a dramatic conquest of the wilder shores of visual art. There were then, as there must be in every small town, six people of a matching insanity standing out against the backdrop of churches and gentility, who saw at once the urgency of the project to place the art of the late twentieth century on a firm new footing. The ambiguity of our chosen title (was it to be an experimental *art foundation*, or an *experimental art* foundation?) was deep, and for many years fruitfully provocative.

The Visual Arts Board of the new Australia Council was eager to invent a place where it could astonish those foreign visitors who expressed an interest in the avant garde. We were already reconciled to this misunderstanding, and perhaps even cynically inclined to exploit it. If there must be an Australian avant-garde to be inspected, it might as well be us. But to succeed not only in the imagination but in the real world we needed a Director with magical powers. We needed an artist of distinction who could keep plausible accounts and negotiate bureaucrats. He (there were not yet any she's) must be capable of showing a sceptical public that the value of art is not finally – nor even temporarily – determined by the salerooms and the dealers.

We had a wretched salary to offer, no fixed abode, and the effrontery to put to Noel Sheridan the unlikely proposition that the vital course of the art of the last third of the twentieth century ran directly through South Australia.

To make the journey from Sydney (which in those days included some hundreds of miles of dirt road) he bought a raucous vehicle with a tiny wooden steering wheel. It broke down in the centre of the great, flat, treeless plane of Hay, which delayed by a week or two his precipitate acquisition of a pair of adjacent houses in the Athens of the South. The second house as he patiently explained to the slower witted – was for the children; of which the eldest was still at school and the youngest in nappies.

The Experimental Art Foundation is now legendary and is still, mysteriously, an ongoing concern. I write 'mysteriously' because the project, as it was first conceived and as Noel nurtured it, was fundamentally absurd. It was an institution committed to the doctrine that the essential nature of art makes it unassimilable to institutional comprehension. Under a less imaginative direction than Noel's,

66

any superstructure built upon such a foundation must have collapsed into a folly. It must have become the object of universal – and not merely of popular – detestation, or ridicule, or both. So remarkable was his success in presenting the Foundation as the authoritative centre of contemporary art, and so rapidly was his example coopted for implementation elsewhere, that his ongoing career as an exhibiting artist was largely occluded by it. But the record –although sometimes overlooked – is indelible.

Among many examples, one is richly characteristic It had its roots in Sydney, and probably indeed much further back than that. My own estimate of its proximate cause was the linguistic philosophical insight that the discipline of aesthetics had for generations concerned itself obsessively, exclusively and to crippling effect, with *the beautiful*. If the appreciatively engaged mind is to be freed from an incapacitating cramp, attention must be paid to such neglected aesthetic predicates as the dainty and the dumpy. Noel's elaboration of this theme, called *Everybody should stones*, began as a text on choosing stones. (Foundation stones? The rock of salvation ... ?) He required observer-participants, in a collective performance, to select a stone discriminately from among others because (for example) 'It is the most odd ...' or ... (in a list extending letter by letter in word length down the page of instructions to '... the most indescribable ...') Thus, as the project forms a pattern in the mind, the specification of it forms a pattern on the page.

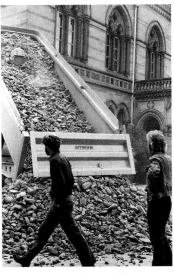

Ian North, curator, Gallery of South Australia

And then, off on a different tack of defeasibility, a stone is to be selected because it is 'most like your mother ...' or 'most like your back, your alter ego, your worst suspicions ...' Or it must be selected as suitable '... for killing two birds with ...'

And so on. The full material incarnation of the work, complete with exemplary pebbles, participants and text, occurred in the Art Gallery of South Australia in Adelaide, where several tonnes of river pebbles were distributed deep throughout

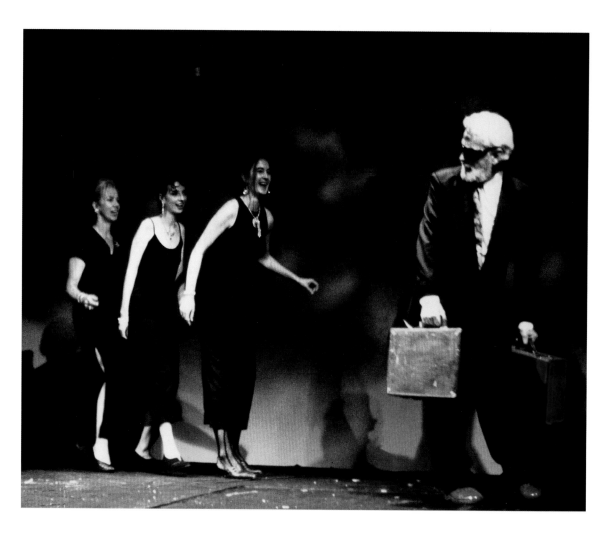

Belinda Carrigan, *Senior Curator*; Japonica Sheridan, *Installation Co-ordinator*; Natasha Vukelja, *Senior Administrator.*

the exhibition space. Visitors were invited to step and stumble among them, exercising their sensibilities to the limit in every direction. It was, by the standards of a very conservative civic gallery, a radical departure made possible only by the disingenuous solemnity of one curator – himself a founding member of the Experimental Art Foundation – who left Adelaide not long afterward. There is a baseless legend, more true in spirit than in the fact, that at the end of the exhibition an unamused administration demanded that Noel should remove the offensive material by wheelbarrow: an indignity that he transformatively handled by publicly donating the piece to the State collection.

If the terms of its original conception had been better understood that handbiting dog the EAF would not have been licensed. It became successful, and a national role model for artist-run spaces, largely at the cost of Noel's nerves, marinated as they were in black coffee and nicotine. Subsequent directors have acquiesced less ambivalently in those insidious contracts of public accountability that assimilate public art institutions to less feral utilities, such as water corporations. He left when he had done as much as it was possible for him to do, when more of the same would be irksome, and when he had a different challenge.

68

Ireland, however, won him back only temporarily when it summoned him home to ease its National Art School out of the less productive grooves of tradition. He has always been a teacher, if rather by example than by precept, but he has always also been a traveller, and unable to resist a challenge.

The most remote city in the world Perth, in Western Australia has a lively interest in strengthening its links with those cities that are accessible only on the internet, or at some risk of deep veined thrombosis in the discomfort of the international carrier. By the late Eighties a Perth Institute of Contemporary Arts was projected that would have all the virtues of the Experimental Art Foundation, without its constraints of poverty and its vice of fundamentalism. PICA would be handsomely funded (as it seemed); and it would be expected shamelessly to flaunt its authoritative credentials in a lavishly custom-modified building in the cultural heart of the city. The directorship of PICA was a very different challenge from the one that Adelaide had presented, and Noel could not resist it. In 1989 – temporarily, as he said – he took leave of Ireland again.

Arguably, this move was a rare mistake for him; although a profitable one for the sandgropers huddled on the western edge of the great Antipodean continent, freely open only to the incoming weather and the Indian Ocean. The times they were a'changing; but less propitiously for Noel than they had changed in the 'seventies. PICA was explicitly, prominently, a public institution linked to the emergence of the new arts industry. His conviction that there is no such industry – or rather, his conviction that to the extent that there is such an industry it has little to do with art – must have been a deep internal cause of stress. It must have contributed a good deal to the heart attack, from which he emerged by virtue of a random (surely not accidental) summoning of the one and only ambulance in Western Australia that happened to have a defibrillator. It is reported (I am sure reliably) that he had to be moved prematurely out of a recovery ward because his lively ruminations on the topic of mortality were wreaking havoc with the stitches of the other patients.

This is not a *curriculum vitae*. One item will serve in place of a list; especially in the field of performance art in which Noel is inimitable. At his farewell from Perth in 1993 a great crowd of well-wishers morosely awaited his valedictory words from the stage; the ritual acknowledgments, the gracious regrets ... Their expectations were confounded by an hilarious mime of Ray Charles, supported by fishnet-stockinged dancing girls and the strains of *Hit the Road, Jack*. Quickly, unforgettably, that is what he did.

*Donald Brook*

69

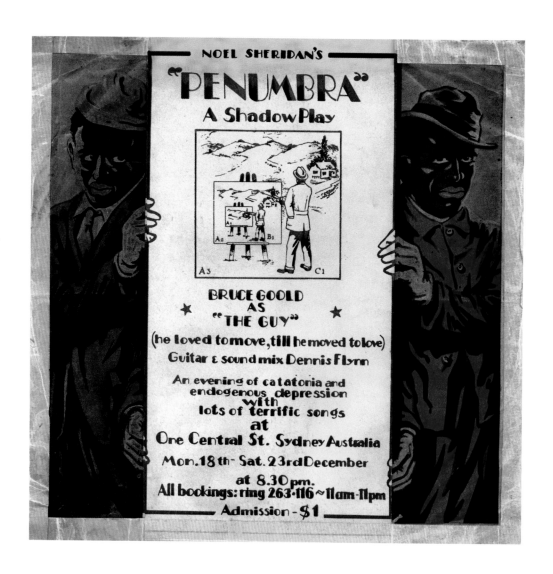

NOEL SHERIDAN'S

# PENUMBRA 2
# PENUMBRA 2
# PENUMBRA 2

PHILIP BATTY
KATE BOSSER
MICHAEL CALLAHAN
DENIS FLYNN
BRUCE GOOLD
MARIE McMAHON
DON MORI
STEPHEN ROBINSON
MARK SHERIDAN

PENUMBRA II A SHADOW PLAY by NOEL SHERIDAN

Performances start 8pm. sharp.
October Wed. 16
Thur. 17
Frid. 18
Sat. 19
Sun. 20

Wed. 23
Thur. 24
Frid. 25
Sat. 26
Sun. 27

Noel Sheridan wishes to thank
the Visual Arts Board of the
Australian Council for the Arts,
Philips Lighting Industries,
for their assistance in the
presentation of this work.

## One Central Street

# **Penumbra** Sydney 1972

## The School Gates

Lights fade up to show gates occupying both sides of the dream screen. The stage right side carries a slide of the actual school gates; the left carries a silhouette of a gate. As the text 'The Gates' is read the colour mixes on the silhouette gate are changed with each phrase. The angle and distance of the light sources from the gate modify the scale and colour mixes of each finished image to punctuate the text. After key phrases (*) a figure goes forward to hang the stencil letters PENUMBRA in sequence from the cross bar of the gates so that the letters are framed within the uprights to spell the word.

The gates of Grantham Street School opened at ten o'clock and the children passed through to the oak doors, which were twelve feet beyond.

The iron gates of the school opened at ten o'clock in the morning and the pupils passed through to the dun coloured oak doors, which lay twelve feet beyond.

71

*The iron gates of Grantham Street School were set in granite and enclosed a concrete yard. The yard was square and cracked. **P**

*The distance from the iron gates to the wooden doors was ten feet. The iron was black and chipped and the wood was a dull brownish yellow. **E**

*Looking through the chipped iron gates, the boy could see the dull ochre doors of the school. The black paint, which covered the iron gates, was chipped and uneven. **N**

*The black paint of the iron gates was broken through with rust sores. **U**

*Dry open rust wounds on the black iron gates showed the dull grey metal within. **M**

Since dawn the doors, which were twelve feet beyond the gates, had been soaking sun. They were warmer than the gates.

*Pressing his face against the cold iron of the gates and feeling the rust flakes in his hands, he stared at the warm ochre doors across the cracked concrete yard. He watched the doors warm and soften. **B**

*My face against the cold iron gates brushed rust wounds. The doors softened and warmed as the concrete yard cracked in the sun. **R**

*The golden doors burst into flames and the iron gates ran molten to the gutter. **A**

I stood outside the gates of the school and looked through the iron bars at the wooden doors.

I looked through.

Looking.

Fade lights to blackout. (5 seconds.)

Sydney Harbour Bridge.

Slow fade up on silhouette of Sydney Harbour Bridge which occupies one half of the screen and is saturated in reds, lavenders, oranges, blues - very rich, romantic colour. Ultramarine rising through lighter blues to pinks. A rose coloured Moon. The right screen carries slides of Sydney suburban streets. As the overvoice reads the list of Sydney suburbs from A to Z in Gregory's Street Directory, the moon begins its slow descent to break upon the bridge and open up the colour spectrum as the list of names finishes. Blackout.

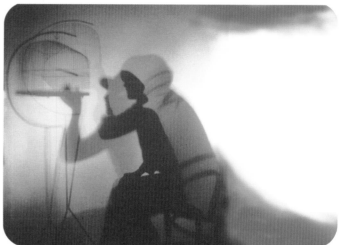

'The Guy' in his room

Snap opening to show harsh silhouette of 'The Guy', double breasted suit, trilby hat, etc. seated on a chair in his room; pensive. He slowly rotates his body through five moves, which open and close the negative spaces between his arms, legs, head and shoulders. Drawing with his body, he holds each finished image for seven seconds before moving to the next. He turns his head toward the gramophone. As he brings the machine toward him he unifies its shadow image with the lower half of his body.

He reaches his hand toward the winding handle of the record player (Blackout into close-up of his hand and the handle. Hold 5 seconds.) Long shot as he winds the handle. Blackout. Leans back. Light up. Long shot to show him looking at gramophone player.

He selects a record. (Blackout then close-up of record. The hand held light is directed through the hole in the centre of the record to fracture and spray the

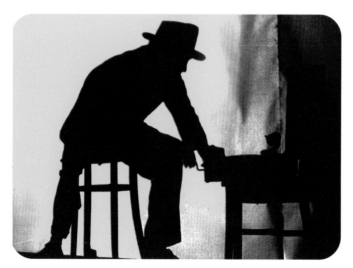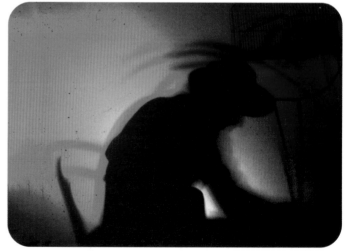

light across the screen. Blackout.) Light up. He lights cigarette. Blackout as he strikes match, which is sole illumination to give close-up of his head and shoulders. Match out. 2 seconds. Light up

Long shot as he places the record on the turntable and moves playing arm to playing position. (Close-up; his hand and playing arm between angle of gramophone lid and surface of turntable. 5 seconds. Blackout.) He places the arm and leans back. Long shot to show him looking at gramophone player as it plays 'Every Night About This Time' by the Ink Spots.

*Every night about this time, memories haunt me,*
*Wondering who, who's dancing with you,*
*Every night about this time.*
*And whenever they croon our favourite tune,*
*A tear falls with every rhyme. Oh how I miss you*
*Every night about this time.*

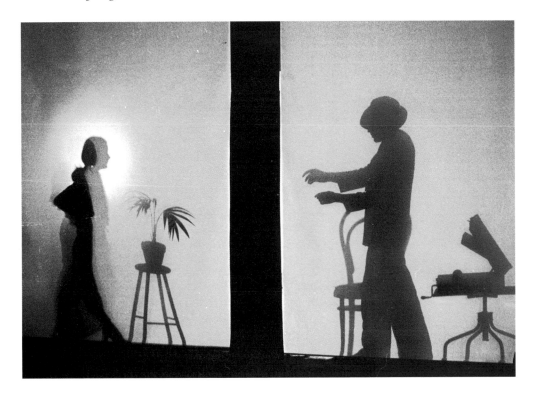

## 'His Girl'

'His Girl' appears, dancing behind him, modifying the light with her lace mantilla. She dances for 16 bars and leaves before final 8 bars. He is catatonic. Blackout.

## Furniture Dance

Fade up. Furniture begins to bend. Bring in palm tree and birdcage on separate sides. Tempo quickens to Satie music and finally both screens mesh as two operators work images to crescendo and blackout.

 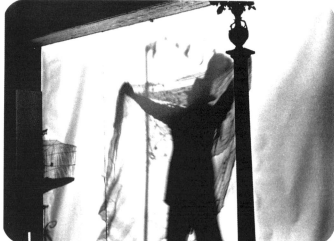

## The Revolution

Snap open to 'The Guy' in his room. Voices from the back of the hall attract his attention. He looks out at audience. Armed revolutionaries invade the space, disrupting the audience and bringing the performance to a halt. Images of Northern Ireland, the Pope's visit to Australia etc. are projected on to the front of the screen.

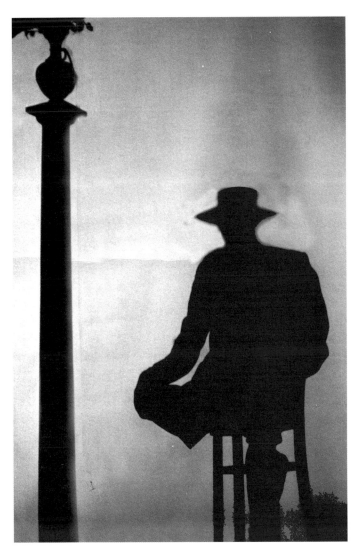

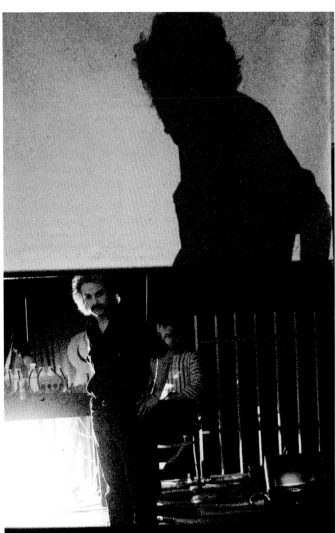

Their leader calls out the shadow operator. The operator raises one of the screens
and emerges with lighting paraphernalia, (Jackson Brown's 'Doctor My Eyes'
plays as he argues with them and until he entices them back behind the screens.)
Highly agitated, he calls for 'Tango: Opening Positions' and manages to get the
revolutionaries out of the light source.

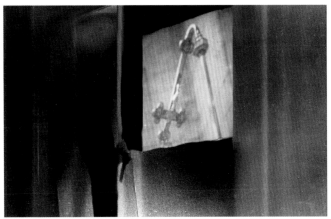

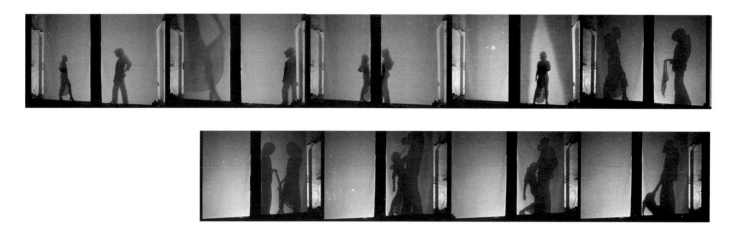

## The Tango

'The Guy' and 'His Girl' take their positions at opposite sides of the dream screen. Music: 'Jealousy'. They dance highly stylised tango that ends with him killing the girl. Tableau.

## The End

Hand held circular spot follows 'The Guy' as he moves to the right screen. Reset Sydney Harbour Bridge and fade it up on left screen. Bring in Aboriginal music. Voice-over reads the suburbs from Gregory's Street Directory but this time only the aboriginal names. The guy undresses and reaches for a spear. He strikes the iconic aboriginal pose as featured on postcards. He turns toward the bridge as the volume of the voiceover reading the Aboriginal names and music build in intensity. Sudden stop. He moves towards the bridge. Hold 3 seconds. Black out.

# It's Impossible <span>Canberra 1976</span>

## Primary Coils

### Primary coil A

Remember, if necessary go and see in order to remember, that ten seconds in the movie 'Lust for Life' when the hero, unable to paint the crows over the corn field turns to the camera and complains through clenched teeth and in an American accent that 'It's Impossible'. Establish this memory and loop it.

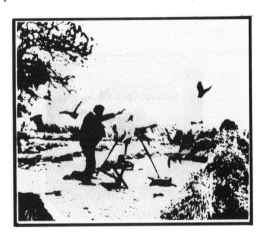

### Primary Coil B

Create a second memory, as close as possible to the first; this should consist of a section of Perry Como's rendition of the song 'It's Impossible'. Structure this memory to include at least two statements of the lyrics basic proposition. Run this memory for as long as it takes to loop.

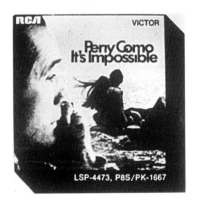

Practice oscillating the memory loops, adjusting the vector relationships, so that Kirk's protest is echoed and echoes Perry's.

If we call the Kirk loop A and Perry B then a B(A)B configuration should appear at least once in the fusion.

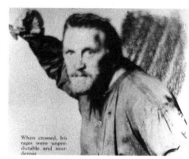

Primary Coil C

Become aware through film, TV or personal participation of that time in British soccer when the crowd sings 'You'll Never Walk Alone'

Fabricate the gestalt, field and ground, to include the scoring of a memorable goal (choreograph this action to your best memory, keeping in mind that it should not exceed five seconds.)

To this memory butt join one second of stunned silence and then add that four seconds of 'You'll Never Walk Alone' during which the phrase 'You'll never walk etc. etc.' emerges with relative clarity.

Run this memory several times and loop it.

Now phase the C loop into the AB memory structure so that the new configuration might be aptly represented by C(B(A)B)C

Or by $\dfrac{B(A)B}{C}$

Or by    C C C C C
       C   B(A)B   C
         C C C C C

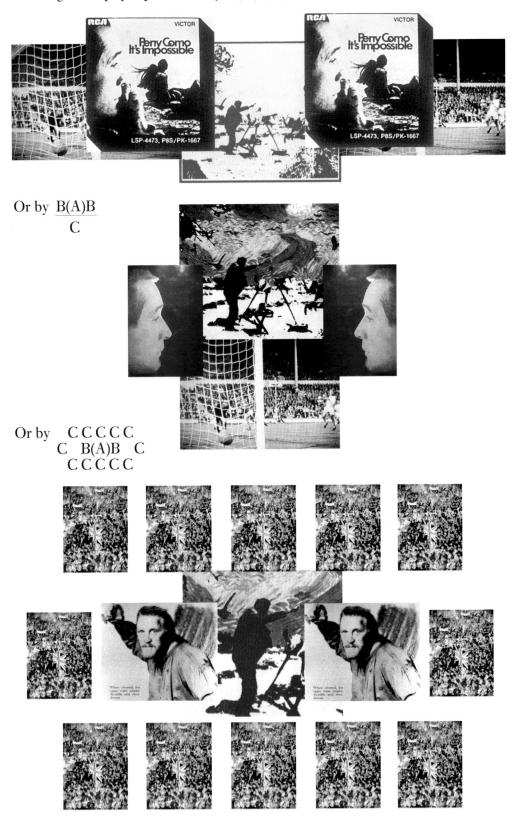

But NOT by CAAAB

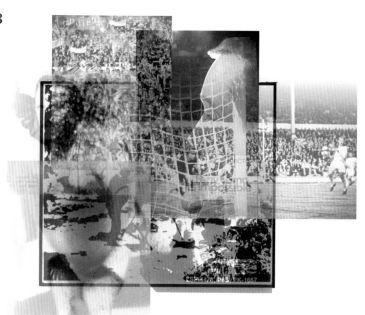

as this is not art .

Secondary Coils

The above mixes may trigger Secondary Coils by association. Consider that Vincent is to Paul as Perry is to Bing as Paul is to – Your choice.

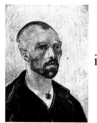 is to  is to  is to  is to  is to

The following diagrams show possible transformer configurations

FIG. 149.—Diagram showing the Pairs of Three to Three Phase Transformer Connections which will and which will not operate together in Parallel.

Star stands for Kirk, Perry, Vincent and the star soccer player of your choice.

Inter stands for international. The international reputation of your star choice

Delta. The meeting and mouth of soccer fans. The Spectator.

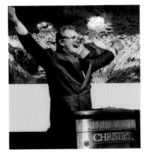 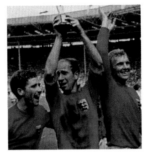

Mix as per diagram. Avoid connections marked X

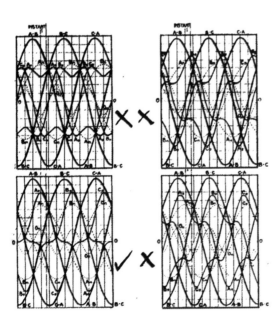

# Tertiary Coils

## Tertiary Coil a

Make a as C coil's tertiary include beneath the singing of the final word 'Alone' the art/life conflict generated by those in the crowd who, unable to sustain the aesthetic tension of the unresolved chord – the final resolving note of 'You'll Never walk etc. etc.' – have pressed on hotly to a life release – the open ended shout.

Isolate an image of someone obsessive who must, notwithstanding the life clamour, resolves the formal aesthetic problem by singing 'Alone' alone.

## Tertiary Coil b

Drawing information from primary memory coil A make small b as big B's tertiary include the anger / lassitude dichomatic image keyed to the Kirk/ Perry temperament antipathy

The Last Days of Pompeii

**2. Parallel Operation of Star/Interconnected-Star with Delta/Star-Connected Transformers.**—With regard to the question of parallel operation of star/interconnected-star transformers with delta/star transformers, it is not necessary to go into this here in great detail, and it is sufficient to state that delta/star-connected transformers or transformer groups will operate satisfactorily in parallel with any star/interconnected-star transformer or transformer group. This holds good whatever the meshing of the phases may be or whatever may be the direction in which the primary and secondary coils are wound, and it is only a question of selecting a proper set of external connections from the transformer terminals to the bus-bars in each case, as explained in Chapter X.

It has already been stated that electrically a star/interconnected-star transformer is equivalent to a delta/star-connected one, though no proof has been given for this. The fact can best be illustrated by means of a vector diagram, and Fig. 93 shows a comparison between the two kinds of combined connections. From this it will be seen that there is the same angular displacement in both cases between primary and secondary terminals, viz., 30°, and therefore both primary and both secondary line currents and pressures are in phase.

Of course, cases may also occur in practice where the interconnected-star winding is required on the primary side to be used in conjunction with a star-

DELTA / STAR    STAR/DELTA

STAR / INTERCONNECTED STAR    INTERCONNECTED STAR/STAR

FIG. 93.    FIG. 94.

*Vector Diagrams comprising the Two Kinds of Combined Connections.*

connected secondary, and in this case the connection would be electrically equivalent to the star/delta. Fig. 94 shows a comparison between these two combined connections, from which it will be seen that there is again the same angular displacement in both cases between primary and secondary terminals.

Now, with all of the above as core synaptic cluster, run your head. The best time to do this is when the electrochemical language that brain uses in talking to itself is at its maximum. Induce this. It is when it stops that the sublime kicks in and delivers delight.

87

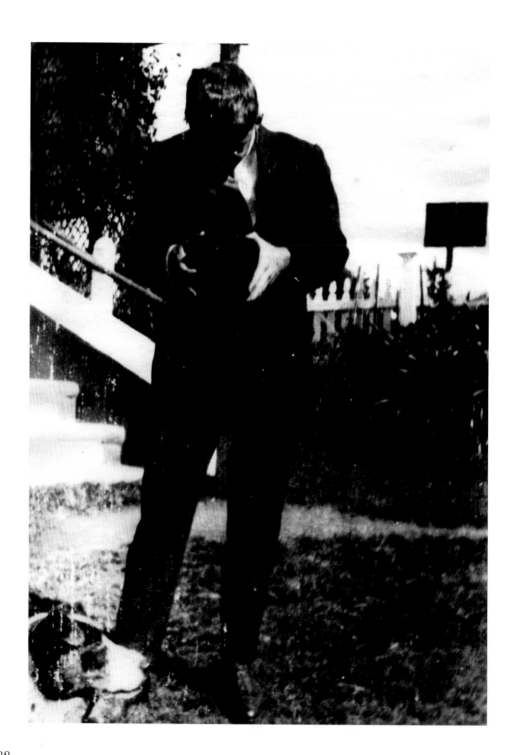

# **Seconds** Sydney 1972

'SECONDS' STARTED from that moment his $2 bid at auction brought him 'Sundry Books in a Brown Paper Parcel' containing the blue book of negatives.[1] Fat with content; its index listed, in a fine cursive hand, the names and events that the 120 format negatives retained in glassine envelopes that had protected, among others, 'Mother at Para' (Number 1) from the light of day or darkroom since 1913. He extracted a thin negative and held it to the light. It was 'Mark Grigson's car at Newport' The index affirmed it. Number 43.

In addition to the wonderful look and feel of the book in 1972 it was this malleable, fleeting interval, when mentally transferring visual information with the assist of language – the index – that was transformative in a way he felt had something to do with how we see art; the function of titles; how the brain sought some structure as if consciousness itself depended on it, the bite and burn of negative spaces that puzzled the mind and agitated certain aesthetic releases to suffuse a system to mask a trauma that revealed a fallacy that was more than simply pathetic.[2] The book was something to hold on to. (Since eaten by rats or ants as part of the vagaries of moving from place to place.)

---

1 The other books in the parcel were: *Encyclopedia of Knots and Fancy Rope Work* by Gaumont and Heusal, Cornell Maritime Press, Cambridge, Maryland, USA; *72 Master Letters and What Made Them Pay*, Shaw Publications, New York, USA; *Sheep Shearing Experting* by L.D. Ryan, Angus and Robertson, Sydney, Australia; *How to Study Strangers* by N. Sizer, L.N. Fowler & Company, London, England; *Underground or Life beneath the Surface* by Knox (*spine intact, front pages missing*).

    These titles, he knew, were too pedagogic, imperative and without the obsession – the art – of the Blue Book. Also it was the case that one preferred one thing above another. Why he could not understand this and just leave it at that, without resorting to footnotes which tediously embellished and unravelled things that one might just as easily relegate to life where the urgency to survive provided the sharp edit that relegated every thing else (all that fell outside the frame) as rubbish – distracted him still. (The attraction of footnotes to visual artists was, of course, the placement, location issue. Get the eye tracking around space.)

2 This was a bad time for him, mental-health-wise, and his attempt to displace himself by another, to get another's life, by entering the bright clarity of the other's narrative was, he felt, getting thrown off pitch by the rhetoric of his personal delusional art preoccupations. He reminded himself that the pathetic fallacy that animated so much of his old work was,

**List of Negatives**

1. Mother at Parra. 6/5/1913
2. Mrs. Clarke at Parra.6/5/1913
3. Welsh, Mitchell & Reynolds sitting out in the sun at school. 8/5/1913
4. Vickers, Riley, Welsh, Reynolds sitting in the sun at school. 10/5/1913
5. Frankie Welsh at T.K.S. Parramatta.10/5/1913
6. Tim at T.K.S. Parramatta. 10/5/1913
7. View from Lenards bridge looking up river Parra.10/5/1913
8. Father on front balcony 227. 31/5/1913
9. View from near kiosk, Domain, Sydney 31/5/1913
10. Mother in Domain, Sydney 31/5/1913
11. Macquarie St. looking North from Domain Gates. 31/5/1913
12. Dam overflowing at Parramatta. 13/6/1913
13. Fatty Lampsplough at T.K.S. Parramatta. 15/6/1913
14. T.K.S. Schoolhouse taken from near Jun. 15/6/1913
15. Jim Mashlen, T.K.S. Parramatta. 17/6/1913
16. Fred Brodie, T.K.S. Parramatta. 17/6/1913
17. Pelham Spencer T.K.S. Parramatta. 17/6/1913
18. Bishop Notts, T.K.S. Parramatta. 18/6/1913
19. View from balcony of Napier, Laura, N.S.W. 25/6/1913
20. Wentworth Falls, from valley. Wentworth Falls, N.S.W. 26/6/1913
21. End of Wentworth Falls. Wentworth Falls, N.S.W. 26/6/1913
22. Kinimala Valley from Wentworth Falls, N.S.W. 26/6/1913
23. Kitty in gardens, Sydney 1/7/1913
24. Arnott White and myself at P.D.C. Parramatta. 10/9/1913

89

25. Prizes for sports, Parramatta 10/9/1913
26. Finish 100 yds. under 14 10/9/1913
27. Finish of hurdles, Parramatta. 10/9/1913
28. Finish of Sack Race, Parramatta. 10/9/1913
29. Piggy Grant, Shelly and Merrie, out Bush. 14/9/1913
30. Merrie, Grant and myself out Bush. 14/9/1913
31. Merrie, Shelly, myself out Bush 14/9/1913
32. Bill Laycock with golf stick 16/9/1913
33. Rick Erley, Robo, Tommy Hood, Parramatta. 17/9/1913
34. Chapel, T.K.S. Parramatta 21/9/1913
35. Group T.K.S. Fellows on Top Bank 21/9/1913
36. Group T.K.S. Fellows below Bank 21/9/1913
37. Fred Brodie T.K.S. Parramatta 21/9/1913
38. Bob, Ted, Jack, Soldrick at Coast Hospital. 25/9/1913
39. View from cliffs at Coast Hospital 25/9/1913
40. Salute from the Cambrian, arrival of fleet, Sydney. 4/10/1913
41. The flagship Australia surround- ed by small craft. 4/10/1913
42. Frank Welsh, Swain, Gar Potts below Bank T.K.S. 2/11/1913
43. Mark Grigson's car at Newport 8/11/1913
44. Mrs. Grigson at Newport 8/11/1913
45. Mark Grigson at Newport 8/11/1913
46. Dr. Grigson at Newport 10/11/1913
47. Tim in cricket togs, T.K.S. 10/11/1913
48. Fred Brodie (idiot), T.K.S. 10/11/1913
49. Gar Potts in cricket togs, T.K.S. 13/11/1913
50. Tea party at H.A.C. down river 16/1/1914
51. Gar Potts on river H.A.C. Rich- mond. 16/1/1914
52. Potts House H.A.C. Richmond 18/1/1914
53. The dam at Burrin Juck N.S.W. 20/3/1914
54. The dam at Burrin Juck N.S.W. 20/3/1914
55. Outlet of Burrin Juck dam N.S.W. 20/3/1914
56. Looking down the Murrinbridge river from Burrin Juck dam 20/3/1914

He thought it looked like a work Duchamp might have made. Not as a readymade (something nominated as art) but as a warrant that was analogous to that artist's 'explanatory' books and boxes ; a codex to life. Or, at least, *a* life. Not his.

So, might the 'Blue Book' – he was already referring to it in caps – be an artwork whose time had not yet come, that had entered the world as bric-a-brac, but now looked so very much like certain artwork documentation that was around in 1972 that, perhaps, this *was* its time. It was destined to emanate as art. The Blue Book of Negatives had chosen him – a readymade artist – for the task.[3]

He set up a small darkroom in order to make prints from the negatives. As he had to teach himself how to do this, and as he learned how to do it, he sensed himself as the young man – whose name he was never to know – who had first brought these images to life.[4]

He pressed on, sustained in the business of mechanical reproduction by Benjamin's master image of the angel of history, face turned toward the past,

---

yes, pathetic. (The task was to get a life and get that other stuff down into the footnotes.) Nevertheless, he could not help but think - that too was a problem - that the faux trauma underlying Burke's 'Sublime' [that could never be made distinct in visual art (it was that medium's idelible 'distinction' that foiled this possibility)] might find (lose?) a footing in Conceptual Art. He found this heartening.

3  He required a theoretical holding devise, not the one for the 'readymade' of course – that was exactly *not* the point – but the reverse, something else; something to do with 'art into readymade'. He was puzzled by how artwork degenerated into culture and then into nature (art's 'expiration' becoming its 'triumph')

   At the time he was thinking about an art movement to be called 'Maximalism' that would mirror this entropic dispersal. It would also be: democratic and as 'undetermined' as life itself, but ultimately futile, nevertheless, somehow sombre. It required working on – later.

4  This idea sustained for a while until it began to dawn on him that Borges had attended to this in his short story about the strange obsessive who rewrote Don Quixote. With that he began to feel somewhat eerie himself, part of a Borgesian conceit, one that perhaps the Argentinian never got to write – just sent a book of negatives in an old parcel of books for auction to Australia so that one day fate would determine a rendezvous so that 'Seconds' could start.

transfixed. He felt exhilarated in the wreckage, part of it; following a precise chain of events, not some generalised catastrophe. The storm was elsewhere as far as he was concerned as he coaxed the images from the magic elixir. He felt situated without being certain what time it was.[5]

The developing task demanded discipline,[6] but by following the young man's journey from 1 to Number 14 (the youth's first sight of the K school)[7] through his school days (Number 15 onwards to 106 when he went to the first World war via South Africa, Sierra Leone, then England and to Ireland, where he only stayed for seven photographs) he tracked him

Soon after the initial excitement of seeing how Number 28 developed 'Finish of Sack Race. Parramatta 1913' showing laughing boys stumbling over the finishing line, by the time he reached Number 163 'Fellows in Trenches. 1917' (more stumblings over the line) everything was becoming uniform. It was as if the images had congealed to cloud every episode in the same dark aspic of, literally, negative space.[8]

---

5 Vice versa was the case.

6 He resisted rushing to develop Number 206 'View from Killarney towards Dublin' although he had not seen Dublin for years.

7 The young boy had gone to T.K.S., 'The King's School'. (Only the colonised mind could be that abject with its appellations) And he had a camera and friends; Fatty Lampsplough (Number 13) and Piggy Grant. (Number 29) made up a merry cast of *Magnet* and *Gem* characters to sustain an Empire's fiction on the other side of the world. Notwithstanding Christian Brothers and their implacable loathing of all things British, had he not at times found in *The Champion* an affinity for Smith of the Lower Third ( that would be the C class) who lived the febrile and oppressed life of the lowly fag. Whatever it meant, if the point of the work was to connect and transmute, then he must cherish these linkages and not impede the clean trajectory of the other's narrative with his own reflex racism. (Some of his best friends were English.) He must remind himself too from Number 208 'Row of cottages, south end of prom, Kingston, Ireland,' renamed Dun Laoghaire (but pronounced Dunleery) that these things take time for the colonised mind to regulate.

8 Early into the second hundred he began to feel the tedium of the task. He was fearful that

En route to war he got Mauritius in three snaps (Number 121 to 123). Here the Dodo was extinguished by heavy blows. Nothing about this seemed to strike (Number 125) the 'Lads Sunbathing on deck A74'.

The casual racism of Number 133 and 144 was the prerequisite bulwark to deal with Number 140.

It was manifest from the second that caught Sandy Martin 'looking out the train window' (Number 153) until Number 286 (Ternnercliffe Montain on the way out) that every shadow on these negs had had a relatively good war. Millions had died, they didn't. The shots of trenches ( Number 163 to 168) that promised so much were situated quite safe in Essex. And the next image (Number 169) showed Dowling with some woman at Sea Camp! Brightling, Brighton, Weymouth, Kingston, Yarmouth. Here, positioned and poised for action, those photographed were forbidden to move.

---

this would lead him to reconsider his other neat idea for a new art movement, mostly textual, to be called 'Reasons for Not Doing the Work', but the push this would need by way of analysis, finding the incomprehensible jargon and the appropriate politics, not to mention the printing of the manifesto, convinced him he was better off doing what he was doing – mechanical reproduction. As for rationale, well, he always had Walter Benjamin in his back pocket – the Fontana papeback to be precise – but by now the art world had so thoroughly trashed Benjamin as index that his position might have to be that he was not any longer just reading about it – he was doing it.

He put together from the evidence of Number 243 'Ivy Hyner at Windsor (1/2 view)' that the following entries; 245, 249, 256, 267 and on, which mentioned Ivy in informal terms, had brought her back to Watson's Bay in Sydney in 1920 (Number 302) as his bride. [9]

Finally, he was setting up a home. Less time for photographs. He made his ultimate entries. Number 323 ' Self with Ghost' proved to be no more than a trick of the light, double exposure had merged two images. Number 324 showed him 'Self standing up at Westella, Cliff St.' until Number 325 produced ' Ivy and Lita standing, Westella'. A child ?

Forty more negatives 326 to 365 completed the book. These were both untitled and undated. They were, for the most part, photographs of domestic furniture. [10]

It was an impressive quantity of photographs. He stacked them, he fanned through them, he got them in sequence, referring always to the index for confirmation. [11]

Time past is an edit and so too is time future when working to a deadline. [12] There is a limit to how maximal one can get. He had to stop. His wife, Liz, had

---

9  An entry listing a Miss Ireland as part of the travelling party (Number 288 and passim) may strike a chord today but at that time, before television beauty contests, its puntime too had not yet come.

10 Beckett's view of marriage was that it was crucially about furniture.

11 Every time he rechecked he sensed the initial sensation receding. Not because he was losing interest, which he was – other people's snaps are seldom interesting to others – but he felt he had trespassed beyond a certain threshold of knowing, into something more like betrayal, pornography or simply bad manners.

12 He had agreed to show work at an upcoming exhibition and time was against him. He was still not clear as to how he might re present the book. He was further away from that originating moment of delight when he felt 'art imminent' in the book in his hands. How was he

bought Santa's Workshop fittings at a Grace Bros' auction. He choose a 6' diameter disc complete with protruding semi circular container from the props. Perfect. He would shed the past and get into time present, courtesy of Santa.

He found, immediately to hand – he simply could not make a mistake now[13] – a device used to preserve meat before the introduction of refrigerators; a wire meshed dome shaped hood to keep flies away. He fixed the book to the disc and

to represent that? Leave it as he found it? Leave it, just there, so that the spectator, through some form of aesthetic osmosis, could detect its essential 'quality'? Ummm.

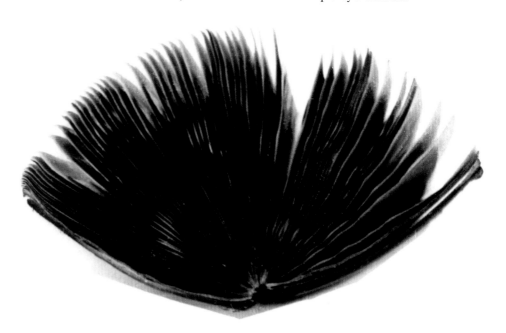

He had shown the book to various people, he let them handle it, ran a commentary on it, elevated it so they could see how like a bird it was. It was futile; they just did not believe it, or rather their responses; ' interesting', 'weird' or 'what else are you working on?' left him in no doubt but that he would have to (they had failed pitifully once more to give him any fair reason not to) do the work.

13 He had managed to reach that crucial pitch of anxiety where he believed there was no such thing as chance.

96

covered it with the device. He rolled up the photographs, numbered them and put them in the container below the meat preserver. He felt things coming together. [14]

He located the body of the book above the people in the photographs. 'The Orange Book '[15] he placed to the right-hand side and then above it, a space for

---

[14] The physical and spatial tension between the wafer thin negatives and their ontological transfer to corporeal prints simply required a bridging text to give the sense of shift; the gradual transfer of transitory states. He devised imperative notes of instruction to assist communication. A print might be exchanged for a comment, another image, money or some other token offering. He needed some kind of public ritual to commemorate what he believed had happened

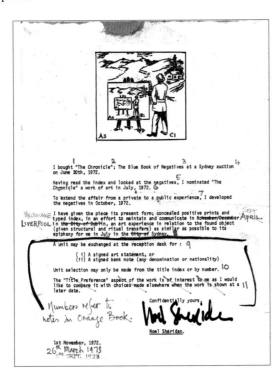

[15] He figured the work needed an alternative commentary. He wrote obscure de Selbyesque footnotes as the 'The Orange Book', per Flann O'Brien, to embellish the work. The main thing was to maintain the integrity and, at the same time, the nuclear mystery of the Blue

283. Uncle Henry, Harry, Uncle Jack, H'smith, Eng. 1920
284. Uncle Henry. Harry, Uncle Jack, Mr. Hyner, Nigger, H'smith 1920
285. Uncle Henry at Fulham, H'smith, Eng. 1920
286. Tennercliffe mountain on way out Sept. 1920
287. Santa Cruz, Tenneriffe, on way out Sept. 1920
288. Miss Bowers, Bailey, Chisholm, Miss Ireland, Ivy on Wahehe Sept. 1920
289. Bailey, Miss Ireland, self and Ivy on Wahebe Sept. 1920
290. Bailey, Chisholm, Miss Ireland and Ivy Sept. 1920
291. Lions Head, Capetown from Wahehe 1920
292. Table Mountain, Cape Town, from Wahehe 1920
293. Mr. and Mrs. Powell , Mr. and Mrs. Cox, Gladys, Molly, Mrs. Lennon, Wahehe 1920
294. Miss Bowers, Ivy, Miss Ireland, Chisholm, Phillips on Wahehe 1920
295. Mr. & Mrs. Powell, Mr. & Mrs. Cox, Gladys, Molly, Miss Lennon, Wahehe 1920
296. Miss Bowers, Miss Ireland, Mrs. Anderson, Fancy Dress Wahehe 1920
297. Westella, Cliff St. Watsons Bay. Jan. 1921
298. Dining Room, Westella, Watsons Bay Jan. 1921
299. Dining Room, Westella, Watsons Bay Jan. 1921
300. Dining Room, Westella, Watsons Bay Jan. 1921
301. Ivy in fawn shirt and Capetown hat, Westella, W'bay Jan. 1921
302. Ivy in white dress, front garden, Westella 1921
303 Ivy in fawn shirt and Sydney hat, Westella Jan. 1921
304. Cloudy on front steps, Westella Jan. 1921
305. Vaucluse from Watsons Bay. Mar. 1921
306. Parsley Bay from Central Wharf 1921
307. Neilson Park from ferry Mar. 1921
308. Manly boat from Watsons Bay ferry 1921
309. Lita Smith in front garden June 1921
310. West side garden at 'Mandalong' M'ville Nov. 1921
311. East side garden at 'Mandalong' M'ville Nov. 1921
312. Trees outside aviary at 'Mandalong' M'ville Nov. 1921

possible offerings. He began to consider what was taking shape. The book as bird hovered above other components in the entirety. The Blue Book *was* the entirety, so too was the *originator* of the likenesses (the image maker) while he, *the agency*, represenative of the initial utterance, was a third part.[16] This distribution of the body as the parts was not new. It was old. The past then as future mass recast. Altered.

*Oh Jesus.*

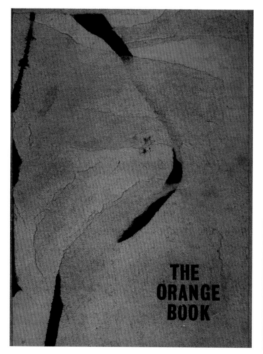

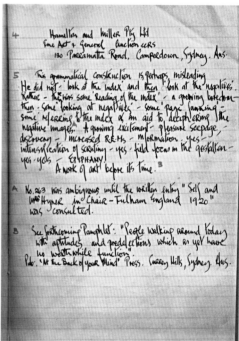

Book and, he reckoned, an unhinged heretical text would help. He would explain all this with another annotated commentary in a 'Green Book'.

16 .The index (*indicare* to disclose) was radical. Through this, one set of mysteries could displace the substance of another. He remembered words from his childhood: *The Union of Saints is the union that exists between the members of the True Church on earth with each other and with The Blessed in Heaven.* He thought of this as an elegant conceptual drawing traversing the Universe, but he could not fathom why they were coming to mind at this time.

98

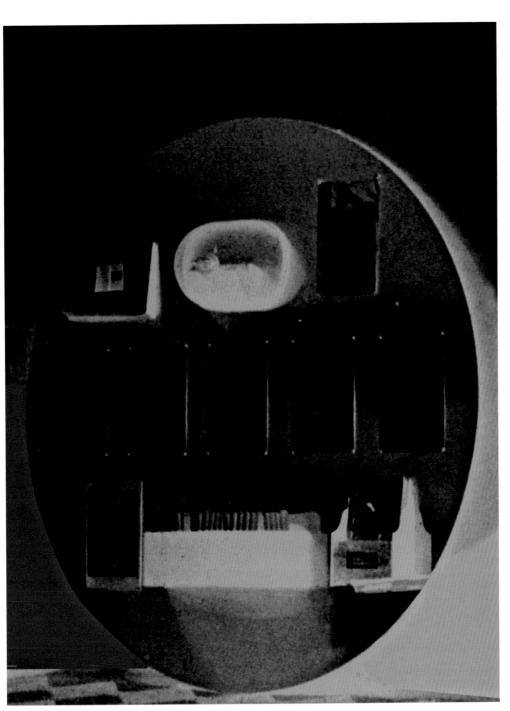

99

# Noel Sheridan and the Aesthetic of Exploratory Excess

I: It's Impossible

These days, when everything breaks down and comes together, we all find ourselves in a vast, tangled forest of signs. Criss-crossing paths multiply in all directions. In many ways, this eclectic and fragmentary zone itself defines our moment of contemporary experience.

As the evolving cultures of science and technology become available, the old modes of artmaking won't play so readily in the halls. The world set forth by the elderly beaux-arts traditions of foursquare paintings and bricks-and-mortar sculpture, looks like an ancient order governed by ancient laws.

There is a sense, via screen and wire, mousehand and click, that the entire world is now a space traversed by signals, more a climate of pure possibility than a geographical elsewhere, and that it envelops us wherever we are, whatever we are doing.

Today the aesthetic of choice, naturally enough, is the aesthetic of exploratory excess. It sets before the viewer a world featured as a swirl of competing energies and stimuli; it searches patterns, connections, instances of conceptual complexity. Back in the 1970s ideas in and around Conceptual art, Minimalism, Performance and Installation Art proposed ways out of the clenched formalism of Greenberg and his museumised followers. It shivered the timbers of the high art approach to culture, and in no time, the heritage of hands-on labour was replaced with abstract operations and procedures that would feed the giddy processes of a burgeoning world of pixellating codes and dancing green phosphors.

Talk about paradigm shift. Like algebra and calculus after centuries of counting eggs and measuring cloth. But from the 1970s to the 1990s, another sea-change. A greater tolerance for ramified expression, new subjects, new perspectives. A perceptible pressure to open out, annex, pull some of that overwhelming ambient complexity into the circuitry of innovative art. From a Minimalist style of restraint and cauterised affect to a Maximalist approach opening the gates to the

myriad ideas and neural discharge of prodigal creation. The dense fabric of contemporary life – its changed ways of doing things and interacting – cries out for this new expressive plenitude.

Ever the stylist of surplus, Noel Sheridan's work entered this process-worshipping Zeitgeist, with its own effervescence, its distinct accent and ethics-cum-aesthetics. Notably, there's an inborn affinity to the Fluxus movement (1962-1988) via Dublin vaudeville (his father Cecil was an old trouper). Behind the various pieces and projects of his oeuvre, Sheridan appears to be doing juggling acts with intersubjective conflicts at the speed of the nervous system. His logic is always ebullient, productive, dynamic, burgeoning.

Despite all manner of irreverent liveliness – those Zen cream pies – there's some serious conjecture going on: how does art really matter? Over the decades he's done an Irish jig with the radical partnerships of postwar thought: Apollo and Dionysius (Nietszche), Being and Nothingness (Sartre), the Raw and the Cooked (Claude Levi-Strauss), Words and Things (Foucault), Capitalism and Schizophrenia (Deleuze & Guattari), New Jerusalem and Disneyland (Baudrillard).

However Sheridan's speciality has always been at the interface of language and events (Ludwig Wittgenstein). In dealing with the problems of philosophy, Wittgenstein confronted the logic of language: whereof one cannot speak thereof one must be silent. The *Tractatus* drew a limit to thinking, or rather to the expression of thoughts. It's Impossible!

'For in order to draw the limit of thinking we should have been able to think both sides of the limit (we should therefore have been able to think what cannot be thought). The limit can, therefore, only be drawn in language and what lies on the other side of the limit will simply be nonsense.'

The solution, according to Francis Huxley in his book on Lewis Carroll, *The Raven and the Writing-desk*, is to capitalise nonsense. Nonsense (capital N) allows us to do what Wittgenstein thought impossible, namely to think both sides of the limit. The things in Nonsense that cannot be thought do not lie on the other side of the limit, they lie on it.

Charles Dodgson (another Ludwig) also confronted the problem: 'When we come to the limit, what then? What do we come to? There must be Something or Nothing … that there should be neither is absurd.' The boundary between commonsense and nonsense cannot be apprehended in itself, but can be marked by a *surd*.

A lot of Noel Sheridan's endlessly ramifying art underlines the ontological discrepancy between the deferential structurings of language and the unstoppable dynamics of becoming-unto-death that make determinations of truth and beauty impossible to verify in any absolute sense (even though we make them all the time).

The medium of *It's Impossible* is mixed media installation for nine slide projectors. Ideas in and around installation have corroborated with the robust anti-aesthetic stance of a lot of poststructuralist writing. Objects or signs are not native solipsists – as the conservative art critical fraternity here in Australia, in the US and Britain, have been bidding us to imagine. Works of this nature hunger for participation in innumerable orders of relevance that locate and shape the life history of the work. Photography, video, performance, sculpture – all the mediums of installation – shed their autonomy. The object itself is not the work but the system of relationships that have been set up. These may be informed by range of disciplines – Information Systems, archaeology, astronomy, ecology, philosophy. Disciplines that left to themselves fall silent on matters unprovable. Installation reflects a polyculture, rather than a monoculture.

Noel Sheridan's *It's Impossible* is a virtual world. Its elements are concrete assemblages, like the configurations of a machine. It's conceptual art as event.

*It's Impossible* comes across as a sort of spiritual quest where the aim is to get Unity to lay down with Multiplicity. There's a Zen-like tension happening here like that 'law of reversed effort' that has come to us from Lao-tzu via Alan Watts. 'When you try to stay on the surface of the water, you sink; but when you try to sink, you float. When you hold your breath you lose it – which immediately calls to mind an ancient and neglected saying. 'Whosoever would save his soul shall lose it.'

The result is a composed chaos (Joyce's 'chaosmos') of art, where thought and perception are recognised as an emergent, collective and bifurcating becoming. Through the co-existent fragments from *Lust for Life*, a Perry Como lyric (*It's Immmmmmm-impossible*: peak Billboard position #10 in 1970), electric phase transformers and the Liverpool Football Club Chant 'You'll Never Walk Alone', Sheridan pits the chthonic spirits of sport with the skygods of art, John Logie Baird is crossed with Jorge Luis Borges. It's a *Walpurgisnacht* played backwards, to break, not to cast an evil spell.

Through the progressive encompassment of these worldly apparitions, through this play of cognate images, an experience exfoliates. Between the desire to estab-

lish an intense solidarity with the imaginative matrix of community, and a desire to overcome desire, to ascend towards virtual light, the artist uncovers a submerged floormap of the impossible. But it's a fractal fold, not a Cartesian split or an AI feedback loop either. It is evoked in the mandalic shapes of the vector diagrams that connect mass and velocity.

The dynamic tensions of this Snakes and Ladders game gives a clue to how Sheridan engages with the polymorphous shapes of experience today, the density of its data, and the absence of traditional clues. Wembley stadium crowds embody immanence, the spiritual intensity of multiplicity in unity.

Out of transcendence/immanence, high/low, serious/jokey, evolution and eternal return, soul and body, *It's Impossible* concocts a horizontal zone of becoming. Unlike fixed forms the dynamic relationships are self-emergent properties. Nature speaks again in a thousand networked tongues.

Indeed this dimensional play is primordial and shows up everywhere in physics: James Clark Maxwell described the relation of magnetism and electricity as 'transverse'. Quadripolarity has long been a familiar concept of electrical engineering. Our number systems expand the way the cosmos does, with paradoxical events befuddling the hung-up linear schemes of systematic gamblers. Multipolarity is now a familiar concept in international relations.

Pushed to the limit of the representable (Wittgenstein/Van Gogh/Kirk) Sheridan evokes a genuine performance of the object/phantasm, out of place, a mere floating effect of all the questions asked and answered, a true utopia: going nowhere, the place of happiness.

Operatic, poignant, playful, funny, *It's Impossible* also helps us (me) think on this complex topic of audience. As the ground of consensus breaks up around us - 'Man petrifies and darkens in the distances he has created' (Elias Cannetti) – we ponder the meaning of connection.

Is it a power whose strength is merely in numbers? (Nietzsche), or it is modulated through the Arts & Leisure pages with culture for sale? Or it is a by-product of a random access society? Or a lost cause?

According to Herbert Blau, what Aristotle spoke of as the spectacle was already, in archaic times, not so much the affirmation of community but – in a drama already predisposed to fracture – the mark of separation, born of the loss of unity. Today there is still that dividend of alienation.

'You'll never walk alone'. … Away crowds prepared for reverence or shattering loss? The Home Crowd identifying with the George Best goal … Walk alone … alone …

Art and community. That old fantasy. That old nostalgia. The artist's dream. The politico's nostalgia. Solidarity. We are haunted by it and it always eludes us. *It's Impossible* sees audience as a function of how we think about ourselves, our social institution: between the culinary ones of the gallery and the cannibalistic one of Wembley.

Community: that fragile and unsteady thing that emerges from my exclusion to it, from my being a foreigner in it. The audience that doesn't exist before the drama or play or game but is *initiated* by it …

## II. Seconds

*Seconds* is a sort of backwards Readymade and also a form of Detective Metafiction that reworks its conventions as a structuring model of the Conceptual process. It is furthermore a fractured allegory of the transformative powers of art. It recalls both Stephen Dedalus' eucharistic metaphors ('transmuting the daily bread of experience into the radiant body of everlasting life') and Andy Warhol (signing a real Campbell soup tin in the supermarket and selling it for a terrific mark up). Sheridan situates the compromised redemptions of contemporary practice between artist-priest and artist-counterfeiter; and *Seconds* enacts a second go at second-hand borrowings.

The artifact arrives, fatefully, like a message in a bottle. Writing in the third person, Sheridan thematises the role of the author and stages the ontological status of the readymade in its capacity to both produce and destroy artifice. The footnotes behave as a kind of hermeneutic act of reading, and as the artist tries to fill in the gaps, underscores the fretting and anxious humour that is part and parcel of Sheridan's style.

Sheridan starts by trying to salvage the instants of a lifetime, to overcome the death implied in the separation between the dates – or snapshots – by assembling these privileged moments simultaneously.

The artwork is in the act of alchemizing these textual and photographic fragments into some kind of narrative. (The Blue Book.) Sheridan – and we as readers – constructs the subject's life in our imagination, and become intrigued (or not) with the possibilities. The referents in this found material are real enough,

but in the context of a Conceptual makeover, they become fictive, the fuel for transformative flight. (The Orange Book.)

The artist-priest has lost sacramental potency, and to be sure, behind the art game there is nothing like a game of cards in which each card has no meaning in itself. However, when the player organizes his cards into a 'hand' then, within the context of the games rules, they take on significance. Though art is sentenced to a stiff rope and short-jump aesthetic throughout the 20th century, it shows an extraordinary will to live. Duchamp, Warhol, Buren – they seem to be willfully turning art into a finite game, played for the purpose of winning or losing, but in fact are exploring art as an infinite game, for the purpose of continuing the game.

*Seconds* performs a secular consecration. The humble portfolio of pictures installed inside the meat preserver becomes a parodic allegory of the Christian Mass. In vernacular imagery Sheridan conjures Benjamin's Angel and the Paraclete.

**'The book as bird hovered above other components in the entirety. The Blue Book was the entirety, so too was the originator of the likenesses (the image maker) while he, the agency, representative of the initial utterance, was a third part. This distribution of the body as the parts was not new. It was old. The past then as future mass recast. Altered.'**

*Altared. Altered.* In the beginning was the word, and from being an object the 'Sundry Books in a Brown Paper Parcel' becomes an utterance. This is the final straining attempt to overcome the paradox of representation and make the Thing identical, beyond any possibility of separation, with its material vehicle.

*This is my body*, or rather, 'this is an especially intricate simultaneous perception: asking for transcendence, asking why transcendence cannot be.' A discovery like that should kill you, but it doesn't.

*Seconds* is a self-reflective paradigm of all art making. It turns the secondary project of reading, into the primary one of production, of imagining, in short of constructing an aesthetic universe through the detritus of the past.

*George Alexander*

| Title | Not Waiting | Writer | Noel Sheridan Sydney 1/4/74 |
|---|---|---|---|
| Medium | Video | | |
| Actors | Noel Sheridan | | |
| | Guy Warren | | |
| | Tim Burns | | |
| Camera | Mitch Johnson | | |

| VIDEO | AUDIO | |
|---|---|---|
| BLANK SCREEN, EXCEPT FOR BAR STOOL IN SILHOUETTE, SEEN BETWEEN THE SHOULDERS OF TWO SEATED VIEWERS: N AND G. (10 SECONDS) | | |
| SLIDE READING 'NOT WAITING' IS BACK PROJECTED ON SCREEN SO THAT BOTH VIEWERS ARE SEEN TO SEE IT (20 SECONDS) | G. THIS IS A VIDEO RECORDING OF A WORK THAT IS NOW TAKING PLACE IN THE SET-TING OF A WORK THAT WAS PERFORMED SOME TIME AGO | |
| SLIDE CHANGES TO 'CONTEXT' TEXT. (7 SECONDS) | N. THIS WORK REQUIRES THAT IT BE PERFORMED IN SOME OTHER CONTEXT. SINCE HOW-EVER ANY OTHER CONTEXT | |
| DOMESTIC SCENE WITH KIDS (3 SECONDS) | N: ONCE IT IS CHOSEN BECOMES THE CORRECT CONTEXT FOR THE WORK, THE CONTEXTUAL REQUIREMENTS FOR THIS WORK CANNOT BE MET | |
| REVERT TO 'CONTEXT' SLIDE (4 SECONDS) | N: NOT EVEN CONCEPTUALLY | |
| N AND G WATCH AS TIM ENTERS BEHIND SCREEN, AS SHADOW, AND SITS ON STOOL. (4 SECONDS) | | |

| | | |
|---|---|---|
| TIM SITTING STILL<br>(9 SECONDS) | | |
| SLIDE CHANGES TO FRAME TIM<br>IN AN ART GALLERY SETTING.<br>(5 SECONDS) | N. THIS MAN IS WAITING IN AN<br>ART CONTEXT TO PERFORM<br>'WAITING' | |
| N RAISES HIS HAND<br>(4 SECONDS) | N: WAIT | |
| N AND G LOOK AT TIM<br>(3 SECONDS) | G: IS HE REALLY WAITING? | |
| N RAISES HIS HAND<br>(4 SECONDS) | N: WAIT | |
| N TURNS TO G<br>(2 SECONDS) | N: NO... HE WAS PERFORMING<br>'WAITING' | |
| N AND G LOOK AT TIM<br>(9 SECONDS) | | |

| | | |
|---|---|---|
| G TURNS TO N<br>(2 SECONDS) | G: I CAN'T TELL THE<br>DIFFERENCE. | |
| N TURNS TO G<br>(2 SECONDS) | N: WAIT | |
| N RAISES HIS HAND<br>(3 SECONDS) | N: WAIT | |
| G TURNS TO N WHO LOWERS<br>HAND<br>(3 SECONDS) | G: HE BEGAN WAITING WHEN<br>YOU SAID 'WAIT'. IS THAT<br>RIGHT? | |
| N RAISES HAND<br>(7 SECONDS) | N: WAIT | |
| N TURNS TO G LOWERS HAND<br>(3 SECONDS) | N: THAT'S WHAT I MEAN | |
| N AND G WATCH TIM<br>(10 SECONDS) | G: HE WAS REALLY WAITING<br>THEN? | |

| | | |
|---|---|---|
| N RAISES HAND.<br>(3 SECONDS) | N: WAIT | |
| N TURNS TO G<br>(2 SECONDS) | N: WHEN? | |
| G TURNS TO N<br>(5 SECONDS) | G: WELL.... NOW | |
| N RAISES HAND<br>(4 SECONDS) | N: WAIT | |
| THE SCENE STARTS AGAIN FROM THE BEGINNING. THIS TIME IT TAKES TWICE THE TIME | DIALOGUE AS ABOVE TWO TIMES SLOWER | |
| THE SCENE STARTS AGAIN FROM THE BEGINNING. THIS TIME IT TAKES THREE TIMES THE TIME. | DIALOGUE AS ABOVE THREE TIMES SLOWER | |
| SLIDE 'ONE HOUR LATER' IS PROJECTED ON SCREEN. | | |

WHEN SPECTATORS LEAVE THE SPACE THE WORK IS
PERFORMED WHEN AND AS OFTEN AS THERE ARE
SPECTATORS NOT WAITING.

# Keep this bastard moving

Melbourne 1976

IT IS difficult for us whose lives are deep rooted in a sedentary habit to realise that their normal state is an ambulant one. From the settlers point of view it is a valuable trait, as there is never any difficulty in obtaining messengers for even the longest journeys. Not only do they enjoy the constant change of scene but they are flattered by the deference shown to envoys and take a pride in 'getting through'. In the bad old days of early settlement undesirable 'bucks' were got rid of by giving them message sticks to deliver to distant neighbours. The message would read 'Keep this Bastard Moving' and he would immediately be sent on to the next man. And so on, until after months of travelling he would find himself stranded, perhaps in a hostile country, hundreds of miles from his own territory.

*The Red Centre* by H.H. Findlayson
Curator of Mammals at the South Australian Museum 1939

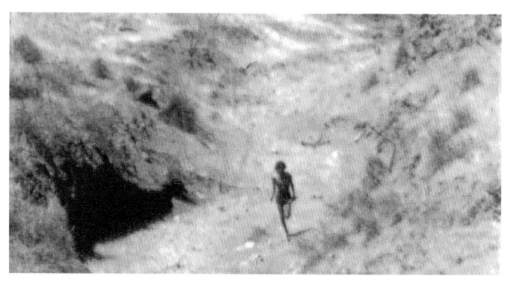

When a dog barks late at night and then retires again to bed he punctuates and gives majesty to the serial enigma of the dark, laying it more evenly and heavily upon the fabric of the mind.

Flann O'Brien

# Sydney letter Early 70s

FIND myself often wondering how you are going and sometimes I see Mark out around town. I apologize that this reply is coming so late but I've been out of the country and it is only now that I'm back and winding down.

I certainly remember the shadow play, Penumbra that you did at Central Street; the sense of memory inflecting the present and the violent, endistancing effect of the IRA and you emerging dishevelled from behind the screen, I can remember that it made a big impression on me and I still remember that effect, but I am not all that confident about my ability to recall detail. After Christmas, in the humidity, I'll begin looking in some of my boxes. The tropicality of Sydney in those first months of the new year should breed something. I can remember that in 1978 I solicited record material from you about Penumbra because I wanted to publish some photographs and I think a short text by you, which if I recall right, mentioned the Beckettian impotence and his unstaunchable capacity to extend and elaborate it. I think it was a paradox that particularly entertained you and I can remember being stimulated by your circumlocutions and it is this small text that I hope to find, I can also remember Bruce Gould and 'natural elegance' and your small Toyota or Mazda which you drove into a pole or some such in the frenzy to haul all the gear into Central Street on time. I can remember you continuing to drive this car and me sitting nervous in the front because the seat belt was stuck or didn't reach across, We were in Cleveland Street and you kept swerving to miss pedestrians. I can also remember the car with the tiny steering wheel which may have been preowned or stolen by hoods from Blacktown or Rooty Hill, which you packed for Adelaide but it blew up I think in the Riverina. For some extraordinary reason then I have vivid memories of your cars.

I also remember our gigs out at the Tin Sheds in 1973. I don't really remember the lecture slides going out of sequence and you and I arguing back to the students that such inadvertence, such Chinese taxonomy, might be an example of 'Post Object Art' but on the other hand in those days we were quick to turn the situation to advantage and extended metaphors were everywhere, extended by us.

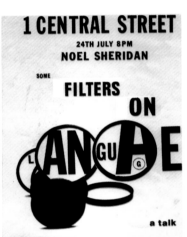

It is wonderful that the same kinds of knobs and handles also stick in your mind because 'the slides out of sequence as an example of Post Object Art' are coming back now I think and 'Bus Theatre' and 'only one of us is Lazlo Toth'. I'm sure you were part of that invasion of the American provided exhibition of Modem Art at the Art Gallery of NSW and the idea that poor Lazlo, like a sore intellectual plague might move his hammer from Michaelangelo to Rothko. The 'slides going out of sequence' and our adroitness must be an avatar of this sort of thing. It was of course as we sat up in our shop in Australia Street, Ted Colless and lan Robertson and Mitch who went early and you [because by this stage we'd all been overtaken by Donald's maxim, 'that to change the nature of art one must first change it's institutions'... Tim blew up a shed in Mildura as a preliminary example and remembering all this stuff it was interesting to stand in the Tate Modern the other day and see all that carefully catalogued and installed stuff by YBA's with hyphenated names and meaningful social connections getting it right ... proper really. Anyway.]

And I think you came into Inhibodress in the dying months of 1972 and yes you did because I can remember you putting down a silver fish or small cockroach attached to bluetack that I was looking at in an odd way and being shamed for ever by my detached cruelty which wasn't except my oddness of being hooked on noticing things and treating them as unimaginable, wary to be approached via wide digression and inquisitiveness, but it threw my indifference into a terrible stark relief and I was appalled at my separation from the things in the world and this may well have begun those deeper strains in my thought that took me beyond the ineffable detachments of sculpture as art into life, to a violent inquisitional of life in art and what is generated in the blue tacks of the iron maiden.

And I'll never forget your Catholic help in 1973 when I came back from Europe after wandering for nine months and pregnant with the despair of distance I got you to proffer your help to re-open old wounds, do some branding with the branding iron etceteras and your dedicated refined savagery with dirt under the finger nails and the close-up of your moustache dripping with blood and cotton as the wound was sutured. All this distempered, fugal complexity was the collectivization of Post Object then and I remember your immersion in all of it, but mostly I remember your intelligent post objectivity and I think that your Joyce/Beckett axis helped bring the miasmas of all this unmanageably deep interconnectivity to the refractive surface of language, metaphor and reference, so a lot was saved for thought and extended discussion that might have been churned into oblivion. I do remember the CAS broadsheet and your editing of it and when I start looking in the boxes I'll find copies. I particularly remember a cover you did with a Magritte like picture of a man wearing a Homburg or was it a slouch hat, painting a landscape in a landscape in a kind of endless mirror regression into the vanishing point. I remember the Chinese boxes of ramified frames within frames and alphabetic letters dispersed to mark orthogonals and such like and the sobriety of a residual academic illustration [more examples of the fertility of slides going out of sequence]. Of course none of this may be accurate pouring as it does out of the head on the spur of the moment before breakfast, but the salience of those years is intact and the beautiful magnitude of Noel in Sydney.

It's a start my old friend. Have a splendid holiday.

*Mike Parr*

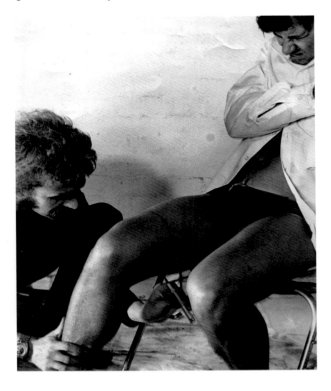

Mike Parr
Reopening Old Wounds

# On first looking into George Brecht's Water Yam Box

I got my copy of George Brecht's Water Yam Box from Kasper Koenig's extraordinary bookshop in Cologne on a trip I made with Liz to get art documentation for the Information Centre we planned to set up for the EAF in Adelaide in 1975. Liz had met Kasper Koenig on a previous visit when, with our three children in tow and Barbara Kirkman and her daughter Nova, she visited every alternative art centre in Europe to get information. She brought back seven shopping carts full of wonderful material (don't ask how, but perfect strangers, her fellow passengers, delivered these carts to me explaining 'that lady', pointing to Liz who smiled them forward, 'told us to do this.') and through her description of me to Koenig (!) I got to his top floor.

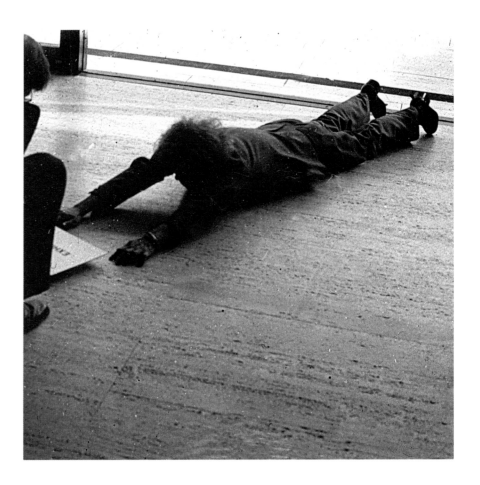

The shop had maybe four floors, and the higher he invited you to go the more amazing the material. My passport was three issues of a magazine I edited on Australian contemporary art which he fanned through, stopping occasionally to ask a question and then 'come vit me'.

He had all the Fluxus works, the artists books, Cage's vinyl 45s, Ashley, Yoko Ono's boxes, Ed Ruscha's casual little masterpieces Klaus Staeck's hard 'Pornographie' Brakewell books, Sherman texts and O'Doherty's box full of brilliance, Wolfe Vostell and Baldessari and on and on. My money didn't reach to cover the very limited editions (3!) but he did a most generous deal with me that packed in a lot of what everybody needed to know about art at that time.

Do I regret leaving this material around in open boxes when I returned to Adelaide so that some people thought *Oh these must be the brochures: I'll take one?* Yes I do, but at the time such thoughts of art as 'precious' or to be 'secured' seemed, this is hard to explain, but, 'inappropriate'. To see them later, indexed and curated and with Liz's notes and numbering system and handled now with those white cotton gloves in an exhibition at the Power Institute was, well, salutary.

I sometimes sat in the Information Centre pondering the cliché if there was to be a fire, what one thing would you save? Water Yam Box was always on the short list and so I was pleased when Nick Waterlow asked me to animate something from the box at the fine Biennale he curated for Sydney in 1977.

I sent a video tape of my take to Brecht in Cologne but, word had it, that he was now into growing crystals and had left the scene.

# An artist's contract with experimental art in Australia Sydney/Adelaide 1971–1980

*To date, art's freedom lies, almost exclusively, in its ability to freely examine itself. This precise and closed activity is underpinned by a more general and open-ended desire to be free. Between the generality of the one and the precision of the other lies the deadline which separates art from life. This tacit desideratum lies at the heart of the unwritten contract artists make with their art.*

*Writing, rewriting, examining and re-examining the nature of this contract might be seen as a metaphor for much recent art – a working out of the difference between 'I make art' and 'art makes me'. From shaping the canvas to working out the gap between the art/life division, moving from the canvas as arena to the world at large, artists place themselves and their art within the terms of an art contract.*
(Noel Sheridan, Experimental Art Foundation, Adelaide, 1976)[1]

As a variety of alternative, 'Antipodean' artspaces and projects developed during the 1970s, Noel Sheridan's name became consonant across the Pacific with new trajectories in the visual arts; a quickening, broadening and detonating of new ideas, concepts, experiences across the whole territory of contemporary art in Australia

He moved to Sydney in 1971, staying first with Brett Whiteley, whom he had met through the Biennale des Jeunes in Paris in 1961 where each had represented their country. That year Noel had taken up company in London with a group of Australian artists, living there for some time. He was attracted by the Australians' gregarious energy and irreverence in the home of all things British.

However, the decisions that brought Noel Sheridan from New York to Sydney were, as so often in his life, circumstantial and impulsive. Speculatively setting his course towards New Ireland, a

linguistic-geographic challenge rather than realistic cross-cultural life-plan, he was deflected and ended up in Sydney. The Sheridans stayed initially with Brett and Wendy Whiteley but despite their lively interaction as young painters in 1961, a decade later their artistic trajectories had radically diverged.

In New York, Noel Sheridan had become deeply absorbed by rising critiques not only of painting's current scope and concerns, but also of the legitimacy of art's encompassing institutional operations; the speciousness of art's claims to subjectivity alongside moral authority and verifiable expertise.

As art's grip on its own legitimacy as a formal system faltered seriously in this period, the whole social terrain was assailed by the combustion of world political and economic events. The attending uproar and temporary closure of the *Biennale of Venice* in 1968 was but one arena of public confrontation during the widespread student uprisings of that year, with their fulcrum in events of 'May 68' in Paris. The 'moment of 68' in wider consciousness had proved that there now existed a mobilised, politicised and articulate trans-national community of young artists and social activists, dedicated not just to repairing social institutions and structures, but transforming or overthrowing them.

Following years of agitation and conflict around the West's involvement and responsibilities in the war in Vietnam, and the undercurrent of nuclear catastrophe configuring the whole structure of Cold War politics, the prosperity of the 1960s gave way to economic recession in the 1970s, deepening rifts across the whole of contemporary society.

Meanwhile the pressures to show emerging work by young artists had intensified and outstripped the resources of existing art institutions to accommodate a rapidly changing situation. These pressures were crucially not merely ones of volume, but also of altered aspirations and ideology. Some, deciding that art could not change

until society changed, committed their energies to directly politicised work and abandoned art making, temporarily or permanently. Others sought to facilitate new forms of art in informal kinds of (non-art) places, breaking beyond the institutional and commercial frames altogether.

Lucy Lippard described the situation at this time in an interview with Ursula Meyer in 1969:
*…in New York, the present gallery-money-power structure is so strong that it's going to be very difficult to find a viable alternative to it. The artists who are trying to do non-object art are introducing a drastic solution to the problem of artists being bought and sold so easily, along with their art… One of the important things about the new dematerialized art is that it provides a way of getting the power structure out of New York and spreading it around to wherever an artist feels like being at the time. Much art is transported by the artist, or in the artist himself, rather than by watered-down, belated circulating exhibitions or by existing information networks such as mail, books, telex, video, radio, etc. The artist is travelling a lot more, not to sightsee, but to get his work out…when the artists travel, whether they're liked or disliked, people are exposed directly to the art and to the ideas behind it in a more realistic, informal situation.*[2]

When Noel Sheridan arrived in Sydney in 1971, some artists were already in touch with leading figures shaping new work in New York, London, and various centres across Europe. The tensions between static, object-centred art and more mobile, live, and artist-centred forms had already widened in Australia into some real ruptures.

Certain artists began to seek their own places and situations for art activities, and the first of the clearly definable 'alternative', artist-run spaces appeared. Mike Parr's and Peter Kennedy's Inhibodress gallery opened late in 1970 (in a disused

---

1. Noel Sheridan (1976), written statement when Director, Experimental Art Foundation, Adelaide.

2 Quoted in Preface to Lucy Lippard's, *Six Years: The Dematerialization of the Art Object*, London, Studio Vista, 1973, p.8.

former clothing factory in Sydney) and operated for almost two years at these premises. Kennedy and Parr showed their own and other programmatically investigative, experimental works, and were avidly in touch by mail with like-minded groups elsewhere. Meanwhile Donald Brook's activities as critic, university teacher, and *animateur* of new theoretical work were also greatly influential in the early seventies in the young Power Institute of Fine Arts at the University of Sydney, launched in 1968.

A strong cross-over was occurring at this time in Sydney, as in some more 'metropolitan' centres abroad, between conceptualism's critique of the idea of art, and Marxism's unpacking of art's social settings and responsibilities. However Sydney was becoming aware of the contradictions of being a 'metropolitan centre' within Australia, but a 'provincial centre' to the world beyond its shores – as distinct from the metropoles of London and New York.

After several years in Sydney, Noel Sheridan took the decision to relocate, following the similar move of Donald Brook (theoretician of 'post-object art' as a local redefinition of conceptual work), to Adelaide where The Experimental Art Foundation was inaugurated late in 1974. Its crucial inaugural funding came from the Australia Council. The EAF, as it became known, represented an adventurous enterprise in Australia to combine theoretical modelling of art's parameters with a steady program of visiting artists, critics, provocateurs, and local production of new works.

Noel Sheridan was founding Director of the Experimental Art Foundation from 1974 until 1980, when he left to return to Ireland, to head the National College of Art and Design in Dublin. In Australia, he was pivotally associated with experimentation, local support systems for artists, international networking and mobility of exchanges. He pursued a vibrant commitment to new horizons and continual risk, underpinned by generosity towards collisions, crashes, even spectacular failures.

Artists came from interstate. Many visited from other parts of the world (often entering from the East Coast, through the Biennales of Sydney and other programs supported by the Australia Council). They came to Adelaide and were woven into the EAF program. There were critics and curators – Pierre Restany, Tommaso Trini and Germano Celant spring to mind – encountering the vast spaces of the Australian interior for the first time by crossing south-west to Adelaide.

The sense of a culture of delayed effect and obfuscated connections that had dogged the programs of public institutions for so long in Australia was suddenly transformed. The tantalising new possibility emerged that instead of waiting for exhibitions, it was possible to have artists themselves, even making works on site and conveying the nuance and particularity of new forms in the making. Instead of waiting for books or magazines to arrive, it was possible to have critics and curators themselves come.

Many artists who came provided important models of sustained engagement with kinds of work that stretched far beyond the realms of painting. Daniel Spoerri, Nikolaus Lang, Stuart Brisley, Marina Abramovic and Ulay were among those who made a vivid impact through their visits.

Daniel Spoerri, N.S. and Nicholas Lang. Flinders ranges. Collecting steer carcass for Spoerri installation.

Noel Sheridan was one of the earliest to became interested in the possibilities of opening up to further change. An artistic proposal he put forward for the Biennale of Sydney for 1982 was characteristically pitched: 'The Biennale of Sydney must go to the deserts of central Australia!' It was a magical naming of a journey that was totally impossible to embark upon at that moment; however, Noel's intimation of the potential for a huge cross-cultural shift within Australia, one that would eventually impact on the whole of contemporary art was correct. It would just take many years of particular efforts and local engagements until a large, detailed and living map was created, cross-threaded with interpersonal contacts and numerous smaller projects. This process would finally surmount two centuries of dislocation and bring Indigenous and European art traditions in Australia into vivid mutual confrontation and engagement, as occurs constantly today. Noel's vision could only be realised slowly and incrementally, through myriad modest steps and smaller forms – but eventually activating an enormous release of fresh creative energies across the country.

Though he excluded the presentation of his own work on principle while Director of the Experimental Art Foundation, Noel Sheridan's sensibility as an artist was ever present. It was vital to the scope of the EAF, its contacts, range of interests and diffuse programming, as well as its particular, nurturing atmosphere. He occasionally managed to accomplish some works of his own in other places: for example, the state Art Gallery of South Australia, shortly after he arrived in Adelaide; and the state Art Gallery of New South Wales, site of a survey of EAF work – and the occasion of a commissioned performance by Noel Sheridan himself in 1977.

Conceptualism in an Australian context involved radical historical reappraisal, authorising a critical dissection of all elements within a local culture that bolstered a conservative vision of art as merely reflecting, representing or picturing the world. Conceptual ideas – often shakily distinguished from or merged with minimalist tendencies – nevertheless provided a productive structure for a critically distancing, analytical and reflexive art practice in the 1970s.

The shift in emphasis from objects to containers, or from things to context, extended more comprehensively to include the containers of art in spaces (the whole exhibition apparatus through which a work might be defined or located). This led to addressing the social containers in which culture itself was 'produced' and mediated. Thus the art *museum* – and its opposite, the *alternative artist-run space* – came to be focal structures for analytical attention.

The new spaces were spawned simultaneously in various parts of the world, with contact circulating across them all: in Europe; in North America (called 'parallel galleries' in Canada); in Argentina (the activities of CAYC in Buenos Aires); in the

Netherlands (De Appel in Amsterdam); in Germany, Britain, Italy, as well as in Australia. Widely differing in particular circumstances, but almost universally characterised by their being artist-activated and experimentally wired to new intellectual horizons for art's growth, these new spaces fundamentally contested any status quo.

These spaces created networks across political no-go zones, between artists and groups across the Eastern and Western borders of Europe, promoting .exchange between artistic communities bridling against the paranoia and trench-lines of the Cold War. The new spaces and enabling networks challenged art museums and public galleries not only in the vast quantity of work they showed but also in their sponsorship of forms of work that could not be realised in traditional sites for art.

Many of the alternative spaces nourished a move towards revitalised *regionalism* in the arts. This was especially pertinent in places – even whole countries – that found almost their entire cultural life shaped by a 'regionalist' or peripheral position in relation to monolithic centres and repositories of 'international' culture elsewhere.

Preoccupation with the social, theoretical and contextual production of art in the 1970s prepared the way for the 'semiotic turn' of the 1980s, when art's linguistic basis – as a series of projective, discursive systems of expression and interpretation – became a predominant orientation of much new work for the last two decades of the century.

When Noel Sheridan left to return to Ireland in 1980, he had participated in shaping new directions for art in Australia that changed its entire subsequent history. The alternative art spaces were responsible for producing bodies of work and collectivities of art production that marked, first, the most comprehensive and radical affirmation of new identities in Australian art history since British colonial beginnings; and second, the emergence of some of the most important of mature Australian artists practising today. The new art spaces altered the sense of mediation between artist and audience. They represented a changed notion of responsibility on the part of artists for the development and presentation of their own and others' work.

Noel Sheridan's position at the EAF made him an activator in the opening of these new territories and the formation of new bodies of work that have changed how we view late-twentieth century art history in Australia. Configuring this history was an increasingly diverse and recurrent exchange with many more parts of the world than was possible previously. In pursuing these possibilities, Australia developed a magnified self-consciousness, both regionally and locally, while at the same time engaging with the world of contemporary art at large. This was reflective both of Noel Sheridan's personal 'contract' with art and of his ongoing contribution to a country that has in various ways indelibly shaped his life and consciousness.

*Bernice Murphy*

1. Noel Sheridan (1976), written statement when Director, Experimental Art Foundation, Adelaide.

2 Quoted in Preface to Lucy Lippard's, *Six Years: The Dematerialization of the Art Object*, London, Studio Vista, 1973, p.8.

# The Real London 1978

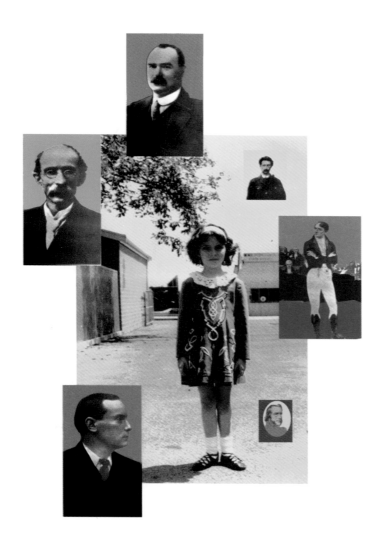

*Keep the backs straight. Don't jump — leap. Batter. Batter. Eyes straight ahead.*
*Straight.*
*Leap. Leap. That's right. Batter. Batter. Glide. Glide. Turn now. Turn now. Concen-*
*trate. Step. Now glide. No falling. Heads erect. Backs straight.*

The voice of the dancing teacher sang out as the children made the steps and
movements of the Irish dances. Why he had thought his daughter needed to

119

know anything about this was as unclear to him as to why he was searching out Dineen and other Irish dictionaries in second-hand bookshops in Adelaide in 1978. This was everything he wanted to be out of, but for a time now everything had washed back and he was trying to sort sense of it. His daughter could not find Ireland on a map and this dancing must have seemed to her as exotic as the Papuan New Guinea documentaries on TV, but her father had gone nuts recently and had told her that this was something she needed to know about. So Japonica leapt, glided – *this was OK* – and clearly her dad was riveted.

*'Step. Step. Batter. Batter.'* The teacher carried a conviction that matched for intensity the searing light of this remote Adelaide suburb. He'd found the house with the big palm tree in the garden and the old man sitting on a stone at the gate, smoking a pipe, who told him that the dancing was 'round the back.' There the dancers were warming up, rehearsing the steps or moving around at random, gliding and battering across the timber floor, shaking the walls and roof of corrugated iron, no thought, just bodies stamping out something that had been drilled into them. Edwin Denby had told him that all great dance had madness in it and it was here.

Then the teacher lined everyone up and brought order. *Cuinas.* She called a slip jig and the other sister hit the upright piano, called the tempo, and … everyone was in to it. Ones who knew told ones who were just beginning what to do. The teacher penetrated the din with *batter, batter, don't weaken, backs straight, glide, now leap, do not jump.*

He was invited to show in an exhibition 'A Sense of Ireland' in London. He wanted to do something about the dancing and the deadline led him to screen posters of famous names he remembered from his history lessons. Those images, together with a film loop of a boy learning to dance, together with the voice of a teacher, like the one in Adelaide, talking to the young boy, would be it.

Why was he making such a raw work when the opportunity to be engaging, charming, up to speed, and art-relevant in England was 'the go'? *Anything but that,* a voice insisted, *'keep the back straight'.* He was boxed within a box but he thought the set, rigid dancing marked a threshold at which the homogenising powers of the culture industry must falter.

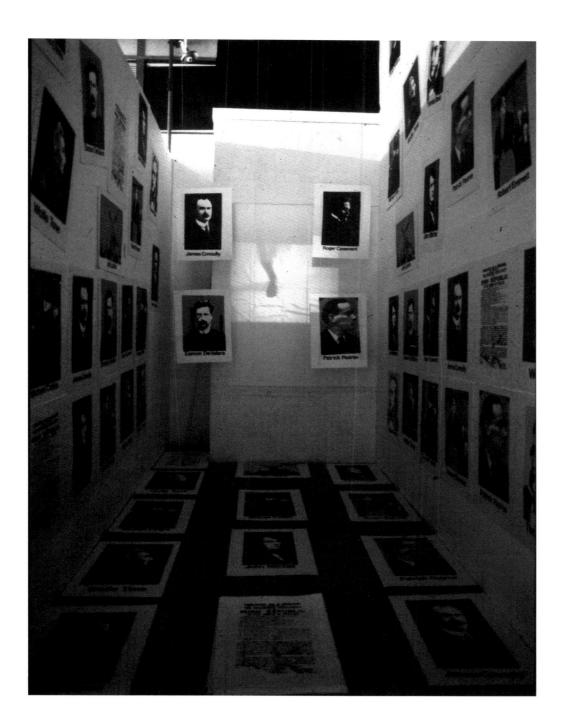

Information for the People
(lucite block with books)
30 cms (h) x 10 cms (w)
x 8 cms (deep

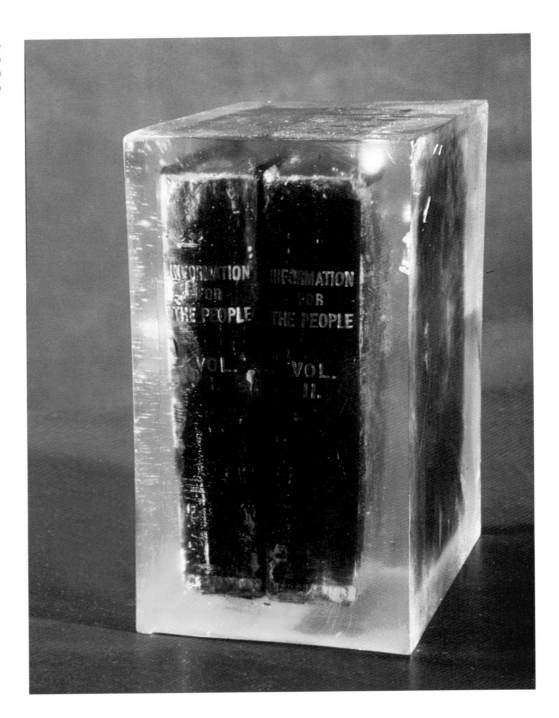

# Information for the People

**S**ITTING ON the beach at Cannes I watched French waiters shimmer across the sand to serve drinks to shimmering citizens. All shimmered under the Mediterranean sun as the theme of the International Art Symposium 'The Social Role of Art' lay across my shoulders like an iron bar.

Praxis was the issue: how to reconcile theory to practice and I was still thinking about it the following day – uneasy on the beach. I wondered if any of this was getting traction in Dublin where I was headed to see my parents before returning to Australia to think about what to do next.

Memory out of sync and disengaged stalls to grip meaning. My mother listening as I tell her that I had been right around the world on this trip. Adelaide, Los Angeles, New York, Toronto, Bologna – *I got this for you* – Paris, the South of France. She thinks this is all well and fine and never once mentions my prospects of getting – *some time, now you have children* – 'a really *job*'. Someone asking am I *'over for the job?'* So long away – twenty years. Has this got something to do with the IRA? No. The College badly needs. *I don't think so.* Badly needs. *Not good.* Work by end–of–year–students. *Very good. Wonderful.* On landings; in stairwells; installations; *'this installation is normally my office, so as you can see, we really need'.* He offers to buy me a drink. I think I need this. And a drink.

The French could do symposia. Drink wonderful coffee, eat finger-food, smoke Gauloise while wearing those great suits with the sloping shoulders and then ask revolutionary questions – *interventions* they called them – about style, the reification of art, the inequity of the class system, the shame and sham of the superstructure and the ones that started 'As Lukacs has established' – and all this punctuated with knowing costive laughs which the brilliant translators transposed to English. The translators worked to keep pace with the speakers – just a slight time lag so that the indigenous punchlines of the international speakers got echoed in the earphones of those who didn't have, lets say, Latvian. All just a little out of sync with each other.

'*Unless Kant got it wrong! Ha ha ha*'. I didn't get it. I doubt that anyone outside the local Latvian Reading Group got it, but the translator's voice in my ear brought the sentence to such a perfect pitch of easy insight and wisdom and a wonderful translation of the 'ha ha ha' to finish that I felt both diminished and engaged. *An art lecturer's dream.* The speaker – that kind of art lecturer – missed all this and had already pressed on to his next position when, mid sentence, a 'ha ha ha' reached him from the floor. He stalled; baffled. He went on, disengaged and diminished. *The nightmare.*

Someone explaining to me in Dublin that all the buildings that were knocked down were awaiting a boom in development that was 'supposed to be about to happen'. (The Dublin subjunctive, mixing hope and apprehension, was incapable of making a mistake. My dad could convey this ironic mode with a look to the four thousand people who came to The Theatre Royal to bind as a community. Citizens.) He saw the Theatre Royal developed into the ugliest building in the world and was now immersed in social actions to save the Olympia Theatre. Not just so that future generations of 'pros' could learn their trade – it was more important than that. I knew I had the theoretical holding devises to construct an epistemology to do with 'art' and 'the community' such that Music Hall – my father was a comedian in that discipline – emerged as the epicentre – consider Brecht – of profound radical avant-garde art import. I knew better than to suggest to my father that he consider himself as anything other than 'a pro'. A professional; part of an elite that refreshed the system. It was all perfectly clear to him. '*How did it fall? It fell notwithstanding. Ha ha.*' He did not wish to know that.

The translators are very well paid but can only spend twenty minutes in the box and then they must be taken out and refreshed. They toiled that day. Trained in the technicalities of science and economics for International Symposia they nevertheless launched themselves into the intricacies of post 1968 art issues that spoke about the basic means of production and the unseen dignity of labour. Behind the glass the translators never stopped.

The symposium wound down and the translators carried the news that 'Community Arts' was the 'paradigm' for the future. The Rapporteur thanked the translators '*without whom none of this would have been possible*' as the national representatives left the conference hall arguing with each other that the final resolution had not quite, or not at all, captured their understanding of the complexities. But the next day they were free to do what they liked in Cannes. I went to the beach.

On the beach everything worked to make a reality of a Raoul Dufy. The sea washed in as pure ultramarine, then turned to a lighter wash of sky that lightly

held white seagulls who were incapable of making a compositional mistake. The sand, a blinding ochre, was made for dancing and kids in primary colours chased lustrous balls or brought little touches of spades and buckets to the blue margin. The prone figures shifted and massed-up to make horizontals that laid down the chord sequence against which everything else got to state its case and fly. 'Beauty' was the only word for it. Unfortunately.

No one in this heat and shimmer seemed to be getting the point. I was not getting it, but I knew if I was taken down a coal mine or made to work a shift on Coca-Cola's production line I'd see the truth behind this brief holiday hallucination. *God, that light breeze.* Marx himself had not got a lot to say about art. It will be something to do in the afternoon - all going well in the future the necessary tasks will be completed by noon - which will allow people to relax. *That sun is getting right into my shoulders. Yes.* The paranoia implicit in all deep structural theories: Marx, Freud, the Catholic Church, is itself a form of denial. I know this. *What a spectacular body!* There must be a way to implement a theory of art so that more people get access to their creativity. *Sandy soccer players acting out their best embellishments on the beautiful game are falling around laughing.* Something needs to be done. Soon.

Waiters, in white shirts and black pants, bring definition and purpose to the riot of colour on the beach. Stabs of charcoal; they bring drinks to people. They are making this work, both as a painting and as a culture. They have a role; they are a source of an energy that sustains the system and conquers entropy. Everyone seems easy with this arrangement. The waiters, agents of desire gratified, are fine with this. Mess with them and you die of thirst. Power politics, yes – but beautifully poised, mutually understood and of verifiable value.

I too am wearing white shirt and black pants, sitting there, neither one thing nor the other But there is something right about this. This is working. Who is directing this? Whatever dialectic is operating within my mind as the opposite polarity of radical change clashes with that of the desire for honourable repose (if that is what art might bring) the synthesis must emerge as: GET EVERYBODY ON TO THE BEACH.

Even at that time I sensed that I had been, perhaps, too long in the sun. People not ciphers or 'painting strokes' got to implement actual Arcadias. That's why there were none. I felt my Socialism shimmer. The argument that Marxism was a science rather than a blind act of ideological faith sat ill with so much of the art that I liked, which was very like that, i.e. *dreamt.* But what to do in an unjust world? Why did the *'stop doing that – do this'* seem always to lead to more victims? And more reasons for outrage.

Looking back through forests of paper that documented all those committee meetings. *'Shouldn't we first consider what we mean by 'art' and then consider what this implies for what we understand 'education' to mean.* Or vice versa. Oh stop. There's supposed to be a dig-out. The topsoil must go in; then the visual equivalent of the Joyce or Beckett will have lumber to burn.

But it starts to look better. Where the Dublin art scene used to be about twenty people, all accessible, full of talk about art, in pubs within walking distance of each other, now there are hundreds. It's better? Surely. Lighten up.

<p style="text-align:center">* * *</p>

I'm in the steam room of the Iveagh Fitness Club which I remember as the Iveagh Baths when I was a child. Those broken windows that made a funnel to focus the cold wind and where the water in the pool was either freezing or so hot that you thought there might be a plot to boil small boys. This now has 'Celtic Tiger' written all over it and I am here in the belief that if I swim ten lengths of the pool every day I can continue smoking. Seamus Heaney's 'redress' that lies at the heart of developing art and civilisation sustains me in a logic for an addiction that I am not willing to discuss any further.

'Hello.' Someone close to me has spoken. I peer into the steam.

'Do you remember me. I went to NCAD a few years ago.'

'No, but then I'm not very good at faces (AND YOU DON'T HAVE ANY CLOTHES ON) but I would remember the work. What area were you in?'

'Painting.'

'How is it going?'

'Well I'm in IT now. E Commerce. You know? 'There's loads of NCAD people here.'

He mentions someone's name from Fashion and another from Industrial Design – *who is upstairs in the gym right now* – and his list continues until his tiny telephone rings. I hear him cancel the band for the launch and instruct someone that 2K is too much, *no fucking way*, and he'll be there in fifteen minutes. He folds up his phone, says it was good to see me –*'everyone's here'* – and then he disappears into the steam.

It's hot. Shimmering. The beach. I try to see it as I rub the wetness in my eyes.

126

# The Playboy   Dublin 1985

Playboy Frontcloth
26.5 cms x 57 cms

Playboy Backcloth
102 cms x 102 cms

Vincent Dowling asked me to do a set for his production of 'The Playboy of the Western World' in 1985. We spoke about it and he wanted a shadow prologue of the murder. Put simply, Vincent explained, it would capture the 'pulling the heads off chickens' quality that lay somewhere at the heart of the text. (I couldn't wait.)

In the event none of this happened. Theatre productions are a flux of contending agendas and The Abbey is this by 10. But I believed I had the permission to go to excess sustained by a classic of excess. (Any excuse to get painting again and do a kind of painting from a time past when it didn't know you couldn't do this, that or the other in its name.)

I was aided by a former student of NCAD Angie Benner who painted the three scrims and front cloth to scale from paintings. John Behan showed me the West and made a neat model of the cabin from sticks and plaster as we discussed, over breakfast, how we might get the 'heads off chickens' feeling into it.

The actors navigated the shallow space, of what I see in retrospect was really a very big painting, without complaint (*pros* indeed).

Playboy Centrecloth
57 cms x 32 cms

*Playboy of the Western
World*. Act two

The Races
57cms x 32cms

Chrisy and Pegeen
(detail)

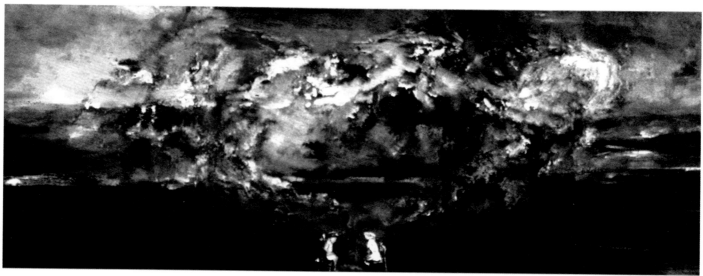

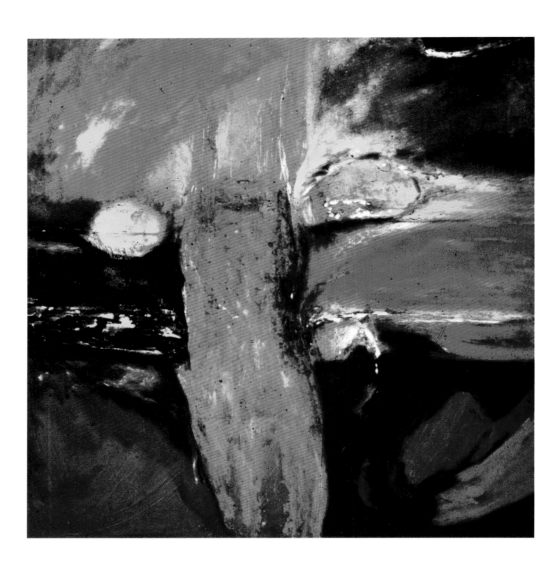

Go Christy
122 cms X 122 cms

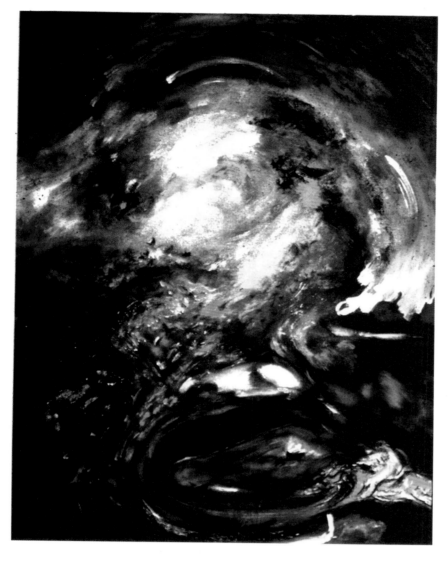

The Races 2
120 cms x 70 cms

Christy comes to town
92 cms x 122 cms

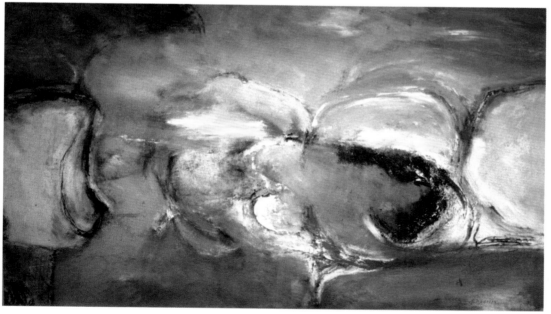

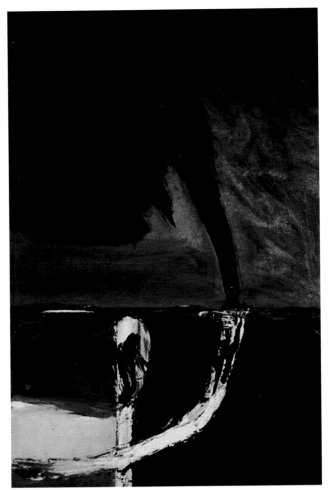

What rough beast?
92 cms x 61 cms

Christy's Da cleft
92 cms x 99 cms

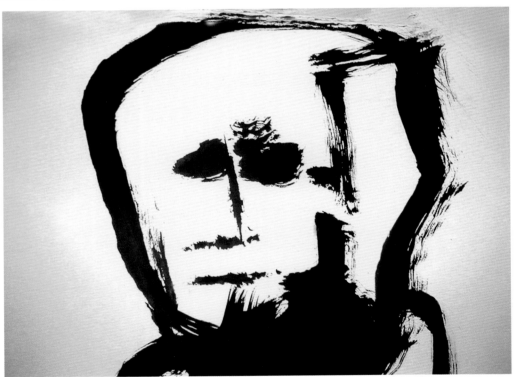

**ABBEY**
The National Theatre

# THE PLAYBOY OF THE WESTERN WORLD

J.M.Synge

Opening
Tuesday 5th April
1988
(£5 previews
29/30 March, 4th April)

with

John Cowley
Deirdre Herbert
Nuala Hayes
Miriam Kelly
Muireann Kelly
Peadar Lamb
Barry Lynch
Máire Ní Ghráinne
John Olohan
Micheál Ó'Briain
Niall O'Brien
Geraldine Ryan

Booking
Abbey Box Office
Tel: 787222

Painting by Noel Sheridan 1988    Design Brendan Foreman

Director
Vincent Dowling

Associate Director
Caroline FitzGerald

Set Design
Noel Sheridan

Assistant Designer
Geraldine O'Malley

Costume Design
Anne Cave
Rachel Pigot-Judd

Lighting
Tony Wakefield

# Our Land – Our Body <span>Western Desert 1993</span>

*It is an awful thing to confront crimes on which your culture is founded, and it is almost unbearable to think that you can make no amends to the victims without committing fresh offences. As usual in our culture, which is not without resources, the answer is simply more and more consciousness, because only in the most painful knowledge does the idea of justice arise.* [1] *Peter Schjeldahl.*

## Approaching Warburton

Warburton, from the air, looks like a handful of pebbles thrown carelessly across the desert. As the light aeroplane turns to begin its descent, the sky abruptly disappears and the horizon is lost. An effect of this is to transform the once arbitrary pebbles into specific markers that now seem to punctuate in a significant cluster the spiky sameness of the suddenly immediate, vertical earth. Scale fluctuates in and out of the mind's control and my instinctive reflex to counter these vertigines by using the window of the plane to master visual incoherence has great difficulty holding.

A yet deeper pass lifts the flat earth to press itself up against the frame of the window and the small plane seems to expand to meet the slow, spiralling, picture plane of the quickening landscape. We are in it. The effort to focus the mind through the eyes, to use the window frame to control 'what is there' intensifies detail. (The small screws that hold the fabric of the plane in place now become utterly real; significant markers, full of an energy and puzzling resonance out of all proportion to their modest status.) This is a complex continuum. The idea of a boundary or edge to this experience feels shakey.

I become aware that I am replaying my formal preoccupations with Aboriginal art to deal with the odd unease I feel on our miniature flight over this immense continent This primitive flying is strange to me – I think this plane may have a singer sewing-machine engine – and running a modernist art vocabulary is proving as inadequate for coping with the impact of radical flight as it has been toward understanding the visual culture of the people I have come to meet. A

1. Peter Schjeldahl. *The Hydrogen Jukebox*, University of California Press.

sense of suspension; a compact cleverness of technological advance overlooking, but markedly distinct from, the open-ended expanses of primal nature seems to sum up my situation.

I think back on the little I know about Aboriginal art and the difficulty I have trying to connect their culture with mine and the distortions inherent in my attempts at translation. One of the first Aboriginal artists I met was Emily Kame Kngwarreye who came to the Perth Institute of Contemporary Arts with the CAAMA/*Utopia* exhibition.[2] I had seen her astonishing paintings in the Holmes à Court collection and written a short introduction which in part said:

*It is not that the work of Emily Kame Kngwarreye is authenticated by modernist precedents (Cezanne, Pollock, Tobey, Johns and others) rather it is the reverse of this. Those explorations that moved from a naturalist base to abstraction in search of truer articulation, are somehow authenticated by the powerful knowledge resources that Kame Kngwarreye and others in her community seem to effortlessly draw upon, across thousands of years, allowing us to glimpse and feel for ourselves what is radical in great art.*

This was easier written than understood. What did I mean exactly?

Peter Schieldahl, an American critic I admired, had all but dismissed the Aboriginal paintings he had seen in Australia because of their failure to deal, in particular, with the formal problem of 'the edge'.[3] I knew what he meant and his other judgements came to preoccupy me, not because of the formal issues he isolated, but as an indication of the difficulty, the limitation, inherent in any attempt at matching or translation which used the formal criteria of modernism as a template. Yet what had made these works seem so extraordinary to me was exactly this template. What gives?

Derrida on how things look:[4] 'Every sign, linguistic or non linguistic, spoken or written, in a small or large unit, can be cited, put between quotation marks and in so doing it can break with every given context, engendering an infinity of new contexts.' The implication here, as he went on to point out, was that 'there were only contexts without any centre of absolute anchoring'. Most Aboriginal culture was probably so shattered by now that it too was subject to Derrida's prog-

2. *CAAMAIUTOPIA.* Sponsored by the Holmes à Court Foundation. Curators: Ann Brody and Rodney Gooch. Perth Institute of Contemporary Arts (PICA) June 1990.

3. Peter Schjedahl, *op. cit.*

4. Jacques Derrida, *Signature, Event, Context. Glyph* (1977). Rosalind Krauss's essay 'Using language to do business as usual' develops this theme in *Visual Theory*, Polity Press.

nosis. But how did the makers of these works, these signs, once, and possibly still, anchor and register these signs?

I got an opportunity to learn something of this when Kame Kngwarreye and one of her nieces (Myrtle Petyarre, also a painter, who sometimes translated for the older painter who had little English) walked with me around the CAAMA Utopia exhibition.

Sometimes the painters sang snatches of song in front of the pictures or shuffled in dancing steps, or showed on their bodies where the designs, would go. When Kame Kngwarreye came to the room where her pictures were installed, she said, 'That's my name.' She went up very close to the picture and began to follow with her finger a path that she traced from within the overall complexity. (*It went across and against the structure that I had seen in it.*) She went backward and forward with her fingers across the paintings as if locating something. 'It was here, it was there,' she'd say, counting sometimes or moving around the work, shifting from minimal English to the rapid fluency of her own language. Always she stayed close up to the work. I wrote what English she said although the 'beat' was impossible to notate – late Beckett was the drift.

Mulga Bore Dreaming
90 cms x 60 cms

Artists Emily Kame
Kngwarreye
and Myrtle Petyarre

*I was here I was there I was there I was there I am here it was there it is here it is everywhere I was there here I am here there was everywhere us where I was here I am there am I was is it is was us now then it I am it is me and us and it is now and then is it us or me and them here and there I am me and them here and there I am me two three*

*four five six mob them whole mob there and here is us and them as was together as was it is here there it was it there and here hear it as it was now and then it was here it is now it was it here it is is it us or me or it here and there or so it is*

Sound seemed key to their understanding of the paintings and she sought to include her niece in the experience. Myrtle Petyarre joined in, supporting and singing a counter point. Language charged the paintings which in turn animated the talking. Through Myrtle Petyarre, Kame Kngwarreye – she was in her seventies and was getting tired – told me that she intended to get some of her nieces to do the paintings for her in future. 'Same thing,' she assured me.

### Warburton
The plane landed at Warburton and I checked my baggage. I checked that I had George Alexander's cautions intact:

*The bridge many build to the Aboriginal world too often uses condescension for its support. The black becomes the conscience of Western narcissism. There is also a kind of romance with insufficiency, and with the terminology of disadvantage, a breathless pursuit of the 'Primitive' with its exotic promise of a final absolute proximity that will make alienated white people 'whole'. The uncertainties are never reduced, only multiplied by any encounter.*[5]

Artists Christine West, Elizabeth Holland, Betty West and Lalla West.

5   George Alexander. Catalogue essay *Inland*. Curator: Robert Owen. ACCA Melbourne.

As I approached the community I mustered one consoling thought which was that the people had invited me to come. They wanted to show something of their culture in Perth, which was not without Schdjeldahl's *resources*.

Warburton confirmed that bringing as much of Warburton as possible to Perth; the earth, the dogs, the kids – the whole hooley – was the best thing to do if others were to get some grasp on how embedded what we called art was in the life of Aboriginal people. We would live in PICA spaces for ten days. Liz, who joined me a few days later, pointed out to me how easy it seemed to be to enter the culture; the people's reflex hospitality; their custom of sharing things, made the transition easy. The difficulty would lie in getting movement in the opposite direction. The entire exercise was open to art critical charges of 'spectacle', 'inappropriate appropriation' and the full agenda of 'correct' negativities. Fortunately the Ngaanyatjarra people couldn't give a fuck about any of this as they had a clear agenda of their own to celebrate and show.

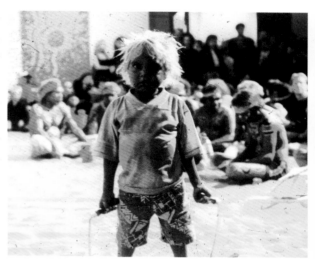

Installation PICA

Women Painters and Seven Sisters Dreaming Map

Gary Proctor, who initiated this project[6] arranged that we could travel great distances in the Toyota with a group of elderly Aboriginal people to see certain important places and rock paintings in the Warburton area. The sense of the relativity of distance within this journey was something that could not be brought to Perth. After a while there seemed to me to be no middle ground to the experience of this landscape; things were either very far away or microscopically close. Tommy Simms, our guide, might draw our attention to a formation on the horizon and immediately relate it to some small stones at his feet. The transition for him, and the other Aboriginal people in the group, seemed effortless but I could almost feel my eyes clicking in and out of focus trying to follow the trajectory of his hand. Scale too was disordered: some huge rock might be a detail in an account that had as its source some cluster of tiny pebbles; the footprint of an animal was often bigger than the animal. I wondered if, rather than being a representational convention to give narrative emphasis, that, somehow, this was the way it was *seen; felt,* through the eye, onto the nervous system, and that some art by Aboriginal peoples was an attempt at a true representation of that interaction or *sensation*. There was no question but that we were all seeing the same thing – but the *sensation*.

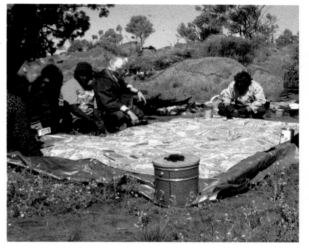

6  Yarnangu Ngaanya, Our Land – Our Body. Curators: Gary Proctor. Noel Sheridan. PICA Press 1993

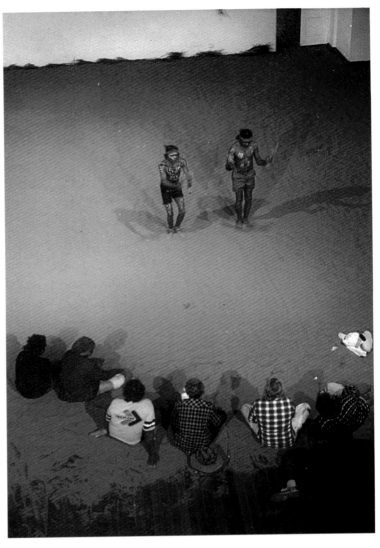

Men's Dance
Installation PICA

Liz, NS and Tommy
Simms. Western Desert

Women's Dance
installation PICA

Cezanne had spoken of his relationship to the land in terms of *sensation*, as spiritual. In seeing a Cezanne through some later commentaries, as nascent cubism or as charts of his struggles with art's formal properties, occluded the metaphysics. It was only later, after I had seen his paintings and reproductions of the paintings, that I got an opportunity to visit Aix. By now it was difficult to see the landscape outside of the paintings, but it was the disjunction of the form of the representation against the fact of the landscape that finally surfaced the sensibility that ordered the anxiety it felt before the mystery of the landscape. The organism's relationship to the land seemed crucial to the form of the representation it generated. The feeling of the bodies and sensibilities (communal, plural) connected to the land was palpable in Warburton.

The physical presence of the people; their bodies, their shapes, their gravity, modulated the way I was starting to see the art. It was the opposite to going to a conventional studio where often the task was to isolate the work from the body

language and the conversational formalities of the occasion. Here the talk seemed part of everything and the bodies of the people sustained the work as ineluctably as they registered the landscape I felt *I knew* this talk; it was talk for the sake of it. It was about myths which would always be theirs and secret, but the form, as the voices sounded the litany of events and the little sticks clicked or illustrated or erased the stories in the earth, was … 'everything and all at once'.

'A myth,' as Brian O'Doherty pointed out, 'is simply a way of making talk possible, of "experiencing" something while leaving it unchanged.'[7] I loved this; art should be like this. This form of understanding, a substitute for and soft redress to that other drive toward comprehension through analysis, would always escape my reach from within Aboriginal culture, but the desire for convocation which, perhaps, lay deeper than the ostensive conventions of individual cultures might be something that one could attempt in art, even yet.

I was dreaming this. The nature of my illusion was brought home to me in a small incident when Mister Lane, in trying to give me an idea of the age and importance of certain rock paintings, said to me, *'These go back a long time ago … from a time when we were,'* he searches for the word, he points to himself *'Naked!'* He laughs, opening the sublime into which I could feel myself, the Toyota and the other precarious paraphernalia begin to fracture and descend.

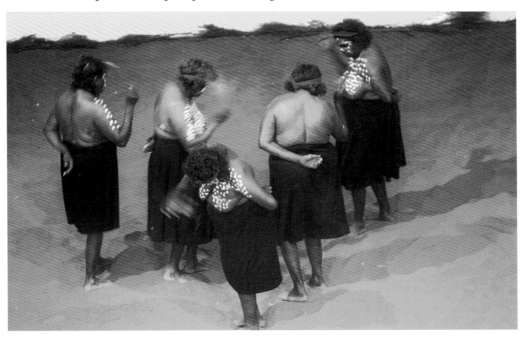

7 Brian O'Doherty, *American Masters*, E.P. Dutton (New York).

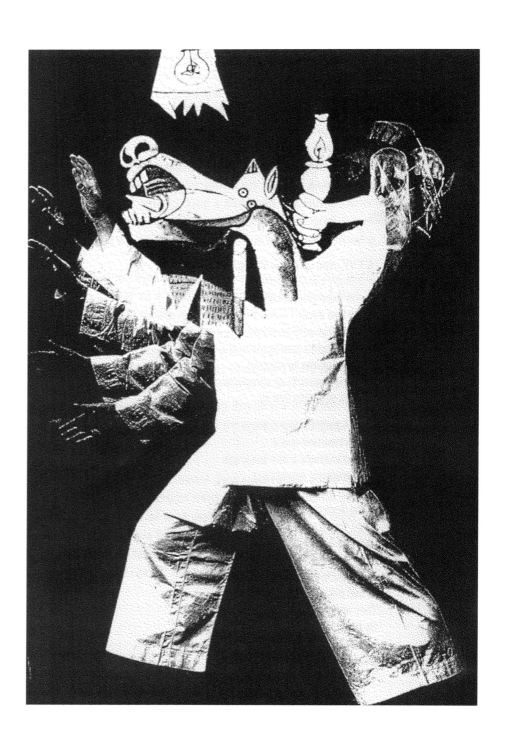

# Mr Chen

*The work was performed as a reading with slides. Ideally it should have been read in conjunction with Mr Chen's demonstration of the full form of Tai Chi Chen. For reasons that become clear in the text this was not possible. NS*

THE ENGLISH LESSON with Mr Chen is off to a bad start.

'Bright.' Mr Chen points to the light bulb in the ceiling.

'Yes, bright.... but it is called "the light". The light is bright . . . when the bulb is lit.'

'Yes?'

'By electricity.'

'Lectricity?... Bright?... Light?' Mr Chen is pointing at the bulb.

> *This is our first lesson and we've gone straight to the heart of
> Wittgenstein's problem of ostensive definition.*

'Sorry Mr Chen'... 'Wittgenstein' I explain.

I smile at Mr Chen. Mr Chen smiles, then tentatively

'Gen stein.' He points to the light.

'No. Sorry... Look.'

I point through the window. 'The light.'

'What is light?'

> *Paula Cooper who ran a gallery in New York thought that light was the
> essential subject matter of art. What does the painting say about light? That
> was it for Paula.*

This is no use to Mr Chen who only wants to know what light is. Simply. I point through the window. Mr Chen knows this one.

'Window.' Mr Chen smiles and points *at* the window.

I thrust my finger as if going *through* the window. I am pointing at a skyscraper. I shift my finger and point .... at clouds. *See, I'm pointing at light?* To clear up any confusion I go into a sort of Marcel Marceau number and using both hands I draw the light through the window and disperse it through the room opening my arms wide to indicate its expansiveness. I move in a circle.

'Everything... Light.'

'Light is... everything?'

> *Well, for Paula Cooper it is...but no...*

'When you see everything... the rest is light. Or rather light is what allows us to see everything.' I nod encouragingly at Mr Chen. Mr Chen takes out what

looks like a pocket calculator but is in fact a small translating machine. An electronic English/Chinese dictionary. It is shiny from use, the black enamel is peeling, the letters have almost disappeared from the key-pads.

> *A dog-eared computer! Just the job. Now we will ground ourselves solely in language. Language is reality; the rest ... metaphysics.*
> *(But fuck Wittgenstein. Get serious.)*

'Bright. Light ... let's do that,' I say.

Mr Chen types it in and presses a button. Chinese characters appear on the small screen.

'What does it say?'

'The potato. A sickness.'

'Oh.'

> *The famines of China; mere footnotes to gigantic cultural sweeps. No special or shared famine mythology here ... Dynasties.*

'May I?'

Mr Chen gives me the calculator. I type in 'light'. It appears in Chinese and I hand it to Mr Chen who looks at it intently.

'What does it say?'

Mr Chen looks at the light bulb.

'Not heavy.'

'Ah, yes.'

> *How did we ever learn English? Mr Chen looks to be in his very healthy mid thirties, but maybe the deep structural networks of the brain which help us learn language are gone – for both of us.*

Mr Chen and I are in the Perth Institute of Contemporary Arts at eight o'clock in the morning learning English and Tai Chi respectively. We had come to this agreement when the Chung Wah Association in James Street closed for renovations and the Tai Chi classes were abandoned. Jenny Tang arranged that I could continue Tai Chi classes with Mr Chen in exchange for teaching him English.

> 'You must make him speak. He only wants to speak Chinese. He won't talk in English. He must learn to make conversation and stop using that pocket computer or there will be trouble for him.'

Almost everyone in the English class at the Association seems to have one of these little computers, so there's not much English conversation - just flashing the little computers at each other, explaining everything in Chinese. For the English class, mostly elderly Chinese, this is a great game. 'Test your computer!' Mr Chen enjoys it too, but when Jenny Tang enters 'all smiles stop together'.

On our first morning Mr Chen shows me his TAFE certificate which says: English. Intermediate. Passed.

> *Welcome to pre primary Mr Chen. Let's talk.*

I point to one of the paintings in the graduate student exhibition.

'Picture.'

'Picture' says Mr Chen. He moves toward it... and points.

I move in and quickly trace around the wood. 'Frame.' I tap on the glass. 'Glass.'
I point inside and to the side. 'Mount.' I point to the centre. 'Paint'... 'Painting'...
'Picture. Yes?'

> *In Paris Joyce had a photograph of Cork city in a frame made of cork and
> Frank O'Connor recalls asking him, 'Is it Cork?' 'Yes,' replied Joyce, mov-
> ing on. ( An anti epiphany?)*

'Painting.'

'Painting.'

'What is the painting?' asks Mr Chen.

I look at it closely for the first time. The work comprises bits of other work that
didn't work pasted together into one large work that doesn't work. (I don't say
this to Mr Chen.)

'What is the painting?'

'What does it mean, do you mean?'

'Yes.'

'Ah ... is abstract.' *Why am I speaking like Tarzan?*

'It is abstract' corrects Mr Chen.

'Yes, it is abstract ... "it" is a pronoun.'

'Yes, I know. What is abstract?'

'Is complex ... sorry ... It is complex.'

'What is complex?'

'Complex is ... complex. Difficult ... not easy.'

'Abstract is complex?'

'No ... complex is ... well yes, in a way.'

> *We have hit the flaw in formalism; it is not a universal visual language. I see
> what Mr Chen sees. Strips of painted canvas. Vertical lengths. Uneven
> widths. Congealed colour; building superintendent browns and muddy munic-
> ipal greens that come from enervated, desperate student mixes of everything
> that's left in the tubes. THERE IS NO LIGHT IN THIS WORK. I think
> 'collage' and it improves. I think 'materialism' and the strips of canvas and
> the paint lift slightly. I think 'Ad Reinhardt' and light is a possibility. I think
> Alberto Burri ... I ...*
>
> *I think John Cleese. THIS PARROT IS DEAD. It WAS art ... but IT IS
> NOT NOW.*
>
> *('Is' is such a tiny word to describe time present. And what's 'was'?.)*

Iz-waz?

Mr Chen waits expectantly, but I have started to think of how my tongue works
in my mouth to make words. Now my tongue won't work. *Take it quietly.* I say

'quietly' quietly a few times to myself. (I had never noticed the click in the final 'klee' of quietly and the elision of the 't'. It's impossible to locate where the tongue begins on the 'quie' – it just emerges and then shovels out the 'klee'.) *Ask Mr Chen something; get conversation going.* Before I ask I say 'ask' to myself a few times. Now I'm not sure 'ask' is a word. 'Ask.' It doesn't sound right. Nor, come to think of it, do I think 'rasher' is right. 'Eggs' should be' ovals' maybe...and 'Jam'... jam?... jammed.

'Picture' *Nothing comes out.*

I concentrate telepathically. I narrow my eyes and gaze hard at Mr Chen. My friend understands. He smiles uneasily.

'We do Thai Chi now' he says.

I nod my head.

## 2

I am standing face to face with Mr Chen for the first time. At the Chung Wah, among the others, I could fake a little; checking the moves from those on either side of me. Not here

> *(I felt I was better at Tai Chi than Philip from Singapore. It wasn't just that Philip was seventy, he was also impatient. He was into property and he couldn't stop thinking about deals. He explained to me that his wife had urged him to get out of the house and relax. Whether Philip's English allowed him to distinguish between 'urge' and 'insist' I can't say but I got the feeling she'd insisted. Philip needed to take charge. If you came in early and he was there, he'd offer to check your moves.*
>
> *'Let me see. I help you. We do it together.'*
>
> *We might start doing it together but soon Philip would stop and consider my moves. Any hesitation on my part and he was in.*
>
> *'I'm not sure of the next bit, Philip. I think you cross the hands and pivot on the feet to face the other way.' Philip considered this. He looked at my version of the movement.*
>
> *'Wrong.'*
>
> *'I'm pretty sure ...*
>
> *'No, this way.'*
>
> *Philip then went into a series of incoherent moves that anyone who'd seen even one episode of David Carradine in action in 'Kung Fu' knew couldn't be right.*
>
> *'See. Like me. Make a big circle with the hand, don't turn your head and don't move the feet.'*
>
> *'But if you don't move the feet, Philip, you'll fall'*
>
> *'O.K. Move the feet, but don't cross the hands.' This is what Philip*

*wanted – a deal … negotiation. 'O.K. you can move the head a little, but make the circle bigger. That's too much with the feet.' We went on like this until Mr Chen arrived at which point Philip withdrew.*

*'I have to go now. But let's do lunch.'*

*As the definitely-assimilated-into-Western-ways Philip reached the stairway at the end of the room he turned and called out 'Soon.' This had the effect of making everyone in the room feel under some vague imperative from Philip – just what Philip craved.)*

'Yes, Philip, soon.'

### 3

I was face to face with Master Chen. My feet were planted firmly in the first position.

*(I felt I was closer to the real Tai Chi than the diminutive jelly bean of a lady from Hong Kong who came to classes in designer outfits of black silk. She usually wore three or four pieces of very expensive jewellery – she had little diamonds on her computer – and she wore tiny black silk slippers. She had all the moves but they were difficult to detect as she performed Tai Chi with whispering discretion and exquisite gentility. 'Killing with Kindness' might have been the name of her style. Mr Chen never gave her instructions and she never asked. She existed out of time in a special world that was part Hong Kong chic but backed by dynasties of custom and practice. (She was the one in the background of all those Chinese erotic paintings; outside the main action, fixing towels.' 'That's what you do? This is what I do.' She was like that in class; a contained world of decorum and efficiency within the general disarray. She was in her sixties and she revelled in herself.)*

I miss her this morning.

### 4

Mr Chen nods.

I begin, *pause*. Raise the arms, *pause*. Drop the arms. *Slow*. (*This is the great thing about Tai Chi, you have loads of time to think of what comes next.*)

'You think of what comes next.' Mr Chen shakes his head. 'Do again.'

I raise the arms and ... Mr Chen moves in and makes adjustments to my feet, waist, shoulders, hands, elbows, fingers, head.

'That's right.' he says. 'Do again'

I raise my arms ... Mr Chen adjusts the shoulders, the hands, the fingers.

'That's right.' smiles Mr Chen.

I do the arms. He does the hands and the fingers.

'That's right' he beams.

I do the arms. He does the fingers.

'That's right.'

I can't believe this is only the first movement. I've practiced at home and I am convinced I have the first fifteen movements down solid. Not Mr Chen. I raise my arms.

'Your leg is too ...' Mr Chen stretches out his leg and demonstrates its inflexibility, clenching his muscles.

'You too ...' Mr Chen searches for the word.

'Solid?'

' Yes. No good.' Then he asks 'what does 'solid' mean? '

> *How in the name of the crucified Christ would I know Mr Chen – I can't even raise my arms properly, never mind the bleedin' legs. (This is trouble, I'm starting to think in a Dublin accent.)*

'Solid?'

We do the computer. It comes up with 'full' in Chinese. Mr Chen is truly happy with this.

' Yes. In China in Tai Chi we say ...' He shows me the Chinese word on the screen. It seems very long for 'full'. It looks like lots of people on a building site moving stuff. Maybe filling in. Yes. Full.

Mr Chen places all his weight on his extended leg.

'Full.' Mr Chen points to his other leg. 'Not full.'

'Empty.'

'Yes, empty.' says Mr Chen. 'Keep the leg empty. Do again.'

I move the empty legs. I raise the arms. Mr Chen raises and lowers his arms to show me what he means. *I begin to get it ... It's not up and down ... it's 'trom' and 'eadtrom'.*

'Trom' I drop my arms. 'Heavy' (I don't say it's 'heavy' in Irish)

'Eadrom' 'aye-trom'' I say as I raise my arms.

'That's right. Aye trom? What is that?' asks Mr Chen.

'Light.'

'Light?' Before Mr Chen can look at the bulb I say firmly 'Eadtrom.' I lift my arms. I get it right. Even I can feel the missing pronoun click into place as the wrists shift to complete the phrase.

'Eadrom.'

'That's right.'

*wanted - a deal ... negotiation. 'O.K. you can move the head a little, but make the circle bigger. That's too much with the feet.' We went on like this until Mr Chen arrived at which point Philip withdrew.*
*'I have to go now. But let's do lunch.'*
*As the definitely-assimilated-into-Western-ways Philip reached the stairway at the end of the room he turned and called out 'Soon.' This had the effect of making everyone in the room feel under some vague imperative from Philip – just what Philip craved.)*

'Yes, Philip, soon.'

3

I was face to face with Master Chen. My feet were planted firmly in the first position.

*(I felt I was closer to the real Tai Chi than the diminutive jelly bean of a lady from Hong Kong who came to classes in designer outfits of black silk. She usually wore three or four pieces of very expensive jewellery – she had little diamonds on her computer – and she wore tiny black silk slippers. She had all the moves but they were difficult to detect as she performed Tai Chi with whispering discretion and exquisite gentility. 'Killing with Kindness' might have been the name of her style. Mr Chen never gave her instructions and she never asked. She existed out of time in a special world that was part Hong Kong chic but backed by dynasties of custom and practice. (She was the one in the background of all those Chinese erotic paintings; outside the main action, fixing towels.' 'That's what you do? This is what I do.' She was like that in class; a contained world of decorum and efficiency within the general disarray. She was in her sixties and she revelled in herself.)*

I miss her this morning.

4

Mr Chen nods.
I begin, *pause*. Raise the arms, *pause*. Drop the arms. *Slow. (This is the great thing about Tai Chi, you have loads of time to think of what comes next.)*

'You think of what comes next.' Mr Chen shakes his head. 'Do again.'
I raise the arms and ... Mr Chen moves in and makes adjustments to my feet, waist, shoulders, hands, elbows, fingers, head.

'That's right.' he says. 'Do again'
I raise my arms ... Mr Chen adjusts the shoulders, the hands, the fingers.

'That's right.' smiles Mr Chen.

I do the arms. He does the hands and the fingers.

'That's right' he beams.

I do the arms. He does the fingers.

'That's right.'

I can't believe this is only the first movement. I've practiced at home and I am convinced I have the first fifteen movements down solid. Not Mr Chen. I raise my arms.

'Your leg is too ...' Mr Chen stretches out his leg and demonstrates its inflexibility, clenching his muscles.

'You too ...' Mr Chen searches for the word.

'Solid?'

' Yes. No good.' Then he asks 'what does 'solid' mean? '

*How in the name of the crucified Christ would I know Mr Chen – I can't even raise my arms properly, never mind the bleedin' legs. (This is trouble, I'm starting to think in a Dublin accent.)*

'Solid?'

We do the computer. It comes up with 'full' in Chinese. Mr Chen is truly happy with this.

' Yes. In China in Tai Chi we say ...' He shows me the Chinese word on the screen. It seems very long for 'full'. It looks like lots of people on a building site moving stuff. Maybe filling in. Yes. Full.

Mr Chen places all his weight on his extended leg.

'Full.' Mr Chen points to his other leg. 'Not full.'

'Empty.'

'Yes, empty.' says Mr Chen. 'Keep the leg empty. Do again.'

I move the empty legs. I raise the arms. Mr Chen raises and lowers his arms to show me what he means. *I begin to get it ... It's not up and down ... it's 'trom' and 'eadtrom'.*

'Trom' I drop my arms. 'Heavy' (I don't say it's 'heavy' in Irish)

'Eadrom' 'aye-trom'' I say as I raise my arms.

'That's right. Aye trom? What is that?' asks Mr Chen.

'Light.'

'Light?' Before Mr Chen can look at the bulb I say firmly 'Eadtrom.' I lift my arms. I get it right. Even I can feel the missing pronoun click into place as the wrists shift to complete the phrase.

'Eadrom.'

'That's right.'

*Trom and eadrom (the ying and yang of Tai Chi), dun an doras (close the*
*door), Witt-gen-stein ( the three moves to get ready to 'dun an doras' (single*
*whip), 'light' (do nothing), the empty legs gather the ball ...*

I'm in bed trying to put myself to sleep by imagining I'm doing Tai Chi and it's
not working. I can't see it. When I next see Mr Chen I ask him if I can video him
doing the form. The moment I've said this I feel I have made a terrible mistake.
As usual his smile is unreadable to me. It's not 'yes', it's not 'no', it's like the I
Ching – you read yourself into it. I read 'shame'.

' It's just that I can't remember the moves.'

*(Oh Christ, the man has spent his life at this and my idea is to instant-video it.)*

'I'm sorry.' If only he could speak English... could disentangle this. That is
what language is for. But because he can't, we must deal with reality. We do the
form; we speak little because I just want it to finish.

The following week Mr Chen says. ' We should make video.'

He hands me an envelope: 'Department of Immigration' ... his file number: ...
born 1935 ... married ... two children ... PRC ... mother beaten ... perform labour
... fled to Beijing ... capitalist ... manual labour ... humiliated ... resin factory ...
became sick ... Buddhist ... Cultural Revolution ... teacher ... arrested ...
I can't deal with this sudden explosion of intimacy. At a loss, I find myself saying
conversationally 'What did you teach?'

'Chinese History ... you read other letter.'

Minister for Immigration. A refugee is defined ... United Nations Convention ...
your application assessed ... criteria ... therefore rejected. Reasons for decision ...
do not consider Mr Chen can have a well founded fear ... Department of Foreign
Affairs and Trade advises ... the Third Plenary Session of the 11th Central Com-
mittee formally repudiated in 1978 ... I find no evidence ... not detained ...
removed from his post and investigated, eventually to be hospitalised ... I give no
weight ... I find no evidence ... I do not consider ... I accept as credible ... I do not
give weight ... my consideration ... full ... his fear s... empty ...

' I must go back to China. But first I make video for you.'

We didn't make a video, but Mr Chen did the first section of the form for me,
perfectly. 'So you will ...' he searches for the word.

'Remember'

'Remember? What is remember?'

*'Remember' ... is ... well... complex. Oh Christ. English is hard. Thought... taut... all of those ambiguities Mr Chen. You've explained to me how sensible Chinese is. No shifting tenses, 'same word all the time'... as precise as Tai Chi I'm sure. Reality is precise, Mr Chen, but our remembering of it gets tangled.*

He begins the form.

*'Remember'. We bring to it bits and pieces of our individual pasts ... then language fails us. We shovel it out like clay. Dig for definition ... bury meaning.*

Brush left knee and pivot.

*The four master waves in motion, all Erin listening, the sycamores and the wild geese and gannets, the auspices of all the birds.*

Deflect downward, parry.

*the rockabye baby swing of his sinister dexterity, lazily luistening, the eyes glistening, the superior man stands firm, remorse disappears.*

Diagonal single whip.

*Dissimulating fore and aft, on and offsides, he rolls back the far back centuries, he eats up nature in all her moves and senses.*

Turn and strike.

*Like traveling famines he does not change direction but, revelling in his astonishing self, he drinks in draughts of purest nothing to expel in radiant basnabeatha epiphanies.*

Strike again.

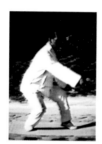

*Basnabeatha, deaths of breaths, trom agus eadrom, succeeding in nothing, but ever sustaining the self renewing movement of immutable laws, beginning anew at every ending.*

Roll back

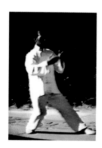

*(Does that breath soft fall mean downy death or the love embrace from iron heels and helping thighs?)*

Press, withdraw and push

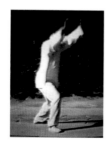

*He lifts to look, to fill up soon. Philip. What bright light beckons? Stop and glow jewels chart the path, movement and rest beget each other.*

Lean forward. Return. Ward off.

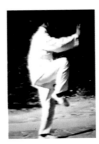

*the light giving power of transforming movement endures.*

Conclusion.

*You are the great Finn leader, Chen. Claritas is what you do. That immaculate light*

'Is this where we bump-in utopia?'

Two mighty men, bronze and gold, have entered the gallery.

'G'day. Ansett freight. We've got aboriginal paintings here from Utopia in Alice Springs. 'Utopia Women Painters'' he reads from the docket. 'Is this PICA?'

'Yes.'

'Where do you want us to bump them in?'

'Here is fine.'

'Right.'

Mr Chen and I help to bring in the work. I have a honey ant dreaming and I notice that Mr Chen is walking with a water dreaming. The men bring other dreamings: the snake, the glider possum, the kangaroo, the rainbow serpent and the crocodile. The goanna and wild orange dreamings drift past the water-lily and the black currant. The room is full of a language none of us can speak.

The man counts off the paintings, pointing at each one. He finishes.

'Beauty,' says the man, looking at his receipt book.

'That's right,' says Mr Chen, looking at the paintings.

'No worries, comrade,' says the man, looking at Mr Chen.

# The Head <span>Perth 1994</span>

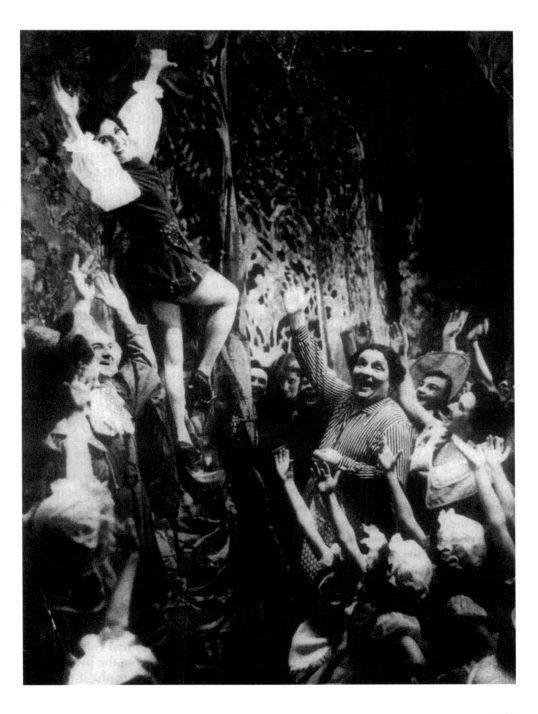

The man in the heavy lipstick, false eyelashes, ladies' stockings, and high heel shoes is earnestly explaining to me how upset my mother is that I have been playing snooker instead of going to school. The man, who is my father, stammers badly.

He is a professional actor so it is difficult to gauge the true depth of his concern. I remind myself that it was himself and a three foot high friend of his who taught me to play snooker in the first place. The miniature friend is also in the room, dressed as a policeman. He nods in agreement with everything my father is saying.

— It's wrong to upset your mother, says the tiny policeman in a high voice.

— This is serious, says my father, putting on a blonde wig, adjusting his bra and dress as he follows the tiny policeman out of the room.

I follow them and watch from the side of the stage of the Theatre Royal as they chase each other around a table that is out of all proportion to the gigantic painting of a kitchen that hangs behind it. My father no longer stammers; he now speaks fluently and rapidly to the four thousand people who have come to see this. I can see him adjust his breathing, waiting for the wave of laughter to subside and then, before it dies, he says something which lifts the laughter in an unbroken rhythm as he turns it back to rest in the darkness until he entices it forward again.

For the next eight minutes he encourages and nurses this huge, full throated, choir of an audience to madness and anarchy. All of his intelligence and energy is devoted to this; women are abused, babies are thrown off stage, the handicapped are mocked, sex is trivialised, marriage is destroyed, important people and ideas are ridiculed. This is great. Everybody loves this. (Later, some will complain that he goes too far; but in the darkness of their desire for convocation he confesses for them and he absolves them, all in one fiercely illuminated public ritual.)

I smile at him as he leaves the stage, hoping he will continue the mood of euphoria, but he is already in serious conversation with another man, also dressed as a woman, who was his dying daughter just moments ago.

— Feed with the ear! Feed with the ear! he is telling the man.

The first sentence he says loudly, the second is a tone lower and slower. He is trying to explain pitch and timing, how you must listen to catch the subsiding laughter and feed the straight line into the sound so that the comedian has the correct platform from which to launch the next line.

— I was back-feeding myself half the time. He can't hear the silences, my father complains as I follow him to the dressing room.

— What's back-feeding? I ask him.

The comics' dressing room. Cecil Nash, Bill 'Magso' Brady, Cecil Sheridan, Jimmy Harvey, Mickser Reid, Dolly Sparks, Val Fitzpatrick, Patty Ryan and Mick Eustace.

— When you have to repeat the straight line yourself to start the movement and ... Never mind about that. We have to ... talk. He is now stammering again. As he changes from women's clothes into a hearse man's claw-hammer coat he continues to give me advice. He removes his wig and false eyelashes then he pulls a cloth cap on his head. Finally he is dressed in the coat, the cap, a string vest, baggy trousers and a tie, but no shirt.

— You'll amount to nothing, he advises me.

I follow him from the room and down the stairs to the side of the gigantic stage. It is terrifying and he is terrified. He clasps his hands across his stomach to stop them shaking The titles of the popular songs he will parody are written on the back of his hand and he checks and rechecks them. His entire nervous system is tuning up to meet the impact of lights and noise. The sense of communal expectation sharpens as the orchestra plays his introduction. He shuffles forward to encounter it.

I notice that the man conducting the orchestra is beautifully dressed. He understands scale and perspective and sight lines; he looks great from everywhere. He is Jimmy Campbell and he is the tuning fork of this entire theatre and all the people in the audience know that they could never reach his perfect pitch of eerie, satanic elegance. Their consolation is that they don't have to; they have paid for him to do this for them. He is English; he is respected. Grand. Because of him there will be a centre of order and control; the red artificial carnation, the patent leather hair and the pencil line moustache guarantee it. This man is a 'pro'. To the audience, and everyone outside 'the profession', a pro is a travesty of the class system; to a pro being a pro is class. Not high or low; simply transcendent.

The immaculate conductor smiles secretly up at my father who makes his slow walk to the centre of the stage. Off stage these men lead very different lives, but here, as pros, they work closely together to tell all the people in this huge auditorium that my mother is a shrew who drinks the children's allowances, pawns the furniture, persecutes my father and goes on the town with my slut of a sister, leaving twelve younger children at home for my father to mind. Each song is introduced by an arpeggio on the piano. In the pause, before the orchestra enters, the conductor leers up a my father; encouraging him to ever deeper blasphemy. Nice. The entire orchestra 'feeds with the ear' through him. He sources the rolling laughter through his shoulders and arms up to my father, who faultlessly cues into the black.

— What, in God's name, do you see in snooker, my father wants to know. It's a waster's game. Are you listening to me?

We are back in the dressing room and my attention is disappearing into the

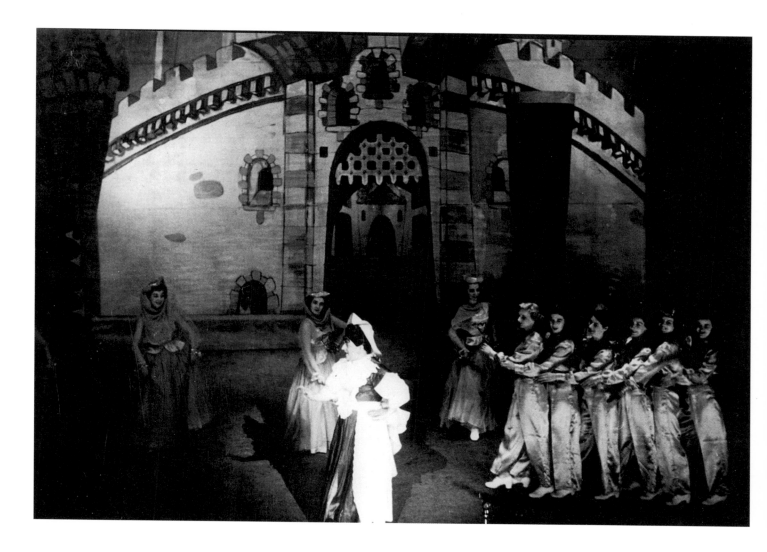

small dots of red greasepaint that my father has placed with a match stick in the corners of his eyes. He uses these to give 'life to the eye' at great distances. Close up the dual vanishing points confuse perspective. There is no focus to seeing and I am wondering why this happens.

— I'm telling you now. Look at me. If you upset your mother again, I'll fucking kill you.

I stare at him in amazement. Not because he is going to kill me, but because he is using 'bad language'. Bad language has never been in our house. My father is a madman about this. Why is he saying it to me now? He says it again. The other actors in the room listen. My father looks at me through the language and I sense that I'm supposed to say something.

My father turns from me and back feeds the little policeman; saying the word. Right on the beat the little policeman says it. Fuck! Now everyone is saying it. They're saying it to each other, to me. It is dropped casually into the general conversation.

My father has given a new permission for me among these men. I'm supposed

to be a man now on this potent sign. I know better than to say the word myself, but I know that he has upped the ante on our relationship. We must now be serious. Men!

Now he begins talking about our responsibility to my mother. It is clear that he is utterly dependent on my mother; it is the opposite to everything he was saying on the stage. Only she knows the truth of this man behind his language, fluent or halting; only she can mother his disastrous extended childhood. What she does is harder than focussing the latent uproar of four thousand people. He knows this well, and I am to know it.

I hear his halting speech stitch and nail the details of my new life into place. He is angry and I think of how easily he could destroy me with the power he has developed in his hands and shoulders as an upholsterer; stretching wet leather across wooden frames packed with horse hair. As a child I can remember the beautiful precision of his doing this; rapidly spitting tacks from his mouth into the stretched webbing and then tap, tapping them home with perfectly weighted, timed blows of the claw hammer.

Kathleen, Ethel (Sherry) and
Cecil Sheridan, 1914

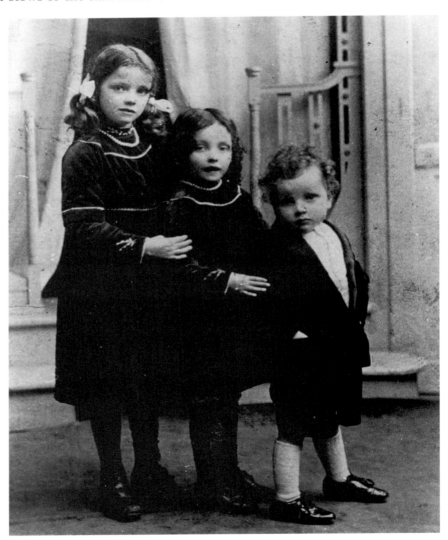

My grandfather, who was also an upholsterer, told me my father was a master craftsman. My grandfather's skills had become redundant but my father was the new generation, dealing easily with the new styles. There was little demand for the plush, pleated, Victorian button-back, velvet outrages that were grandfather's style. This thought sometimes made my grandfather sad, as changing styles were later to sadden my father.

N. S. and his grandfather, 1940.

N.S. 1967

In Ireland, at the turn of the century, my grandfather was considered strange. Aloof. He had a subscription to *John O'London* and was always going on about Charles Darwin and how we came from monkeys. He would not pray for his wife who was dying of T.B. but kept talking about invisible germs and how his daughter should not nurse her mother or be in the same room with her because she would catch these germs. Heartless. Imagine dividing the natural bond between mother and daughter, the relations whispered as the disease ran wild through the rooms. Both young women died among much prayer. My grandfather sent his remaining daughter to Sion Hill and set up house with my father who was seven years old. My grandfather retreated to his books, weekend pints of porter, singing in pubs and knowing the answers to difficult questions in general knowledge to the amazement and annoyance of the inhabitants of the Clanbrassil Street public houses.

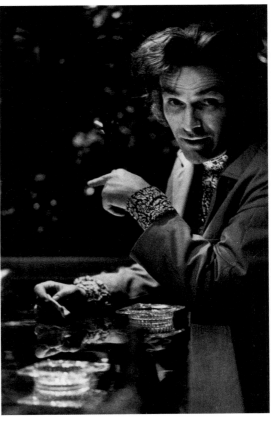

Grandfather used to get barred for not ceasing to sing or for not stopping explaining, with that sharp double intake of breath with which he marked his superiority, the vagaries of the English language. 'Cleave' means 'to split', 'to separate' and yet we say 'Cleave to your wife'. See, it's here in the dictionary.' He sometimes had to walk as far as Emmett Bridge in Harold's Cross to get served.

Without women my grandfather and his young son made a shambles of home life. Some awful thing happened that kept my father moving nervously and impatiently throughout his youth until he met Nan Doyle from Lock Street in Ringsend who agreed to marry him because, she told me later through baffled tears, he used to make her laugh.

It is twenty years on and I have come from New York, in cowboy boots, flares, sideburns and hair to my shoulders, to a theatre in Ayr in Scotland to talk with my father. Ayr is a seaside resort but it's winter now and outside the grey sea is smashing the memory of summer illusions to smithereens.

I come into his room and sit down beside him as he makes up. I ask him how he is and he says he's a bit depressed. I ask him how the show is going and he says not great. He is the support act for an Irish tenor and a girl who had a record hit, but 'maybe the mix is wrong' he tells me, 'or the timing'. He looks at me in the mirror.

— It's very nice of you to come backstage. He seems dazed. Who are you? Do I know you?

I tell him who I am.

— Jesus, I'm sorry,. I didn't recognise you in those clothes. Did your mother tell you ... I'm a little depressed. He begins to cry.

He is not a little depressed; he is clinically depressed. He is intrigued with the word for his depression: 'endogenous'. He says it many times. I find myself telling him that Joyce couldn't understand how such a beautiful word as 'glaucoma' could be destroying his eyes.

— You know while you were away they had a competition in one of the papers for the best parody of *Finnegans Wake* by James Joyce. Well, you know me and and parodies. I found the book in your room and I sent one in.

— How did you go? I ask him.

Wrong! He'd won but my ear had missed 'I found the book in your room' and that this was a cue for us to heal old wounds. He couldn't like Stan Kenton or Lenny Bruce and at some point Joyce got bundled in with these other 'semi-pros'. Not to be talked about.

— It was very good, he back-feeds himself. Of course the whole thing is parody but he is great with words. 'Halt on eat words' is very good for 'Hilton Edwards'. That's the way Hilton used to talk. Wonderful timing, Mac Liammóir – but you have more time in plays. They're both gone now of course. He begins to place the red dots in the corners of his eyes.

— I'm next, I think.

I look at him, startled.

— I'm on, he explains. I'd better go down.

I follow him down to the side of the stage. Everything of life has been drained from this occasion. Everything is hollow. Sounds are hollow as the music lags and the drab conductor keeps his eyes down, turning the sheet music mechanically. Without laughter the litany of my father's parody woes sounds raw. Parody depends on a shared mythology, but here there is only the cold unforgiving reality of desperation, going out from him and playing itself back into the white circle of light that imprints and illuminates his isolation.

I follow him to the dressing room. I have to tell him that this is upsetting my mother; that he's got to try and get a grip on this.

— I know. I know. he breaks down again. But what is this? What's happening to me?

— You're going to be all right, Head. Don't worry, I tell him.

His perfect ear catches the fear and falsity of the line. What is happening to him is chemical and language disintegrates in the torpor of its sullen toil.

I bluster the line: 'Where's your fucking anger, man?'

We both listen as the once potent word hangs in the silence, signifying

nothing. There is no centre to this and words won't hold. The red dots of vanishing points instead of bringing me close drive me back several hundred feet to look down upon us. We are one in this pool of genetic endogeny and I feel myself suddenly drawn to its source through the carmine vanishing points in his eyes. It is terrifying and as I tighten the pressure on my clasped hands I notice that I am a mirror image of himself. We seem as fictions; parodies of men.

I begin to collage bits and pieces of anecdotes he had told me about himself. Reminding him of the past. Trying to build a structure into memory.

When Charlie Chaplin came backstage to him at the Metropolitan Edgeware road
and they talked about music hall; how, on tour, he beat the Hungarian gymnast at
arm wrestling and the man's wife woke him up at three in the morning asking him to
let her husband win because he couldn't sleep and how he let him win because the
man was the frog in the transformation scene of the panto, but also because he knew
that humiliation was paralysing for a pro and that his own upholsterer's strength
was not like 'a specialty act', not the very centre of a man's existence as a pro. And
then the time he got the gallery in The Olympia to quiet down after the English dou-
ble act left them in uproar, insulting them because in answer to the innuendo in the
straight line 'what can you get in Dublin for a penny?' a young woman's voice rang
out the perfectly pitched 'An Erinox' and how the roar of support for her split the
two cultures and the English woman panicked and gave the crowd the finger and
how he had to go out and get quiet and explain that she didn't know what an Erinox
was and didn't mean anything against Dublin and how he turned it all around and
brought the anger off the cushions to line up the laughter to fall into the pockets
and....

This house of cards collapses and I take him home.

— You know I've cured about four people since I've been here he tells me.

We are in St Brendan's where, to judge by the smiles and waves he gets from staff and patients, he is a clear favourite. He is torn between the anguish of his endogenous depression and his pro's desire to get traction. He's still in business.

— I visit the wards first thing in the morning and my opening line is 'Good morning campers'. After that I do the business with the tablets pretending to mix them up and describing what will happen to each one when they get the wrong medication. I tell the one about the 70-year-old couple who took the monkey gland pills and the next year they had a baby. He looks at me.

— Was it a boy or a girl? (I try to finish high.)

— I don't know (pause, low) they couldn't get it down off the chandelier to find out.

I try one: 'Another 70-year-old couple got married recently; they spent the honeymoon getting out of the car.'

He explains in detail why this joke 'wouldn't do for Dublin'. He still has no hesitation in speaking for the entire city in these matters. And he does know

N. S. and The Head, 1958.

163

something about a time in Dublin and he wrote for it and sang it and showed it to itself. Now he is planning a panto for Christmas, he points out the patients he has written parts for. We talk about everything except my mother who died earlier in the year. It is too late now for either of us to speak of not upsetting her; we have both made a complete bollox of that. For him now, with her gone, the rest is mechanical, academic. Finally everything is game ball, lined up and it's just a matter of clearing the table.

A mental image of my father lines up with my other art heroes; those who were blest and marked. Real pros; hard acts to follow. And my mother — even better than that.

# Going Ashley

 Sometime very late in the last millennium. An elderly composer goes to Melbourne (to Australia) for the first time for opera reasons. He and his beloved fall for the strange animals and the people. After the opera week a few lectures here and there to read parts of new librettos and see the sights. He mentions to a new acquaintance in Melbourne that the last stop is Perth. 'I think we'll rent a car and drive across. To see the sights.' The new acquaintance: 'Oh, I wouldn't do that. You'll never get there.' (I don't think he meant 'on schedule'. I think 'never' was the key word.) Wow!

Perth. The most Western point of Western civilization (to use a phrase.) From there on, apparently, it's old copies of *National Geographic* magazine, where the women aren't properly dressed and the young men, wearing Michael Jackson, T-shirts and driving two-stroke Yamaha bikes exchange heads for fun on Saturday nights. World War II movies of island jungles (clearly set in a Hollywood studio) with heavy casualties on both sides. The Yellow Peril. Until you get to Hong-Kong-by-the-sea, where the Michael Jackson T-shirts are made. But what is between Perth and that other world? I am uncertainly scared. In a sense, the end of the world. What do they do there? And why am I going there? Who will listen to the banal but beautiful existentialism of the escaped Irish who made it to the wild mid-west of the USA? I imagine 'Road Warrior' or a hundred square miles of Chinese restaurants.

At the risk of hurt feelings I will admit that the reception committee was a shock. At the risk of hurt feelings, the components were of such different sizes. There was a very large young man. There was a small woman. And there was everything in between. ('Road Warrior.') And they were the students (protégés) of a man of about my age and obviously of my gene-pool [hair begins turning at around forty; serious inability to digest vitamin B12 – it has to be injected, because of an internal parasite (don't go into that), which is important to mental health – unusual tolerance for alcohol, uncommon to the rest of the world (a friend of mine, different gene-pool, goes to Ireland for a vacation, comes back infuriated 'You go to

see an important site and they have to stop at every pub along the way and talk.'
Poor fellow. 'the ineluctable modality of the visible'] – and literate. Or perhaps
the word is 'verbal.' Or perhaps the word is 'articulate' – about ideas that I want
to hear about. (I know half a dozen people from Europe and the Middle East who
speak six or seven languages, but what's the use? If what they say to me in
English ...)

I am somehow 'at home' with this man. I want to keep him talking to me as long
as I am there. I use any excuse. Finally, on the day of my performance I propose a

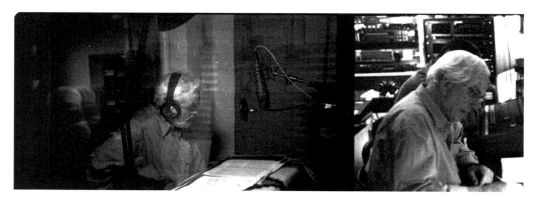

bargain; I will sing my words tonight, and tomorrow night *you will sing as much as
you can of Finnegans Wake*. Because it is clear that he understands the Wake. I
have never understood the Wake. Between the ages of 20 and 25 I carried *Ulysses*
with me everywhere, like a young priest carries the Book. But the Wake has
defied my understanding. I have read every book written about it (every detail of
the blend of the twenty-two languages Joyce knew; every detail of the geography
of Dublin, every detail of every myth I already know about. Every detail: subject,
verb, predicate, period.) But what about the sound, sir? Why am I unable to read
the sound?

The bargain goes as promised. The first night I sing or speak or whatever they
call it. The reception committee and their extended families treat me with great
hospitality. They have been trained in voice literature by this extraordinary man.
I am more 'at home' than I have been in a long time.

The second night something of a miracle happens for me. The same audience.
There is a feeling of breathless anticipation. Noel Sheridan appears at the micro-
phone, beautifully dressed, as if for an occasion. He explains *Finnegans Wake* (its
why, its technique, its pleasures, its difficulties, and its source) more clearly than I
have ever had it explained in any form. I am transported back some fifty years to
the insurmountable problems of my first encounter with the monster of twenti-
eth-century song. Then he begins to sing.

I don't understand one word, as they say. But that's an exaggeration. Occasionally, over the period of an hour and a half, I do understand one word or maybe two. Otherwise, the sound is just flowing through me, like a cure. I am in Dublin at the Wake. I am beginning to want a drink. (This particular desire is not unusual for me. Delight runs in my family. And my closest friends are usually, it seems, attracted to delight as an art form.) But this time it's different. It is as though I am being infected. Noel Sheridan is making me want to *be* James Joyce, along with all that that entails. This man can really sing. He can do what singing is. He can lead you astray.

(Let there be no poets or musicians in the Republic. Go for it, Greek. Sit around all day wondering why the parts don't fit together. Be solemn, whatever, about the things we don't understand, which is more or less everything understood only in delight: love, death, the way it works – 'and still it moves.' When you get it figured out, give me a call.) The sound is flowing through me. This is what they are all afraid of. Another form of delight.

With great foresight I have prepared myself for delight after delight. I have brought along a bottle of respectable Irish whiskey so that after the singing of the Wake we can speak at greater length. I want this sound never to stop.

So, we arrange that when Noel is next in New York, we will simply record *Finnegans Wake*. No problem. I have a small sound studio with voice booth. Noel will just stay in there all day until the vocal cords give out. And then the next. And then the next. And in the in–between times (that is, when we are not doing the *Wake* itself) we are recording Noel's explanation of what it means. I still don't understand a word of the thing itself. Now this monster song is in the loudspeakers and on tape. Along with a deep history of Dublin and Joyce. (In a more up to date accent.) On and on. The recording engineer is in shock. How will we edit something that we don't understand? (He is also in awe. Later he asks if he can use a paragraph or two in his résumé-portfolio.) Never mind. Just keep pushing that record button. This will not be heard again in anyone's lifetime. It is like a brief, last glimpse of the pyramids at Giza.

I think we have about a third of the *Wake* recorded at this time. It is possible that we will not finish. I am 'getting along' and there are no patrons on the horizon. And there are many things to do to keep the income more or less incoming. Is this a reason to be sad? Of course not. We have done it for the sound. And I have the sound on tape. I am not a museum. I am a musician.

Probably on reading this the Joyce Estate will have some lawyer write to me or

call me to order me to stop. How can I say it? I don't intend to sell it. And if I were in it for the money, I would be a lawyer like yourself. It you want to make money on James Joyce, go for it – but watch out for the Greek, who is still around and doesn't like the sound of things. I don't sell things, except my own. And even then, may the powers of my imagination forgive me.

Inevitably, at some record-industry function, my wife discovered a recording of the Wake, and she bought it for me. A huge box. A steep price. I think she misunderstood. No insults intended, but I have not opened the box. I don't know even who the actor is. And I don't care. I am not interested in James Joyce.

Noel sent me a book called *The Lost Theatres of Dublin* (Philip B. Ryan, The Badger Press, Westbury, Wiltshire, 1998.) I don't review books, but I can say, after many readings, that it is at once not a good book, because the organization is so not organized, and in some ways it is a very good book, because it is as imperfect as its subject. And now, because of the book, I understand why Noel understands the sounds.

Someday the gypsies will be gone. Someday the ghettos of Trieste will be gone. Someday maybe even Ireland itself will be gone. The microchip in a molecule, self-reproducing. The nanosecond. But the Greek was wrong. It will never be perfect. And someone will discover in a box, who knows where, a few pieces of something that they (apparently) called sound tape. And the technical archaeologists will finally, in controversy, hear something that no one will understand. And there will be a lot of arguments. And among the arguments there will be the correct one, probably misunderstood. This person, whoever he was, was not interested in James Joyce. He was interested in Noel Sheridan.

*Robert Ashley*

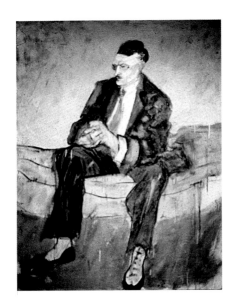

# Not waiting – again

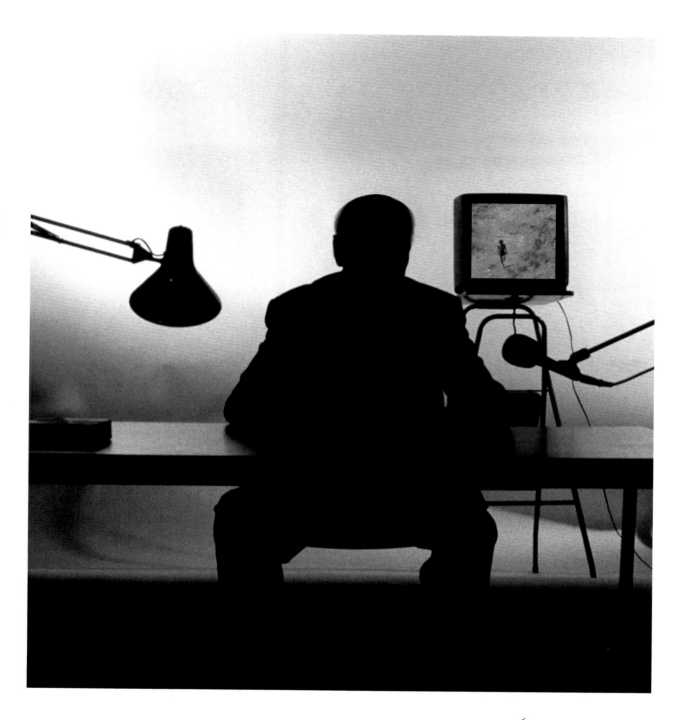

# This is not art, this is a dog barking

'Consumption accomplishes the act of production only in completing the product as product by dissolving it, by consuming its independently material form, by raising the inclination developed in the first act of production, through the need for repetition, to its finished form; it is thus not only the concluding act in which the product becomes product, but also that in which the producer becomes producer.'

Karl Marx[1]

'A clock that is working will always be a disturbance on the stage.'

Walter Benjamin.[2]

*Not Waiting* was a performance work performed for Live at Project '98 in the Mint Theatre, Dublin. The piece was both a contemporary work and a re-evaluation/re-make/re-presentation of work made by Sheridan in the mid Seventies. A work with the same title was first exhibited/performed in May 1976 in Australia. The *Irish Times* art critic, Aidan Dunne wrote two days after the event, that in *Not Waiting*, Sheridan had

'...ingeniously dragged people and events of the 1970s into the auditorium, into the collaborative space created by our collusion in his enterprise, or should that be his collusion with our bid at being an audience. Without this collusion there was no performance, but how could we be sure there was one anyway?'[3]

This was a very accurate assessment, having been present at the performance, I too was struck by the collaborative and contextual questions posed by the work in relation to the artist and spectator's functions and to the passage of time. In his

1 Karl Marx *Grundrisse* Trans. Martin Nicolaus (Vintage, New York, 1973) p. 93.
2 Walter Benjamin, 'The Work of Art in the Age of Mechanical Reproduction', *Illuminations,* ed. Hannah Arendt, trans. Harry Zohn (Schocken Books, New York, 1969) p. 247.
3 *Irish Times* 4 September 1998

review Dunne highlighted something extremely complex in both the elastic nature of the collusion of audienceship in the creation of art and in the translations of old work into new.

The ritual of a theatre puts waiting and looking together. The curtain rises or the stage lights up and an overcoding of the audience visual attentions is attempted for a specific duration. The old image is that of the safety curtain that descends and stays firmly in place to stop further emissions of the stage. The theatre presents an economy of dark space interrupted by performances, vision is privileged over audition (*theatron,* derived from 'to see'). The curtain falls like a symbolic blink and as Herbert Blau put it, '...we often forget that the intervention of the curtain in the open arch was a achievement of great psychic dimension ... what we see there is, if you reflect upon it, *better not seen* – at least in life'[4]

Traditionally, the live work happens in a particular frame and you depart with your memories. If such a work never ceased or if the frame became too broad, there could be problems.

*Not Waiting* expressed an interruption in this process on a number of levels, it was not the original work of 1976 remade, nor was it independent of that history. It was not the last word, the final version, in fact, continually through the performance Sheridan, in character as Noel Sheridan the deferential conceptual artist, articulated the evanescent quality to any closure in the work. Once commenced, *Not Waiting* almost became too self-conscious to commit an ending. The solution proposed by Sheridan was that the piece would only eventually find closure or resolution or some moment of similar significance, someday at some random moment in the future lives of the audience and artist. Visually the performance was over, the stage would be cleared, but Sheridan proposed that sound and audition (a dog's barking) would persevere long after. Clearly there is no beginning or end in audition and that waiting for an ending in listening is self-defeating. *Not Waiting* was an instruction in how to achieve an ending, or art, or whatever, by not doing the thing that must be done.

Was this a philosophical parody? In part, it was, but even then, the humour was honest and edgy. Afterall the reification of the delimiting of ideas, of 'Not Knowing', in art (and in artists) is often profoundly funny. *Not Waiting* explored this seam with widespread audience approval. Partly this was because of who Sheridan is and how he operates on different routes in the art world; he is a well

4 Herbert Blau cited in Patricia Mellencamp, 'Seeing is Believing: Baudrillard and Blau'
  *Theatre Journal* (May 1985), p. 146.

known veteran of conceptual art, administration and academia, he is a painter, performer, curator and writer, he has lived in other art worlds outside this state. To have travelled and keep travelling these roads and still be a somewhat believer in art is not too remarkable, rather what *Not Waiting* provided was a rare platform for Sheridan to risk improvising on how art and knowledge might sit uncomfortably in the audience and on stage, in a live moment. To do this he generously resurrected and re opened old work of his and others and temporarily fixed our gaze on the processes of audienceship, chance and necessity. *Not Waiting* took its cues from a number of sources, as an investigation into the nature of art or performance it challenged the giveness of the belief that art making is necessarily an artist centred activity.

Sheridan entered the stage from the audience's left and sat at an office desk on which there was a lamp and a mike. He wore a black suit with no tie, his reading glasses hung down from his neck. He remained seated for the duration of the work. On stage on the audience's right a screen displayed two 16mm films transferred on to video, film one was a loop titled *Keep This Bastard Moving* on which much of the monologue depended. It was a grainy black and white film of a aborigine male running in a desert space. This narrative piece was a work of Sheridan's from the mid Seventies, its origin based on a quote from *The Red Centre*, by H.H. Findlayson, Curator of Mammals at the South Australian Museum, 1939 where he writes:

'It is difficult for us whose lives are deep rooted in a sedentary habit to realise that their normal state is an ambulant one. From the settlers point of view it is a valuable trait, as there is never any difficulty in obtaining messengers for even the longest journeys. Not only do they enjoy the constant change of scene but they are flattered by the deference shown to envoys and take a pride in "getting through". In the bad old days of early settlement undesirable "bucks" were got rid of by giving them message sticks to deliver to distant neighbours. The message would read "Keep this Bastard Moving" and he would immediately be sent on to the next man. And so on, until after months of travelling he would find himself stranded, perhaps in a hostile country, hundreds of miles from his own territory.'

Sheridan admits to being captivated by the deviousness and abusiveness of the white settler in their capacity for creative adaptation. The ideological position of colonialism is clearly present in the 'bastardising' or perversion of 'native customs'. The coded message stick is no longer information in a sender to receiver model, the stick itself is the courier (the frame, the actor), the individual who carries it, the message (or the stage prop) to be delivered to the periphery of the colony. The 'troublesome' aboriginal (in the eyes of the settler) makes a heroic

effort to 'get through' the harsh landscape from station to station. There is more than simply deception taking place here, after all it did not take colonialism to introduce concealment, deception and distortion into aboriginal customs and everyday life. Colonialism is much more about the distortion of reality and a progressive critique of its power no longer depends on ascribing essential values to bygone pre-colonial societies. Certainly there is an abuse of power but it is arguable that even revealing the true nature of the settler's message that the aborigine would give up their desire to achieve status and respect as being a good 'journey man' within their own cultural set of distinctions. That desire has got nothing to do with the coded message and yet the story presents a paradox because the settler articulates the aborigine's desire precisely through the secret coding of the stick. In other words, Sheridan, through this paradox, attempted to posit a set of relationships and positions within colonialism that were not centred on essential values. The quotation and film clip initiated the materialistic representational concerns of the performance.

Film two was something different, it showed a clip of Sheridan as a young man in the performance of a feigned or real psychotic state, moving from a passive to an aggressive state in a laboratory white cube. This clip was from a work made in New York in the 1960s with Harry Smith as cameraperson which was tangible evidence that corroborated part of the monologue. But it was more than of a documentary function, it was a film about phenomenology, transformation, and experimentation, a window on the convergence of technologies in the Sixties, the CIA, cognitive psychology, LSD, and a particular tradition of conceptual art performance.

Throughout the performance Sheridan's character was that of a mature professional a doctor or academic, his style of enunciation was intimate but halting, the quiet word, the late night reflection on the difficulty of making a work with meaning about the histories of interculturalism and/or the problems of context and reception post Duchamp. *Not Waiting* started as a vivid story about Noel Sheridan the filmmaker making *Keep This Bastard Moving*, a story not widely known, a story that led to other stories and observations as he proceeded to move out of the specific memories of his art practice in the mid Seventies. A course through this material was guided by the significance of the situation defined by Findlayson and by a related quote by Flann O' Brien similarly introduced to the audience at the beginning of *Not Waiting*. The quotation was as follows: 'When a dog barks late at night then retires again to bed, he punctuates and gives majesty to the serial enigma of the dark, laying it more evenly and heavily upon the fabric of the mind.'

*Not Waiting* concluded on stage with a fragmented endgame, a registering of all the elements in the performance, chairs, tables, lamps, audience, an inventory of what had happened, what had been attempted. In the end, Sheridan was invoking the ghosts of his old colleagues who helped him make his work and coaxing the audience and himself into believing that one day in the future if they strove for a mind free of expectation, the ordinariness of life would become more artful than ordinarily supposed. The true beginning of *Not Waiting* was at the moment where the monologue left off.

The epistemological status of 'Not Waiting' as a notion contradictorily implies both a non-climactical value and a knowing absence of expectation. Knowledge is conventionally discussed in terms of resolution, of resolving ideas in one's mind. *Not Waiting* was careful to avoid such a position. The desert of *Keep This Bastard Moving* was potentially the desert of boredom but the monologue paid attention to the details and life on the surface of the Australian desert. Surface and depth are further descriptions of states of knowing and *Not Waiting* clearly prioritised the surface, it was not directly concerned with a revelation of hidden knowledge or an ideological laying bare of a particular situation but in the interspace and choices between the 'latent' thought and the 'manifest' text. For example, the performance was preoccupied in expressing just how the act of 'Not Waiting' might appear and what might be the mechanisms for revealing it on the surface. Nothing is ever complete on the surface. The preoccupation with surface and choice is also particularly evident in the art work *Everybody Should Get Stones* (1971) a book work made on the philosophical permutations of the unfathomable density of pebbles on the surface of an Irish beach. This work was also remade as an installation with the same title. In common with *Not Waiting*, the *Everybody Should Get Stones* works shared a phenomenological attitude that wryly embraced Victor Shklovsky's well known definition of art that 'exists to make one feel things, to make the stone *stony* ... to impart the sensations of things as they are perceived and not as they are known.'[5]

The formative mechanism or activity that seemed to fascinate Sheridan was how meaningful exchange can be expressed through involuntary understanding of events. A repeated metaphor of 'not knowing' in *Not Waiting* was the 'presence' of animals and their lack of self-consciousness in not knowing. As mentioned above, the key moment of epiphany in *Not Waiting* was expressed in the script as the desire for a dog to randomly punctuate a silent evening with two distinct but related performances; a restless barking and then a silent resignation as it settles

---

5  Victor Shklovsky, 'Art as Technique', in *Russian Formalist Criticism: Four Essays*, trans Lee T. Lemon and Marion J. Reis (1965) p. 12, Shklovsky's italics.

to lie down. Live performance is an ideal space for such an examination because animals can and can't act at the same time. An animal's non-knowledge of our reality (our framing of them as actors or non-actors) is not some other scene or alternate reality but rather bound into our ability to meaningfully shape experience and reality. There is also an element of self-parody is such a metaphor, animals always pose the risk to the actor of upstaging them. Their particular quality, what Sheridan refers to as 'visual adhesiveness' in another similar theatrical context, can short artistic circuits. As Bert O. States has remarked, 'the dog is simply at the lowest echelon of living things that come on stage tethered to the real world.'[6]

There is in the end an emphasis on situational knowledges that entertain the contingent and relative, what was of importance in my opinion was that Sheridan chose 1998 as the time to re examine such issues. *Not Waiting* expressed itself to Ireland in the age of Riverdance and unparalleled consumerism. It was not a work of nostalgia. The work of art in the age of consumerism was a reading I drew from the piece. The monologue reminded us that too much knowledge can destroy possibility, the example chosen was Limbo, a place for those who knew nothing of its existence before they went there. *Not Waiting* was an exploration of the ideological not as something hidden or as false consciousness but as on the surface of our pre structuring of reality and of being. We inhabit intimately the structure of commodity relations. It is our everyday, we are not outside its scope. The critique of capitalism is a product of capitalism, it is not from a position outside of capitalist relations. *Not Waiting* took something of a deconstructive stance, it was a mediation on the currencies of knowledge and non-knowledge in a coded system. It effectively broke down in a live environment the conventional separation between the world as reality, the artwork as representation and the place of subjectivity as the artist. *Not Waiting* took up the Duchampian challenge to the perceptual semiotics of art, it stuck to places where one is not supposed to be, Limbo or the middle of no man's land (a link between Australia in the seventies and Ireland in the Nineties). As Deleuze and Guattari wrote in 1980:

'... it's not easy to see things in the middle, rather than looking down on them from above or up at them from below, or from left to right or right to left: try it, you'll see that everything changes.'[7]

*Brian Hand*

6 Bert O. States, 'The Dog on the Stage: Theatre as Phenomenon', *New Literary History* 14 (1983) p. 381
7 Gilles Deleuze and Félix Guattari, *A Thousand Plateaus; Capitalism & Schizophrenia*, trans. Brian Massumi (University of Minnesota Press, USA, 1987) p.23.

# Not Waiting. Technical

A table and chair set centre stage about 5 metres from front row of audience.
Video screen stage left about 6 metres from audience..

Table set as if for a talk or lecture; table lamp with on/off switch, water and glass. Also a mike of good quality to pick up occasional soft speaking

The table area is lit but not framed so that the light-spill faintly illuminates the general area.

House lights down .

Enter N who sits at the table. He speaks for about a minute to introduce the work

N. *To get into this work I'd like to show a work from the mid 70s To set that in context I'd like to say a few words about ideas that were live in the art scene at that time. The art/ life glitch that Duchamp had initiated by bringing the outside inside to nominate it as art was getting more focus. Artists tried to get into the gap between art and life until it became not just the gap but the problem as to which was which. Also the question of who then made the art. To what extent were art works made up, made art, by the audience that received them. So this work was presented as two fragments to see if it could get traction as art. The discussion with the audience that followed the work was to be the work.*

When N. switches on the table lamp. Go to black and project Video One. Image size to fill screen.

This video shows an aboriginal figure moving through a landscape,The action is looped so that the figure moves in and out of frame six times.There is an overvoice which reads a text until the tape goes to black. At this point the operator should mask the projection beam. N switches off his table lamp. In the darkness there is a sound of a dog barking and the reading of a Flann O'Brien text followed by the sound of a dog barking . When the image of the aboriginal reappears the operator removes the masking and plays tape to end. Switch off projector. Remove Tape One. Insert Tape Two

N. switches on table light. Bring up lighting on desk area.

N. speaks for about 15 minutes about the work and how it was made.. This account ends with a description of the artists leaving the outback and going back to Adelaide in a four wheel drive car. The final sentences of this account are to the effect:

N. *I couldn't help thinking about that time. That time within the time. That last time. When was that?*

Project Video Two. Image of N from '60s. Audio: Louis Armstrong 'Play that Music"

After video, N. speaks about limbo and various states of 'not waiting' until he exits.

Bring up house lights.

# Not Waiting. Cues

Set up context for 1976  'Keep This Bastard Moving' video.

Duchamp. 3 Stages of the Readymade.

Model of the artist as messenger within the culture industry

Model of the coloniser

What is 'the dog'?

introduce;

Aggy Read; film maker

Leigh Hobba. musician/ video artist

Billy. musician.

Describe deepening alienation among those on 'the shoot'

Billy and the Ant.

Flashback abreactive video (1969)

Limbo

Purgatory

Heaven

'The Situation' as 'ubiety' not 'conceptual'

Where are we *supposed* to be?

Flann O'Brien God and the Devil

Bosnia

Describe the Space. Get ' Waiting'

Not Waiting.  What is it?

Not ceasing to loiter. Doing time

The musical. The old dancer. In art, life as 'exit at a random moment' is not death.

Intentionality.

The work begins to fail. Breakdown dialogue.

Get the surface of events. Get into real time; represent 'waiting' again' – fail

Can't get the peace; do the work.

Get representation of 'Waiting' again; then Aggy, Leigh and Billy

Fail again. The impossibility now to exit at a random moment.

Transfer from audience back to performer.

Token finish: *I have reason to believe that at some future random moment a dog will begin barking. He will then begin to lie down. And right  then, somewhere in there, in that animal brain. That will be the peace.*

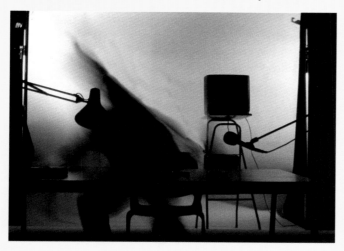

# The case for a certain kind of painting
## Dublin 1998

**W**HAT A WONDERFUL and strange place it is this 'Land of Paint' and everyone who paints wants to get there. You get into it as much by touch as by sight. How heavy or light the touch; how considered or spontaneous the hand movement; what freight of colour or viscosity of pigment gets carried on the journey begins to settle and shape this land. You make a beginning so you can start to look. Then you can travel. Where you want to go is a place you have never been before, but. you know when you arrive that it will be a place you seem to know. What makes it familiar is something from the past of art, and also something of the future – a fresh promise. But the main thing about this land is that it must be made to exist in time present. As effective and authentic as a tea cup, taking its time and space in the world.

As the painting begins to lift you feel it begin to occupy your space and you must negotiate an uneasy contract between you and it so that together you can agree the shared lie of this land. Touch and look your way into it. Then continue the looking for a long time. Nothing gets your concentrated attention like this; your eyes are peeled; looking for a long time, until everything is radiant, significant. It looks interesting. You look at the floor; that now looks equally radiant, significant and interesting. More interesting because it is *really* in the world, part of it, not a representation, not a blueprint, nothing at a remove, but right there, now. This is what you want the paint to be. But you are only at the stage of 'seeing too much'. Everything is too complex, shifting, miraculous. The half of painting that is pain begins to operate here. What stays, what goes? Who is that up to? If you start arranging, you fail. Begin Again.

Touch your way in, scraping, layering, knifing, digging out, plastering on, scraping off. Looking, looking. The eye now skating on it, sinking into it. There are two speeds. The first slick and shiny; the hand and eye racing across the paint surface, skidding away, stalling at times to let the other speed, glutinous and slow, arrest and assist the movement of growth. You try to see what it wants to be. Bring light to this place. Everything receives light but painting contends that

179

light; trapping it so that this dumb, resilient, buttery stuff seems to radiate a light of itself. It is the hopeless faith in that impossibility that makes this land of paint so human, touching, and sometimes amazing.

*You have built a mountain of something.*
*Thoughtfully pouring all your energy into this single monument,*
*Whose wind is desire starching a petal,*
*Whose disappointment broke into a rainbow of tears.*  John Ashbury

Take heart from the cliche 'dumb as a painter'. Press on. Ideas such as 'landscape' are merely hooks to memory that steady the eye. What traps and holds the eye is a visual adhesiveness special to this place of paint. It is another world and part of getting into it comes with the realisation that, as you look at it, *it begins looking at you.* ( If everyday things in the world start to look at you, something is wrong; if painting does not do it, something is wrong.)

Look how it looks. That sweeping scan of stops and glides that sometimes stall to saturation; glimpses that flick as highlights, slow searches that drag across the surface only to be turned as trummels that impede, spur and lift to hover forever. This is a look to which time cannot bring repose – for time is missing from this

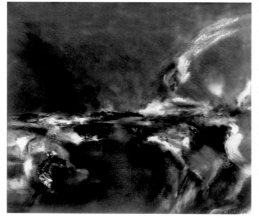

land. It is language that unfolds in time; in this place of space ... *time has turned into space and there will be no more time.*  Beckett.

Consider scale. Whether we see this land as detail or panorama – it could be either – is incidental to the size and scale of the painting itself. Sometimes you get the small, one-shot size; you see it in one take. These are like babies and they hold the fascination of babies; designed for success and even small 'peculiarities' seem full of promise. All seems nascent, full of touching potential and they are the ideal size for the eye to hold and feed.

When they get bigger they demand attention at the uneasy periphery of vision. And look at the time they take! We want these unruly adolescents – or curmudgeonly elders – to simply stay in the frame that is our conceptual frame, but these paintings are grown ups – you don't so much understand as accept them – and they are not so easily accommodated by the eye which must now give time and thought to come to terms with the fact that this moving mass, macro or micro, will be eternally ... *causing some features palpably nearer your pecker to be swollen up most grossly while the further back we manage to wiggle the more we need the loan of a lens to see as much as the hen saw. Tip.* Joyce.

And besides, you can't help thinking – *if only you could stop thinking* – this is a bad time for this kind of painting. It is as incorrect as the Full Irish Breakfast – and for many of the same reasons. Blood, ghee, muscle and brains condensed into a life threatening assault on the system is, well, unhealthy. It could be a matter of life and death; the risk level is high; you are taking terrible chances. And what has any of that to do with art? That was then. Read today's menu: 'Vegetarian sausage with just a hint of hickory'. That weasel 'hint of' points modishly to the fact that you probably have the wrong agenda.

But you know, you just feel, that deep down what everyone wants is the art equivalent of the f.i.b.: the Velasquez, the Goya, the Vuillard, the de Stael, the Guston. the de Kooning, the Reubens and yes – the Bacon. The full edible listing. 'The ates.'

Turn back from these trophic metaphors; they lead to the same queasy euphoria that confuses the floor with the painting. What is needed now is something to prevent the painting becoming linoleum. You have buried the natural light of the blank board where those original marks danced and took their first breaths. You have layered and pulled and tried to save interesting passages that finally had to go under because the logic of this place had begun to take a different turn. This has led you into darker dullnesses where everything seems to die 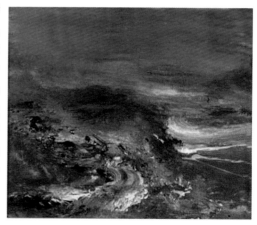 under your hand. Thick and synthetic as lino, it bends and buckles, its light has gone. It can be designed now anyway you push it. It gives but there is no take. There is no resistance. This is the terror of abstraction; how to stop it being interior design. Where you are now, numbed in this paintland, needs craft, cunning, something that works. What do you know from the past that might revive it? Salmon pink will never again travel as miraculously as it did across the silver grey of the small Infanta's dress, but try. There will never be touch like that again, but go on. Not under or over but *on* and *in*. Steal. Maybe that 'pink' has brought something flickering to life. Believe it. Begin again.

What a wonderful and strange place this is. You think you may now know this place because you have traversed it some time ago and traces remain of your having been there. You have shifted things and things have shifted you. You recognise things you made happen but most interesting are things that just happened and .... just appeared out of this land. These are the events that constitute the reason you do this.

[Reconsider; do again. elements feel wrong. ('constitute ?' Surly word . What you

wanted was 'consistency' – in the medium that is – like 'sinewy'. No, that's wrong too. Go back. Take it out. And lose the breakfast section. Won't fit; wrong tone. And that part about pictures looking was wrong. Try again.)]

It is not that the painting looks at you – it is usually too involved with itself for that – but, if you get into this land, it will show signs of your looking out. This is called style.

Press on past these ideas of signs and style. If you carry their freight into this land they will hang out or wander the place like bleating sheep, cute and lost, signifying like mad and this kind of painting can't handle that. Just look, then maybe, if you have truly entered this land of paint, and if you are lucky there will be a moment when you feel you cannot make a mistake. You may be wrong but something of your stuff and of its stuff has arrived. You sense a quickening. Look back, it's here. Just pinch its cheeks, brush its hair, straighten its dress. It's behaving itself – maybe. So send it out into the world. (An act of faith of course, but how sustaining it is, the lie of this land.)

This now is something from the land of paint. It has light. Look at it looking. Thoughtfully pouring all of your energy into this single monument, you have signed off on this contract. You will be happy here. For a time. There is a logic to this place. Stop.

'The Vision of Mac Conglinne'

Haunch of Mutton
Is my dog's name
Of lovely leaps.
(*from the 6th century Irish*)

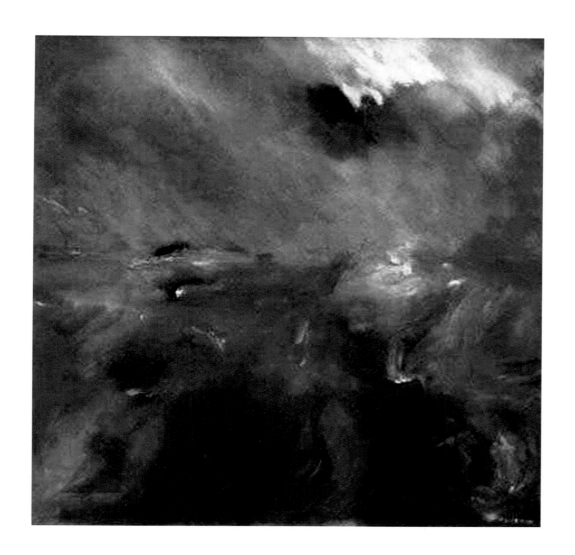

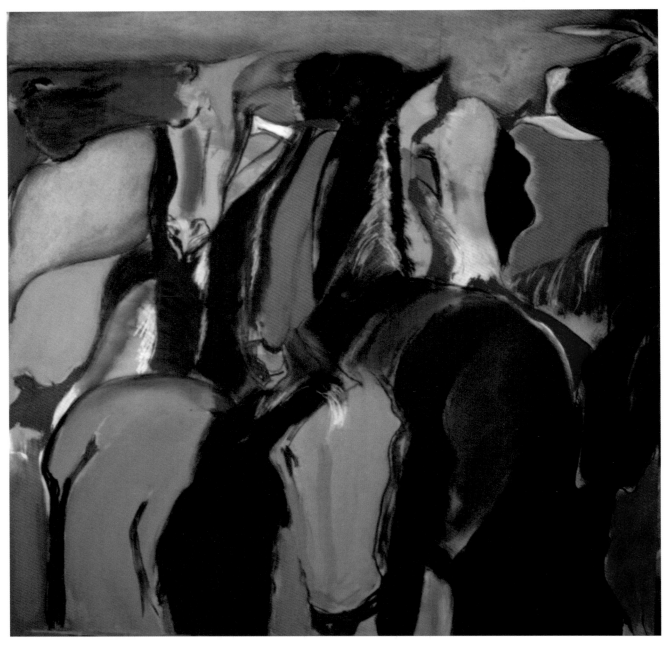

Giddy up Old Paint
120cms x120 cms

# **Missing it** Dublin 1998–2001

*An adventure ceases to be an adventure when it is regarded as such | as an adventure.*
J.P.Sartre.

I had not painted for fifteen years.

I measure out the rabbit skin crystals into the simmering water and 'stirring continuously until glue has dissolved' I inhale. At first tentatively but then in deeper draughts. Imagine this haze as stretched membrane; the stuff of film; the gheegoudal of delight; the balm of all cares; the ground of the unvoiced, the omphalos; 'the better to see you my child'. Pray for us and for all de Chirico prayed for in his prayer for his emulsions and his oil recipes. Just to be this high seems Arcady. Oh Painting.

The Belgian linen takes the size in one wet go. If it were a dog it would shake itself, but it just goes a deeper sienna and breathes itself into new life. I have watched this many times and I know that there is nothing here but loss and shadows sinking. (So leave it for the six hours as the Spectrum label cautions.)

It's nearly night now and I can just see all 6′x6′ of it leaning against the wall like some beat detective on a film noir stakeout. The space is charged and if this were installation instead of a painting-to-be this would do it. Turn on the lights and I cannot take my eyes off it. This is the terminus where flatness, edge, all-over, clarity of production, line, light, integrity and transparency mesh.

I have been looking at it for weeks now. I have been looking at it in the new studio with the great north light and I can't begin to imagine how to go on. At an angle, deflected by surprise, blindfolded? How to get in again? I stretch out my arms, feel it on my face, and carry it to the landing and, out of sight, cover it with a sheet. Later

185

Reading Banville's wonderful *Athena*. Those seven little fictional paintings. He can see what painters can no longer see. The cost of what modernism has won; *the progression of the seasons; unawareness, dissolving in her bitter tears, love's destructiveness, the frailty of human wishes and the irresistible force of destiny.* It's impossible. So that's what I must do. Attempt those faux Claudes and Poussins. Get all seven then you can begin. Oh Paint.

**The Rape of Proserpine 1655**

L. van Hobelijn (1608–1674)

Oil on canvas, 15 x 21½ in. (38.1 x 53.3 cm.)

Although the grandeur of its conception is disproportionate to its modest dimensions, this is van Hobelijn's technically most successful and perhaps his finest work. The artist has set himself the task of depicting as many as possible of the elements of the myth of the abduction of Demeter's daughter by the god of the underworld, and the result is a crowded, not to say cluttered, canvas which with its flattened surface textures and uncannily foreshortened perspectives gives more the impression of a stilllife than the scene of passionate activity it is intended to be. The progression of the seasons, the phenomenon which lies at the heart of this myth, is represented with much subtlety and inventiveness. The year begins at the left of the picture in the vernal meadow by lake Pergus – note the opalescent sheen of water glimpsed through the encircling, dark-hued trees – where Prosperpine's companions, as yet all unaware of what has befallen her, wander without care amidst the strewn violets and lilies that were let drop from the loosened folds of the girl's gown when the god seized her. In the foreground the great seated form of Demeter presides over the fertile summer fields, her teeth like barley pearls (or pomegranate seeds?) and with cornstalks wreathed in her hair: a grotesque, Arcimboldoesque figure, ancient yet commanding, the veritable mother of the mysteries. To her left, at the right of the picture, the trees that fringe the headlands above the narrow inlet of the sea have already turned and there is an autumnal smokiness in the air. Sunk here to her waist in the little waves the nymph Cyane, cursed by the god of death, is dissolving in her own bitter tears, while at her back the waters gape where Pluto has hurled his sceptre into the depths. On the surface of the water something floats which when we take a glass to it reveals itself to be a dark-blue sash: it is Proserpine's girdle, the clue that will lead her grief-demented mother to the underworld in pursuit of her lost daughter. The placing of the girdle in the sea is one of van Hobelijn's temporal jests, for when we examine the figure of Proserpine

suspended above the waves we note that the girdle in fact has not yet fallen from her waist: in this painted world all time is eternally present, and redeemable. With what consummate draughtsmanship has the painter positioned in the pale, marine air the flying chariot with its god and girl. The arrangement of vehicle, horses and passengers measures no more than five centimetres from the flared nostrils of the leading steed to the tips of Proserpine's wind-rippled hair, yet we feel with overwhelming immediacy the full weight of this hurtling mass of iron and wood and flesh that is about to plunge into the gaping sea. With its sense of suspended yet irresistible violence the moment is an apt prefigurement of the rape shortly to take place in Tartarus. The god's swarth features are set in a grimace of mingled lust and self-loathing and his upraised arm wielding the great black whip forms a gesture that is at once brutal and heavy with weariness. Proserpine, a frail yet striking figure, intensely realised, seems strangely unconcerned by what is occurring and gazes back over her shoulder, out of the frame, with an air of languid melancholy, caught here as she is between the bright world of the living and the land of the dead, in neither of which will she ever again be wholly at home. Beyond her, in the background at the top of the picture, Mount Etna is spewing fire and ash over a wintry landscape laid waste already by the wrath of grief-stricken Demeter. We see the broken plough-share and the starving oxen and the farmer lamenting for his fields made barren by the goddess in her rage at an ungrateful earth that will not give up to her the secret of her daughter's fate. And so the round of the seasons is completed. We think of other paintings with a seasonal theme, the *Primavera* for example, but van Hobelijn is not that 'Botticelli of the North' some critics claim him to be, and his poor canvas is utterly lacking in the poise, the celestial repose, the sense of unheard music sounding through its pellucid airs, that make of the Italian painter's work a timeless and inexhaustible masterpiece. However, *The Rape of Proseypine* wields its own eerie yet not inconsiderable power, fraught as it is with presentiments of loss and disaster, and acknowledging as it does love's destructiveness, the frailty of human wishes and the tyrannical and irresistible force of destiny.

Can't get past van Hobelijn's *The Rape of Prosepherine*. Image of Larry Rivers playing sax reminds me that I have chosen a school of painting that is not interested in me. But if I can just get *The Judgement of Solomon* cloak, Larry 'Arcimboldoesque' Rivers has the befitting head to go with it. That'll be Demeter. *(Must not get deflected into stray detail)*

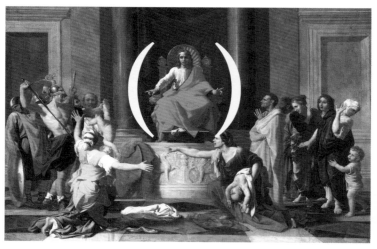

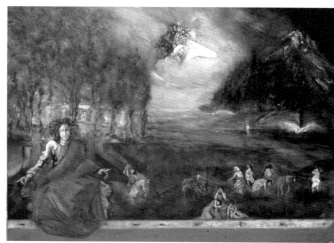

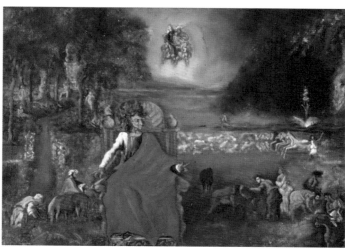

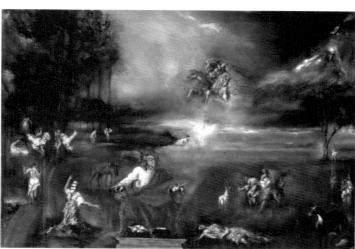

About the Poussin cloak. *(On its side it looks like a bird. The one that Freud discovered in the Leonardo Virgin and Saint Anne? I could never see that.)* What is it with cloaks? I'm making some pictures on the side, but my failure at this picture – the one I now know I cannot do – is all I want to do.

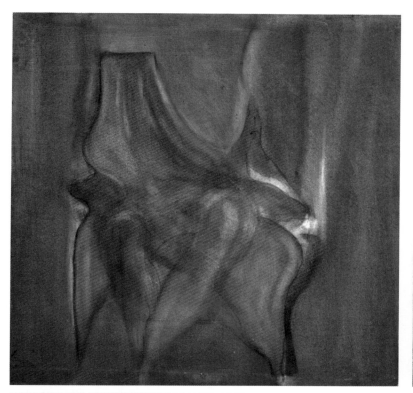 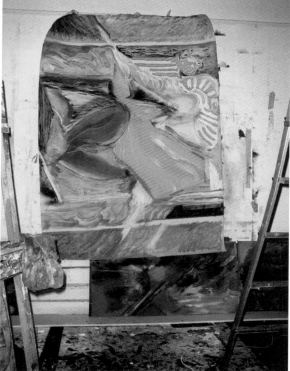

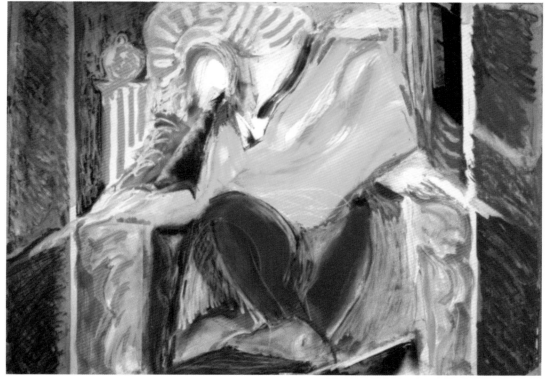

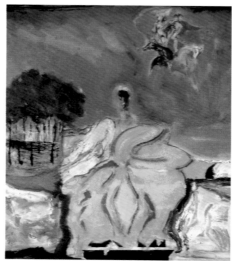

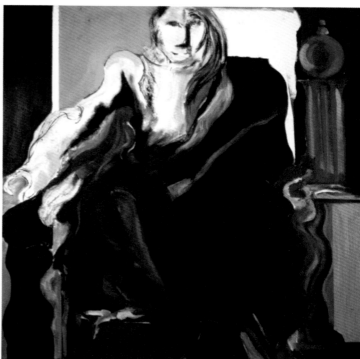

I have stalked this cloak for some time now. What gives?

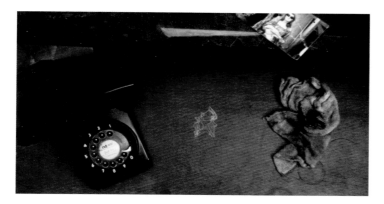

A terrible thing has happened. I was on the phone and without looking I began doodling with the white crayon I was holding. When I put down the phone I noticed that I had the cloak. No question. I believe this drawing. It's just that's it's in the wrong place and it is the size of a postage stamp. *Thank you*. I'm really angry. I take out the large canvas. I am now blind to its beauty. I just want to express something about injustice, loss and disaster and – *hold it* – I think I may have 'Demeter's teeth.'

About the field workers. What happens when you make hay? And what about the woman in the group?

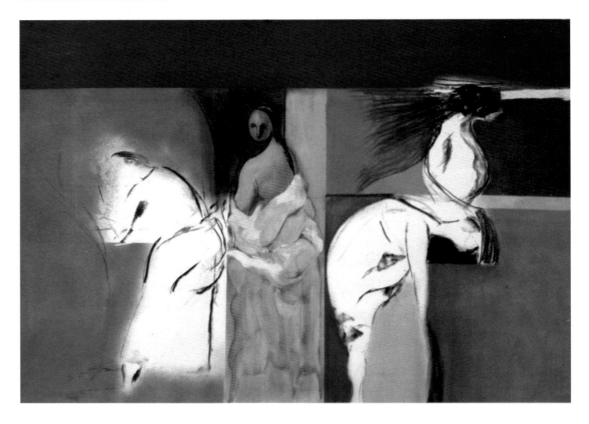

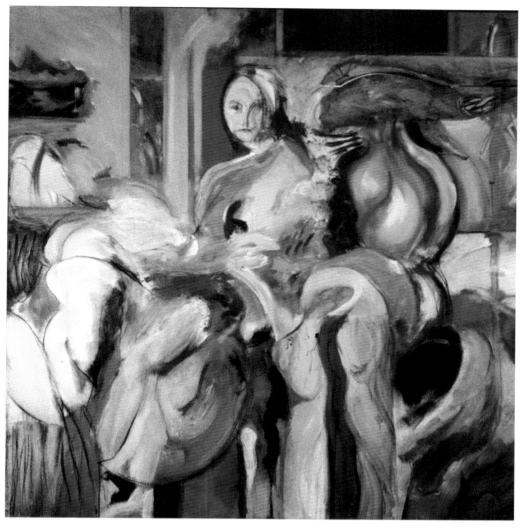

How does she fit in? Perfectly, of course, but as haymaker? They all turn around her, so just make it Liz from memory and then move on.

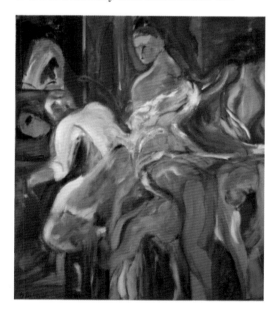

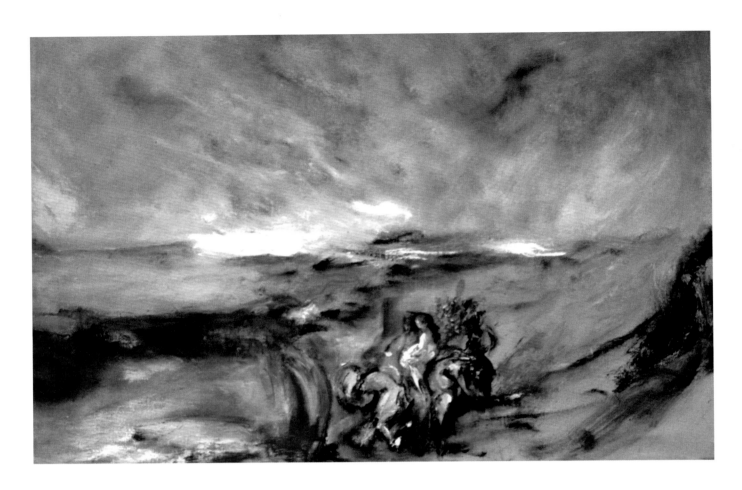

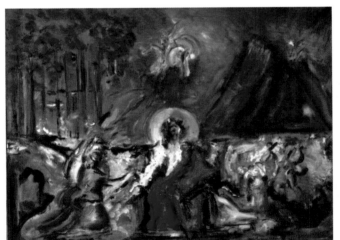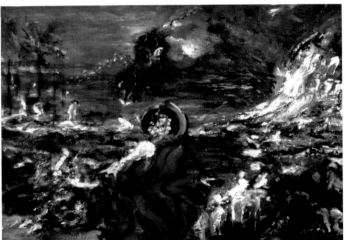

She'll take us all to the seaside and when we get home I'll lighten up and just 'go for it'; maidens, Demeter, horses, god and the volcano – ah the volcano – there can never be too much spillage, smoke and lava all over the shop and the little figures fucking and running around in flake white *(when we take a glass to it)* and, O, the hangover from this will take a long time, you will eat ashes, and you will have to begin all over because this will never do.

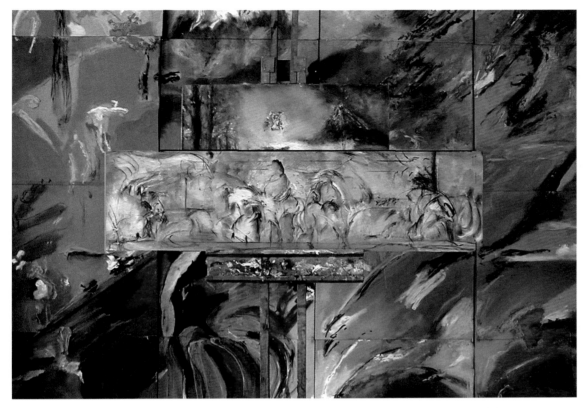

Get distance. Take its photo. Snap. Snap. Full of surprises 'Photography' but, like a mirror, it's just more of the same, but a lot, too, of what you can't see because it's all surface and all there at once, but that wasn't the point when you started this. When was that? What was that supposed to be about? It was about painting and then it was *The Judgement* or was it the cloak or was it the whole thing – or was that something else? Or what is it? Tell me.

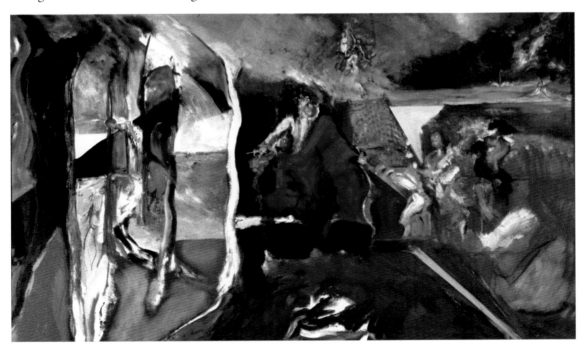

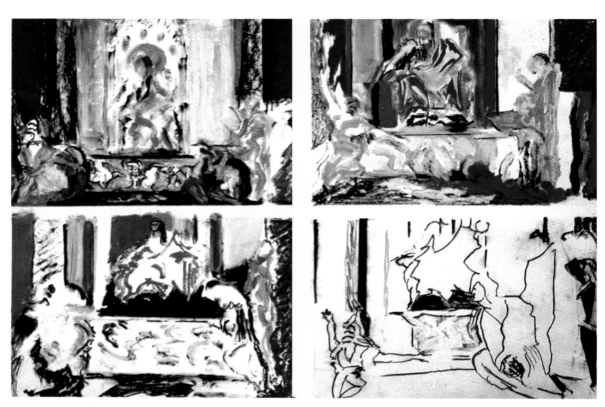

Tell me, tell me, tell me, tell

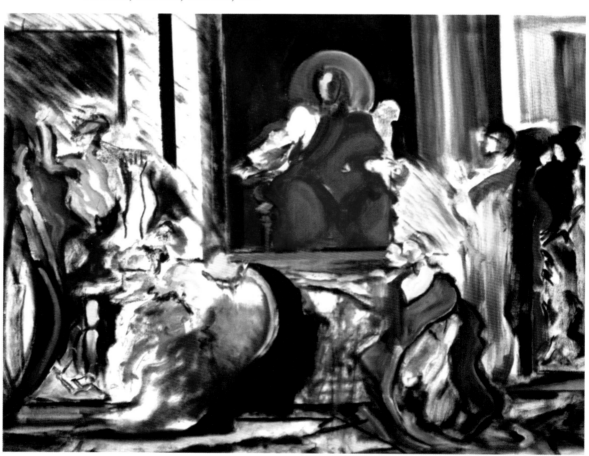

Stephen McKenna's 'The Pursuit of Painting' show at IMMA. See small painting at the end of the corridor. This painting travels. All the way down the corridor to hover and say it's here. I do the wards, getting closer all the time, Watching it getting more amazing as I reach it. It's great. It's by de Chirico and he's called it *Mysterious Spectacle*. What is it about this work painted in 1971 (de Chirico was supposed to have been all painted out by 1918 before going stranger) that rivets.

I take the catalogue home and I'm checking *Mysterious Spectacle* when it tells me what it is. It's *The Judgement*. He's got the secret of the cloak. So clean. The perspective fits. He has broken up the floor into cones, the easel is the throne and the doors are as arches, almost, and the proscenium setting is identical, turned slightly by the placement of the curtains, or so nearly a match that, in this context, with that history, my mind makes a fit. *(The opposing quarter moons and the smaller black shape require a written commentary. Language. But enough.)*

Art is supposed to help you to see, but if all you see, after all, is how good de Chirico is, then 'ambivalent' is the only word that gets what I feel exactly. But go on.

Fail Again. Fail better – blow everything up.

Demeter sketch
244cms x 305 cms

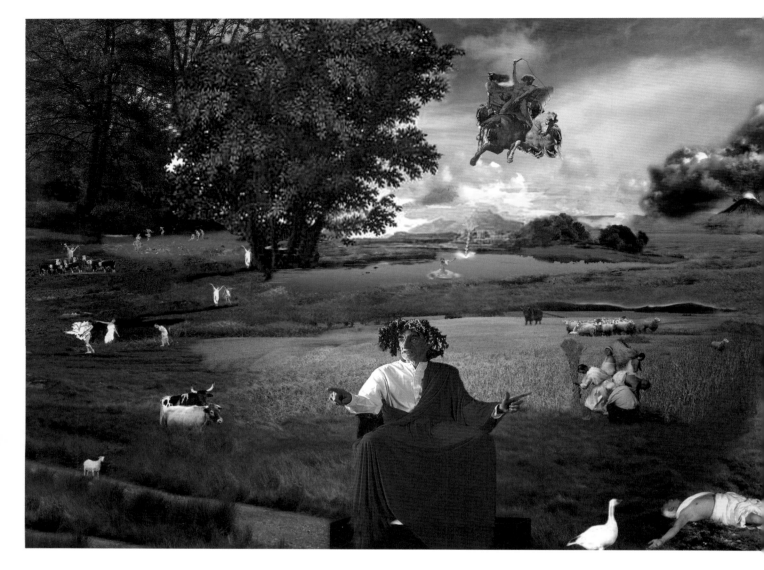

'The Angel of the *Lord*.' Edmund Burke's idea that painting can't represent *Lord*: only 'a beautiful man winged' and that's too precise; not what you might imagine. Consciousness for van Hobeljin came before this 18th century killer information. But Banville knows. So here's the thing: Poussin used little wax figures; put them in boxes, let in tiny slivers of light by cutting into the sides of these viewing devises and he used camera obscuras, I think, but anyway he used whatever was the cutting edge of technology at that time. If Poussin set the basic grammar of today's computer graphics (check it – it's Poussinland minus Poussin.) then those who follow (setting aside: striking colour, perfect placements and consumate draughtsmanship i.e. me and L. van Hobeljin – and I intend writing to John Banville to see if I may speak for van Hobeljin in this) have not only the permission, the obligation really, to use Photoshop. I feel – *let there be an end to it* – they would both want me to do this. Oh you Photoshop.

And meaning? Where is meaning between these two fictions?

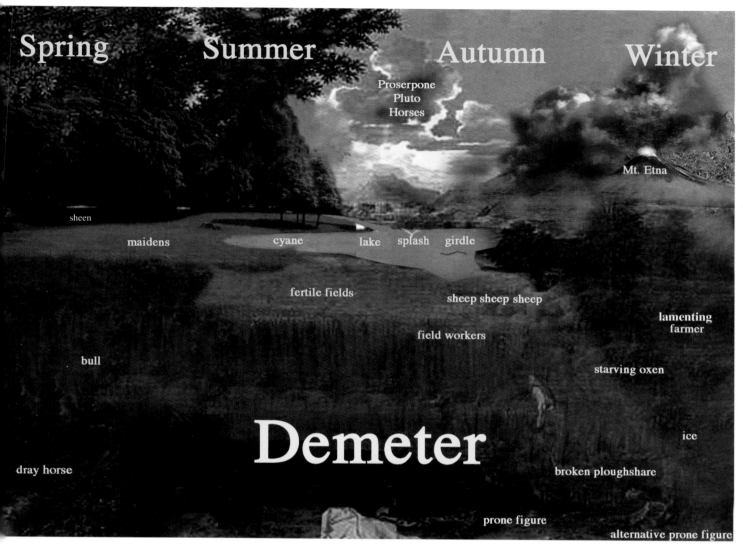

Spring    Summer    Autumn    Winter

Proserpone
Pluto
Horses

Mt. Etna

sheen

maidens    cyane    lake  splash  girdle

fertile fields    sheep sheep sheep

field workers    lamenting farmer

bull    starving oxen

Demeter    ice

dray horse    broken ploughshare

prone figure

alternative prone figure

It's in the gutter – of the book that is – and Massumi has a great text on Deluze and Guattari that nails this. But I have this deadline, and there's this exhibition, and so I just need a few more words to get to this full stop. Just back there.

P.S.
Have lunch with Cyril Barrett S.J. He asks me how the work is going. I tell him it's out of hand but it has been an adventure. We agree that art is an adventure, I tell him I will try to pull it all together in a performance. I am planning the performance as an adventure. Cyril tells me what Satre has to say about 'an adventure'. We visit Wittgenstein's plaque at the Ashling. I go home. Shattered.

Oh yes, the thing about radical painting is ……

*(You can't do it on week-ends, but soon you'll have all the days, and then we'll see.)*

# Afterword

WHAT WAS IT you were thinking when this began? Didn't you first list works for which you might find documentation. Didn't that look a bit slight. Did you not then get the idea to ask some friends, who were really good writers, to write on your work, even though a lot of this was made some time ago, some of it at a time (1950s) when to have taken a slide of a work was egomania, so no record. Or in the 1970s when ephemeral and 'real time' were the only real thing and 'no records' was the rage and didn't you know the writers would do it really well and make it better. Well, that happened.

But what you intended to say about how much Liz and your kids had supported and gone along with you at every other hands turn; moving to newer places before older places and friends had time to settle and too often for reasons that made no real sense – none of that got said.

Well now, Anne: I saw you being born and painted out of that for years. (All for me, again, I know.) And only last year you agreed to be in the never-quite-explained-why photograph of a group of – was it field workers? – dressed up in curtains because, well, this was 'blood' and the same old movie, except you were now a wonderful mature woman and I'd like to think it was your considered decision to do it. Yes? (How could I have moved us from Sydney just when the acceptance you'd worked so hard for came through for exceptional students to go to Sydney High ? How could I? Mindlessly comes to mind. Agenbite)

Mark who got the highest mark in the State of South Australia for art, really good work, and helped me with a shadow play when he was just old enough to hold a travelling light, surely you learned something from all of this Mark, because you went on to become an important, big time lawyer and exemplary father. (See Mark, it is often the lesser mark that helps us do better. I know I should have explained this at the time, but it's just dawning on me. OK?)

Lutie, who helped paint one of my better paintings when what was needed was the innocent eye and who now zaps, zips, prams and firewalls computers at the speed of light and teaches others this sophisticated way of seeing. I know that bringing you to Dublin at an age where you had to do your Leaving Certificate that same year in subjects such as Irish History was far from fair – but knowledge of other cultures can't be all bad. Right?

*Japonica here!* If ever the world gets its act together, it will be ready for this truly creative child born knowing what 'professional' was supposed to mean and she might not approve of an art document that mentioned 'the family' and was just slack about recording material that with a little more attention and focus might – *leave it dad, I'll fix it* – have done better. I will be RHA installed by Japonica.

Adelaide, who engaged the outer reaches of French Theory, thank you for the great tutorials and the time you took to explain that you and I talking together was not 'discourse', no that had a precise meaning (post Lacan?) and if I missed that point none of the rest made sense! I valued greatly – ah value– your editorial advise. Sorry some other excesses snuck in, but the best is you.

Liz is the whole thing really, but that's personal.

The Portuguese grandfather got 'grandad' so I was introduced to my granddaughter Lizzy as Noel Sheridan. We shook hands and she said 'Who are you?' Well, kid, I'm not sure, but there's this book coming out ... First I wasn't sure why, but now *you've* asked ...

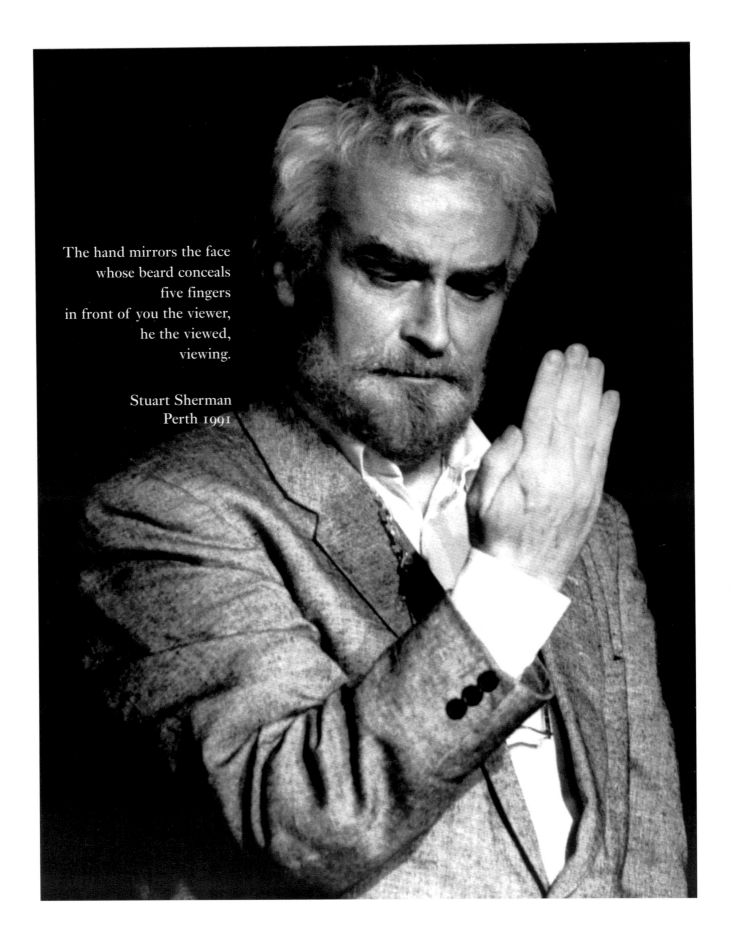

The hand mirrors the face
whose beard conceals
five fingers
in front of you the viewer,
he the viewed,
viewing.

Stuart Sherman
Perth 1991

1958
Dublin, Brussels, Paris

1959
Dublin

1960
Paris, London

1961
London

1962
London, Dublin

1963
Dublin, Rhode Island,
New York

1964
New York

1965
New York, Philadelphia

1966
New York, Woodstock

1967
Dublin, New York,
Philadelphia

1968
New York, Washington

1969
Dublin, New York

1970
New York, Wicklow

1971
Sydney

1972
Melbourne, Sydney

1974
Adelaide, Sydney

1975
Adelaide, Cologne, Mildura,
Hobart

1976
Adelaide, Canberra

1977
Adelaide, Wagga Wagga,
Sydney

1978
Adelaide, Flinders Ranges,
Sydney, London

1979
Adelaide, Los Angeles,
New York, Toronto,
Bologna, Aix, Cannes,
Dublin, London, Sydney

1980
Dublin, Wicklow

1981-84
Dublin

1985
Dublin, Hong Kong

1986
Dublin, Lisbon

1987
Dublin, Caracas

1988
Dublin, Madrid, Barcelona

1989
Dublin, Perth, Singapore

1990
Perth, Hobart, Sydney,
Melbourne, Brisbane, Darwin,
Alice Springs, Adelaide

1991-92
Perth

1993
Perth, Western Desert,
Singapore

1994
Perth, Kalgooli, Singapore

1995-97
Dublin

1998
Dublin, New York

1999
Dublin, Sydney

2000
Dublin, London

2001
Dublin

# Biographies

**Bernice Murphy** was Director of the Museum of Contemporary Art, Sydney, having worked on the development of Australia's only museum focusing on contemporary art over a fifteen-year period. She continues to write and curate. She is Vice-President of the International Council of Museums, headquartered in Paris. She is a member of ICOM's standing Ethics Committee and a member of ICOM's International Committee for Museums and Collections of Modern Art. She was awarded the Australia Council's Visual Arts/Craft Emeritus Medal 1999, for service to curatorship and contemporary visual arts in Australia.

**Mike Parr** began exhibiting in 1970 at Inhibodress Gallery which he startedwith the artists Peter Kennedy and Tim Johnson.He has exhibited continuously since 1970 with regular annual shows in Australia and many inclusions in international exhibitions: Paris Biennale 1977; Venice Biennale 1980; PS1 and the Corcoran, Washington in 1984; Museum of Modern Art, NY 1985; Five (5) Sydney Biennale's and in recent years the Cuban Biennale; Biennale in Japan; Liverpool, UK and most recently a performance festival in Quebec City, Canada.

**Brian Hand** is an artist and writer. He was member of Blue Funk in the 1990s and has recently exhibited with Repohistory in Circulation (New York, 1999), and with The Fire Department in If I ruled the world (CCA Glasgow, 2000). He is currently working as a part-time lecturer and with 147 on temporary and debate-specific projects in Dublin.

**Brian O'Doherty** aka Patrick Ireland is an artist and writer. His work has been shown in numerous galleries in the USA and in Europe. He is the author of two novels *The strange Case of Mademoiselle P.* and *The Deposition of Father McCreevey* (Booker Prize shortlisted) His writings on art include. 'American Masters' and 'Inside the White Cube'.

**Des McAvock** is a well known Irish art critic.

**Donald Brook** is Emeritus Professor of Visual Arts in the Flinders University of South Australia' His writings; 'Flight from the Object' and 'The Social Role of Art' have been influential on art practice in Australia. He was the founding member of The Experimental Art Foundation in Adelaide.

**George Alexander** has published widely in both the literary and art field, including a prize-winning novel, Mortal Divide, and several book-length monographs on artists, including Julie Rrap and Robert Owen. He has just completed a book of essays on the art world (1979-1999) entitled Connecting Flights to be published in 2001. He works as Co-ordinator of Contemporary Art Programmes at The Art Gallery of New South Wales

**Robert Ashley** is distinguished figure in American contemporary music, with an international reputation for his work in new forms of opera and multi-disciplinary projects. Ashley's recorded works are acknowledged classics of language in a musical setting. He pioneered opera-for-television.

**Stuart Sherman** is an artist in several media: performance, film, video, graphics, words. He has presented his work and/or taught extensively in the U.S., Europe, Australia, and Japan, receiving numerous honors and distinctions, including a Guggenheim Fellowship and the Prix de Rome. An American by birth, he lives in New York and elsewhere.

**Ken Jacobs** is a filmmaker, performer and teacher. A key figure in the underground film movement in the 1960s; he founded the Millennium Film Workshop in NYC in 1966. His 'Blonde Cobra' (1958-63) and 'Tom Tom' (1969) are seminal avant-garde works. His invention in the 1970s of his 'Nervous System' performances, using two analytic stop-motion projectors, have been presented in Europe, Japan and the USA. The American Museum of the Moving Image (1989) and The Arsenal in Berlin (1986) have shown retrospectives of his work. He is Distinguished Professor at Binghamton where he founded the Department of Cinema (1969).

# Index